An Uncertain Grace

PHOTOGRAPHS BY

Sebastião Salgado

Essays by
Eduardo Galeano and
Fred Ritchin

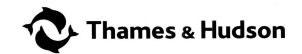

Thames & Hudson

First published in the United Kingdom in 1990 by
Thames & Hudson Ltd, 181A High Holborn, London WC1V 7QX

www.thamesandhudson.com

First published in paperback by
Thames & Hudson Ltd, 2004.

Reprinted 2008

Design by Lélia Wanick Salgado
Duotone Separations by Robert Hennessey

British Library Cataloguing-in-Publication Data
A catalogue record for this book is available from the British Library

ISBN: 978-0-500-28489-6

Printed in Hong Kong by Sing Cheong Printing Co. Ltd.

To my parents Décia and Sebastião Ribeiro Salgado

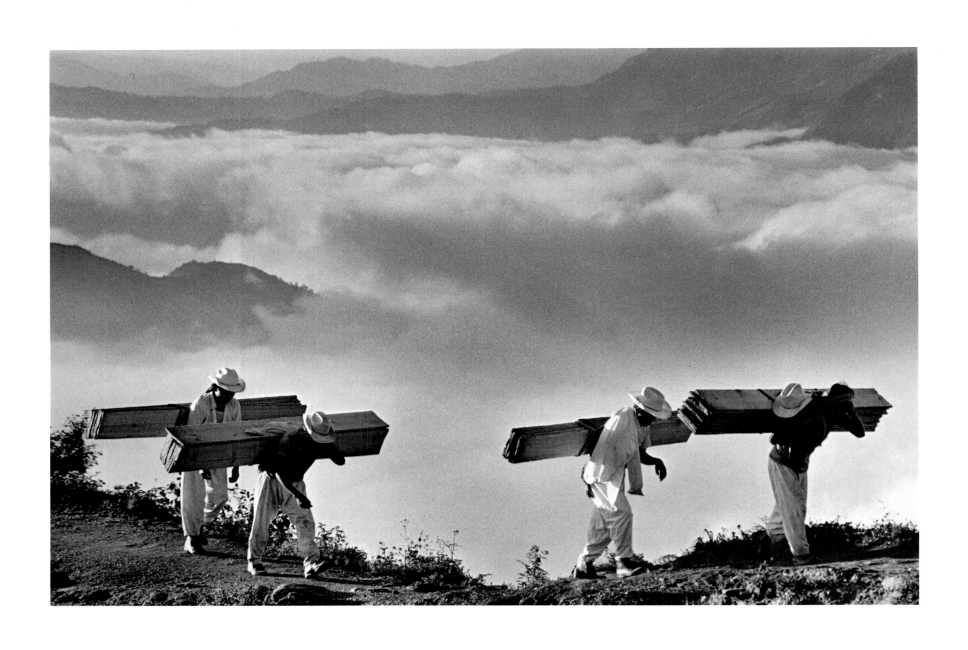

Salgado, 17 Times

Eduardo Galeano

Translated by Asa Zatz

1. Are these photographs, these figures of tragic grandeur, carvings in stone or wood by a sculptor in despair? Was the sculptor the photographer? Or God? Or the Devil? Or earthly reality?

This much is certain: it would be difficult to look at these figures and remain unaffected. I cannot imagine anyone shrugging his shoulder, turning away unseeing, and sauntering off, whistling.

2. Hunger looks like the man that hunger is killing. The man looks like the tree the man is killing. The trees have arms, the people, branches. Wizened bodies, gnarled: trees made of bones, the people of knots and roots that writhe under the sun. The trees and the people, ageless. All born thousands of years ago—who knows how many?—and still they are standing, inexplicably standing, beneath a heaven that forsakes them.

3. This world is so sad that the rainbows come out in black and white and so ugly that the vultures fly upside down after the dying. A song is sung in Mexico:

> *Se va la vida por el agujero*
> *Como la mugre por el lavadero.*
> [Life goes down the drain
> Like dirt in the sink.]

And in Colombia they say: *El costo de la vida sube y sube y el valor de la vida baja y baja.* [The more the cost of living goes up the less life is worth.]

But light is a secret buried under the garbage and Salgado's photographs tell us that secret.

The emergence of the image from the waters of the developer, when the light becomes forever fixed in shadow, is a unique moment that detaches itself from time and is transformed into forever. These photographs will live on after their subjects and their author, bearing testimony to the world's naked truth and hidden splendor. Salgado's camera moves about the violent darkness, seeking light, stalking light. Does the light descend from the sky or rise out of us? That instant of trapped light—that gleam—in the photographs reveals to us what is unseen, what is seen but unnoticed; an unperceived presence, a powerful absence. It shows us that concealed within the pain of living and the tragedy of dying there is a potent magic, a luminous mystery that redeems the human adventure in the world.

4. The mouth, not yet dead, fixed to the spout of a pitcher. The pitcher, white, glowing: a breast.

This neck, a child's, a man's, an old man's, rests on someone's hand. The neck not yet dead, but already given up for dead, can no longer sustain the weight of the head.

5. Salgado's photographs, a multiple portrait of human pain, at the same time invite us to celebrate the dignity of humankind. Brutally frank, these images of hunger and suffering are yet respectful and seemly. Having no relation to the tourism of poverty, they do not violate but penetrate the human spirit in order to reveal it. Salgado sometimes shows skeletons, almost corpses, with dignity—all that is left to them. They have been stripped of everything but they have dignity. That is the source of their ineffable beauty. This is not a macabre, obscene exhibitionism of poverty. It is a poetry of horror because there is a sense of honor.

In Andalusia I was once told of a very poor fisherman who went about peddling shellfish in a basket. This poor fisherman refused to sell his shellfish to a young gentleman who wanted all of them. He offered to pay the fisherman whatever price he asked, but the fisherman refused to sell for the simple reason that he took a dislike to the young gentleman. And he simply said to him:

"I am the master in my hunger."

6. A little dog stretched out upon his friend's grave. His head high, he keeps vigil over him in his sleep between the lighted candles.

An automobile among ruins, inside it a black woman in a bridal gown looking at a flower made of cloth.

Impossible ships in the midst of the infinite wilderness of sand.

Tunics—or banners—of sand lashed by the wind.

Cactuses like swords of the earth, armored arms of the earth.

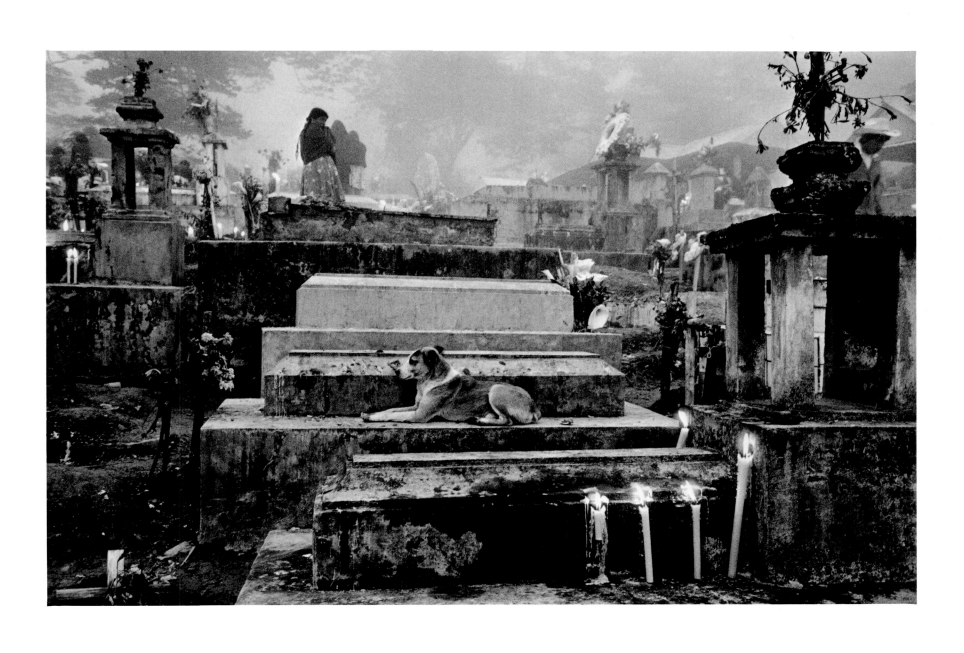

9

In the factories pipelines that are intestines or voracious boas.
And on the earth, out of the earth, there are peasant feet: feet of earth and time.

7. Salgado photographs people. Casual photographers photograph phantoms.

As an article of consumption poverty is a source of morbid pleasure and much money. Poverty is a commodity that fetches a high price on the luxury market.

Consumer-society photographers approach but do not enter. In hurried visits to scenes of despair or violence, they climb out of the plane or helicopter, press the shutter release, explode the flash: they shoot and run. They have looked without seeing and their images say nothing. Their cowardly photographs soiled with horror or blood may extract a few crocodile tears, a few coins, a pious word or two from the privileged of the earth, none of which changes the order of their universe. At the sight of the dark-skinned wretched, forsaken by God and pissed on by dogs, anybody who is nobody confidentially congratulates himself: life hasn't done too badly by me, in comparison. Hell serves to confirm the virtues of paradise.

Charity, vertical, humilates. Solidarity, horizontal, helps. Salgado photographs from inside, in solidarity. He remained in the Sahel desert for fifteen months when he went there to photograph hunger. He traveled in Latin America for seven years to garner a handful of photographs.

8. The miners of Serra Pelada: bodies of clay. More than fifty thousand men in northern Brazil buried in clay, hunting for gold. Loaded with clay they scale the mountain, slipping sometimes and falling, each fallen life no more important than a pebble that falls. A host of miners climbing. Images of the pyramid builders in the days of the Pharaohs? An army of ants? Ants, lizards? The miners have lizard skins and lizard eyes. Do the wretched of the earth live in the world's zoo?

Salgado's camera reaches in to reveal the light of human life with tragic intensity, with sad tenderness. A hand, open, reaches out from nowhere to the miner struggling up the slope, flattened by his burden. The hand, like the hand in Michelangelo's fresco, touching the first man and, in touching, creating him. The miner on his way to the top of Serra Pelada—or Golgotha—leans, resting, on a cross.

9. This is stripped-down art. A naked language that speaks for the naked of the earth. Nothing superfluous in these images, miraculously free of rhetoric, demagogy, belligerence.

Salgado makes no concessions, though it would be easy and, unquestionably, commercially advantageous for him to do so. The profoundest sadness of the universe is expressed without offering consolation, with no sugar coating. In Portuguese, *salgado* means "salty."

11

The picturesque, studiously avoided by Salgado, would cushion the violence of his blows and foster the concept of the Third World, as, after all, just "another" world: a dangerous, lurking world but at the same time *simpático,* a circus of odd little creatures.

10. Reality speaks a language of symbols. Each part is a metaphor of the whole. In Salgado's photographs, the symbols disclose themselves *from the inside to the outside.* The artist does not extract the symbols from his head, to generously offer them to reality, requiring that they be used. Rather, reality selects the precise moment that speaks most perfectly for it: Salgado's camera denudes it, tears it from time and makes it into image, and the image makes itself symbol—a symbol of our time and our world. These faces that scream without opening their mouths are "other" faces no longer. No longer, for they have ceased being conveniently strange and distant, innocuous excuses for charity that eases guilty consciences. We are all those dead, going back centuries or millennia, who nevertheless remain stubbornly alive—alive down to their profoundest and most painful radiance, who are not pretending to be alive for a photograph.

These images that seem torn from the pages of the Old Testament are actually portraits of the human condition in the twentieth century, symbols of our one world, which is not a First, a Third, or a Twentieth World. From their mighty silence, these images, these portraits, question the hypocritical frontiers that safeguard the bourgeois order and protect its right to power and inheritance.

11. Eyes of a child looking on death, not wanting to see it, unable to look away. Eyes riveted on death, snared by death—death that has come to take those eyes and that child. Chronicle of a crime.

12. I have spent five minutes searching for words as I gaze at a blank sheet of paper. In those five minutes, the world spent ten million dollars on armaments and one hundred and sixty children starved to death or died of curable illness. That is to say, during my five minutes of reflection, the world spent ten million dollars on armaments *in order that* one hundred and sixty children could be murdered with utter impunity in the war of wars, the most silent, the most undeclared war, the war that goes by the name of peace.

Bodies out of concentration camps. Auschwitzes of hunger. A system for purification of the species? Aimed at the "inferior races" (which reproduce like rabbits), starvation is used instead of gas chambers. And for the same price, a method of population control. The epoch of peace by fear was ushered in with the atom bombs at Hiroshima and Nagasaki. For want of world wars, starvation checks population explosion. Meanwhile, new bombs police the hungry. A human being can die

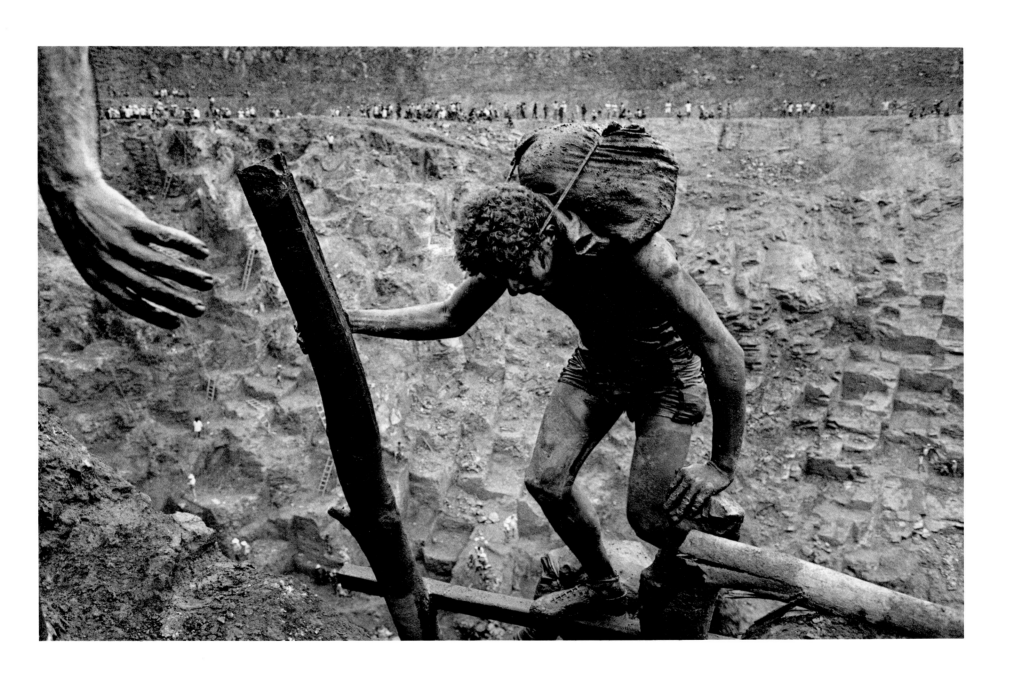

only once, as far as we know, but the number of nuclear bombs currently stockpiled provides the option of killing everyone twelve times.

Sick with the plague of death, this world that eradicates the hungry instead of hunger produces food enough for all of humanity and more. Yet, some die of starvation and others of overeating. To guarantee that the usurpation of bread shall endure, there are twenty-five times as many soldiers as doctors in the world. Since 1980, the poor countries have increased military spending while expenditures for public health were cut back by half.

An African economist, Davison Budhoo, resigned from the International Monetary Fund. In his farewell letter he wrote: "There has been too much blood, as you know. It runs in rivers. It has befouled me completely. I sometimes feel that there isn't soap enough in the world to wash away what I have done in your name."

13. Houses like the empty skins of dead animals. The blankets are shrouds and the shrouds dry shells that encase shriveled fruits or deformed beings.

People bearing bundles, bundles bearing people. Bearers scarcely able to walk the mountains, bowed under timbers large as coffins that they carry on their shoulders, becoming part of their shoulders. But they walk on the clouds.

14. The Third World—the "other" world—worthy only of contempt or pity. In the interest of good taste, not often mentioned.

Had AIDS not spread beyond Africa, the new plague would have gone unnoticed. It hardly would have mattered if thousands or millions of Africans had died of AIDS. That isn't news. In what is known as the Third World, death from plague is a natural death.

If Salman Rushdie had stayed in India and written his novels in Hindustani, Tamil, or Bengali, his death sentence would have attracted no attention. In the countries of Latin America, for example, several writers have been condemned to death and executed by recent military dictatorships. The European countries recalled their ambassadors from Iran in a gesture of indignation and protest against Rushdie's death sentence, but when the Latin American writers were sentenced—and executed—the European countries did not recall their ambassadors. And the reason they were not recalled was because their ambassadors were busy selling arms to the murderers. In the Third World, death by bullets is a "natural" death.

From the standpoint of the great communications media that uncommunicate humanity, the Third World is peopled by third-class inhabitants distinguishable from animals only by their ability to walk on two legs. Theirs are problems of nature not of history: hunger, pestilence, violence are in the natural order of things.

15. A Way of the Cross with statues of stone. A Way of the Cross with people of flesh and blood. Is that scruffy child wandering the dunes of the desert gentle as Jesus? Does he possess Jesus' anguished beauty? Or *is* he Jesus on the way to the place where he was born?

16. Hunger lies. It simulates being an insoluble mystery or a vengeance of the gods. Hunger is masked, reality is masked.

Salgado was an economist before he found out he was a photographer. He first came to the Sahel as an economist. There, for the first time, he tried to use the camera's eye to penetrate the skins reality uses to hide itself.

The science of economics had already taught him a great deal about the subject of masks. In economics, what appears to be, never is. Good fortune through numbers has little or nothing to do with the greater good. Let us postulate a country with two inhabitants. That country's per capita income, let us suppose, is $4,000. At first glance, that country would seem to be doing not at all badly. Actually, however, it turns out that one of the inhabitants gets $8,000 and the other zero. Well might the other ask those adept in the occult science of economics: ''Where do I collect my per capita income? At which window do they pay?''

Salgado is a Brazilian. How many does the development of Brazil develop? The statistics show spectacular economic growth over the last three decades, particularly through the long years of military dictatorship. In 1960, however, one out of every three Brazilians was malnourished. Today, two out of every three are. There are 16 million abandoned children. Out of every ten children who die, seven are killed by hunger. Brazil is fourth in the world in food exports, fifth in area, and sixth in hunger.

17. Caravans of pilgrims wander the African desert, dying, searching futilely for a blade of grass, an insect to eat. Are they people—or mummies that move? Are they walking statues, disfigured by the wind, in the last throes or asleep, perhaps alive, perhaps dead, perhaps at once dead and alive?

A man carries his son—or bones that were his son—in his arms and that man is a tree, rigid and tall, rooted in the solitude. Rooted in the solitude, an amazing tree caresses the air, swaying its long branches, the foliage a head leaning over a shoulder or a breast. A dying child manages to move its hand in a final gesture, the gesture of a caress, and caressing, dies. Is that woman who walks, or drags herself, against the wind a bird with broken wings? Is that scarecrow with arms thrown open in the solitude a woman?

(This text is dedicated to Helena Villagra, who saw with me.)

I.

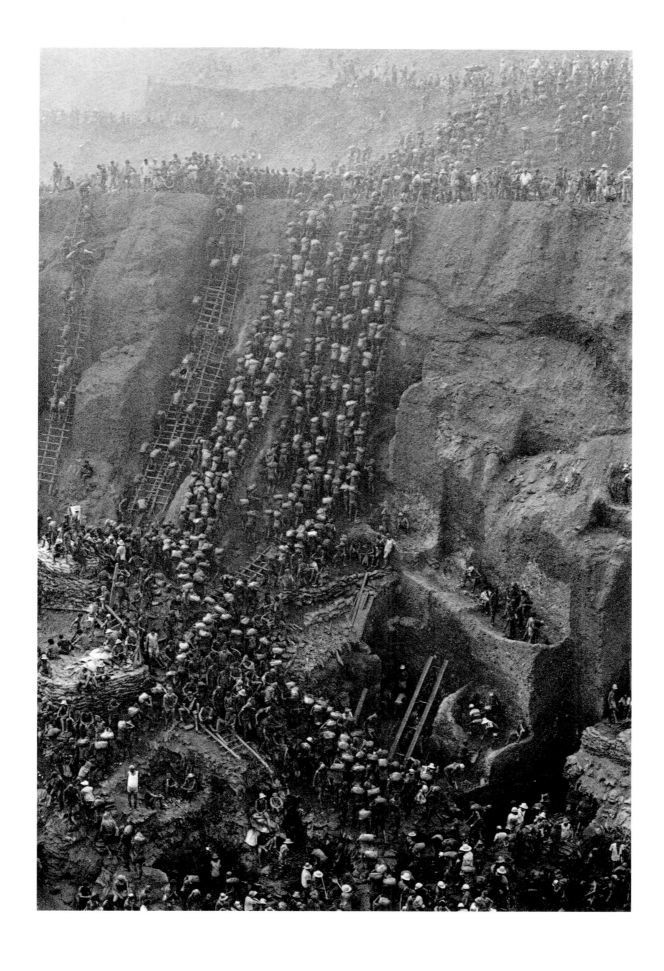

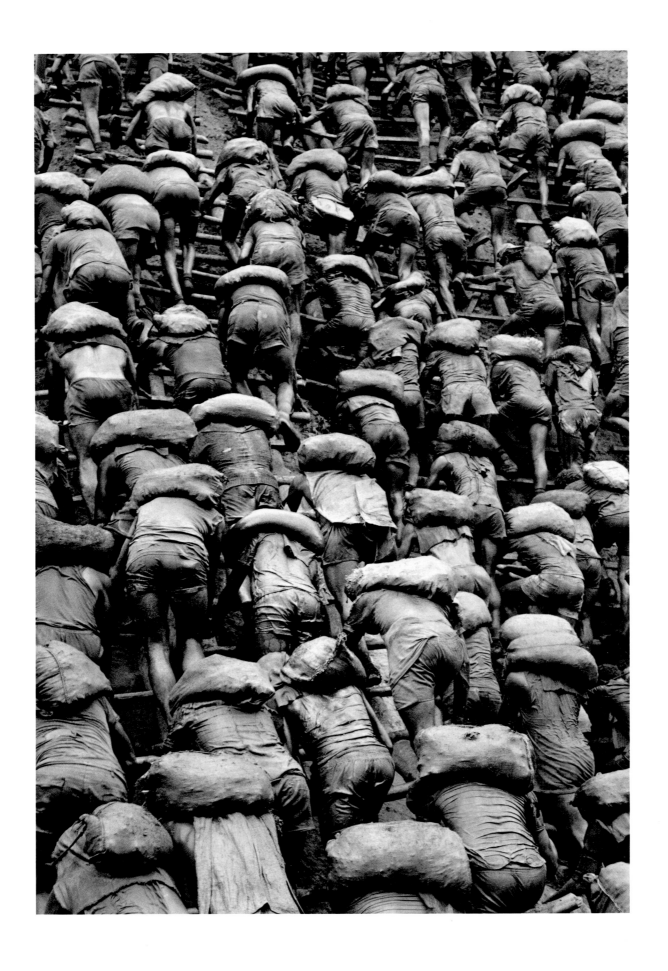

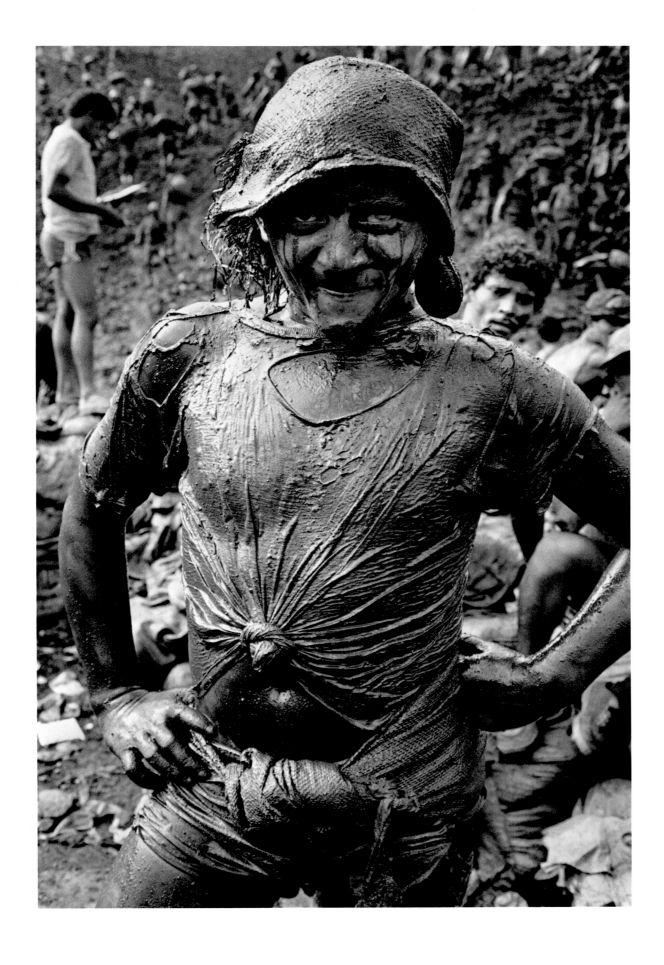

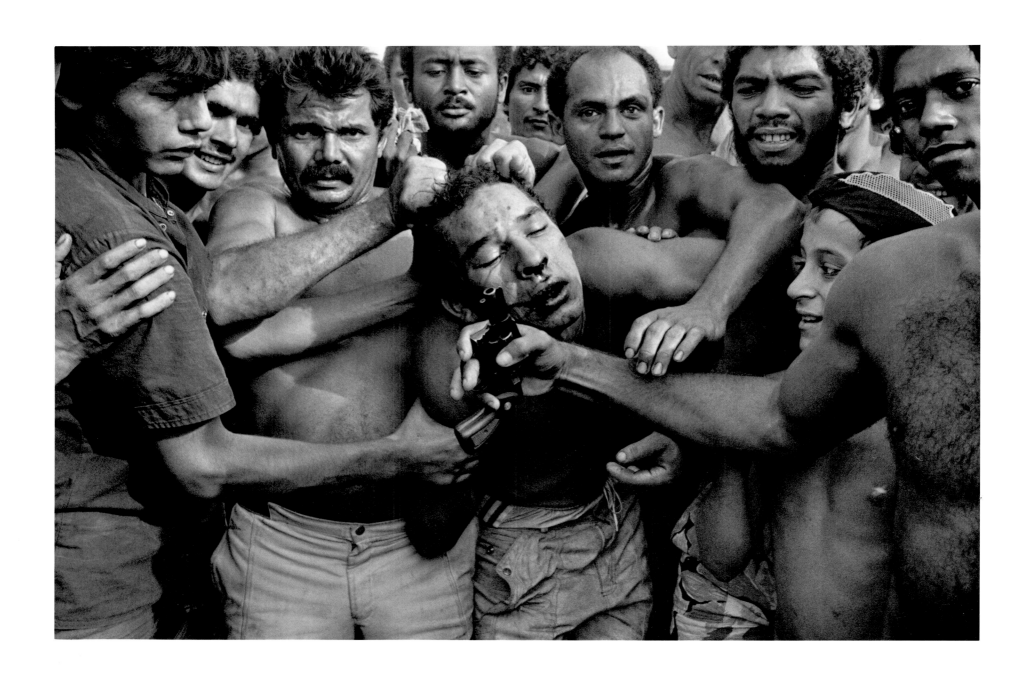

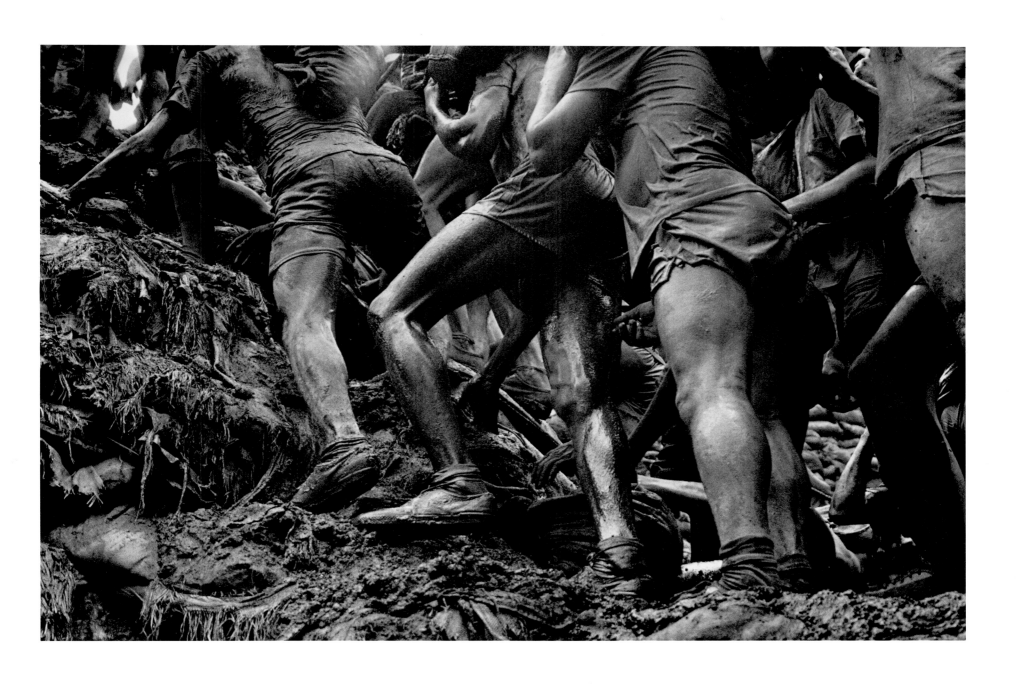

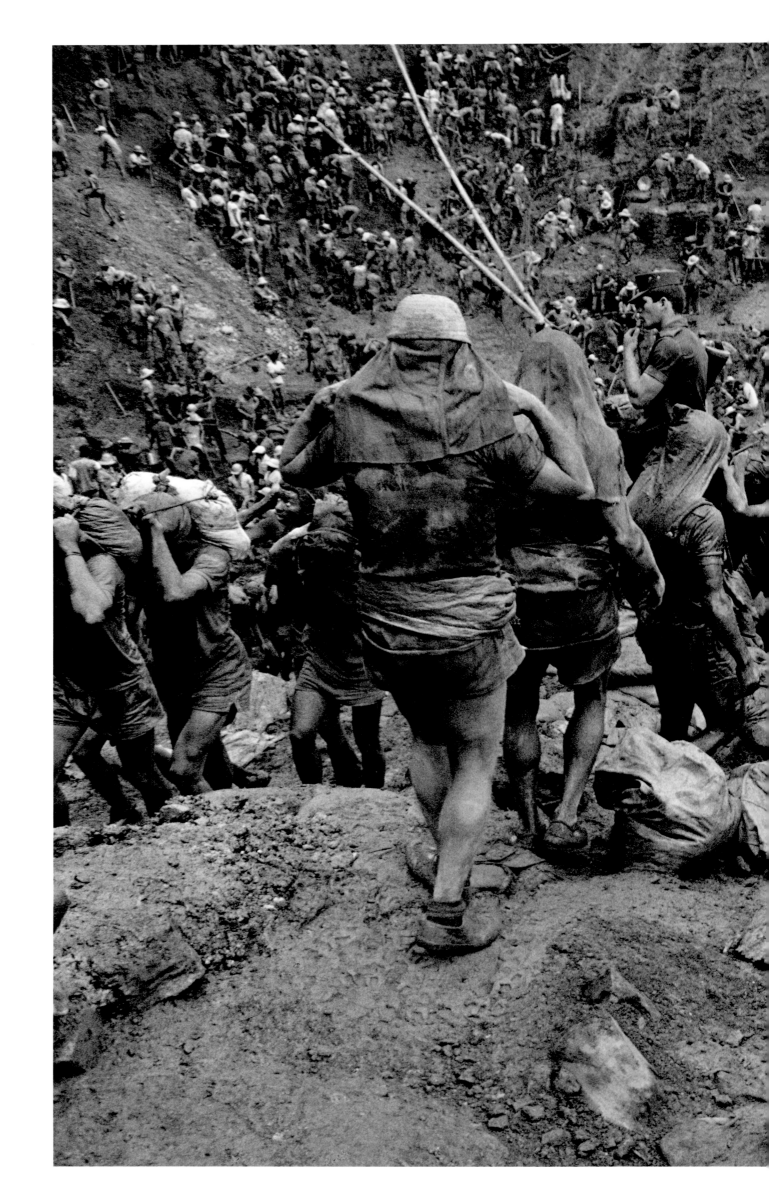

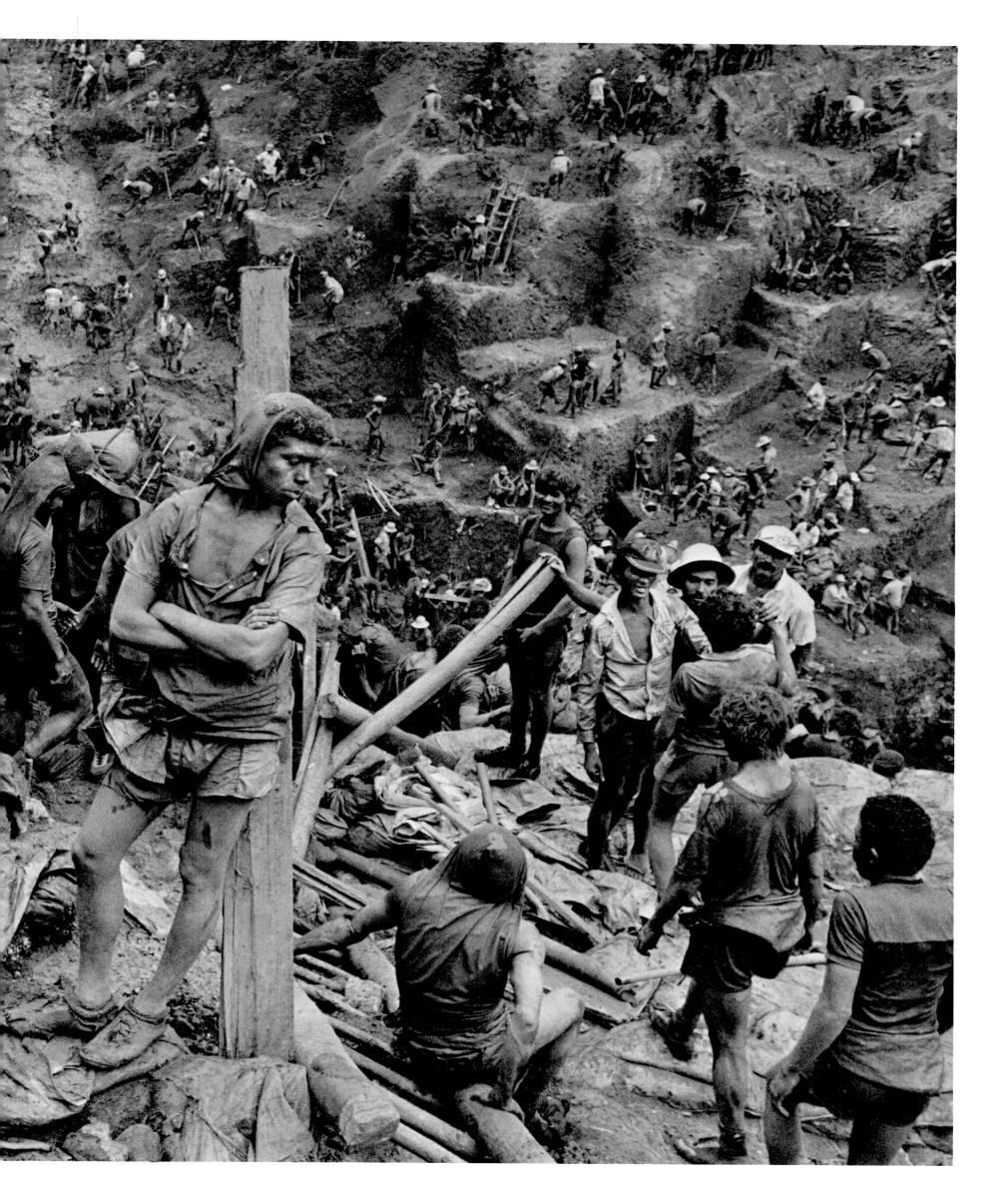

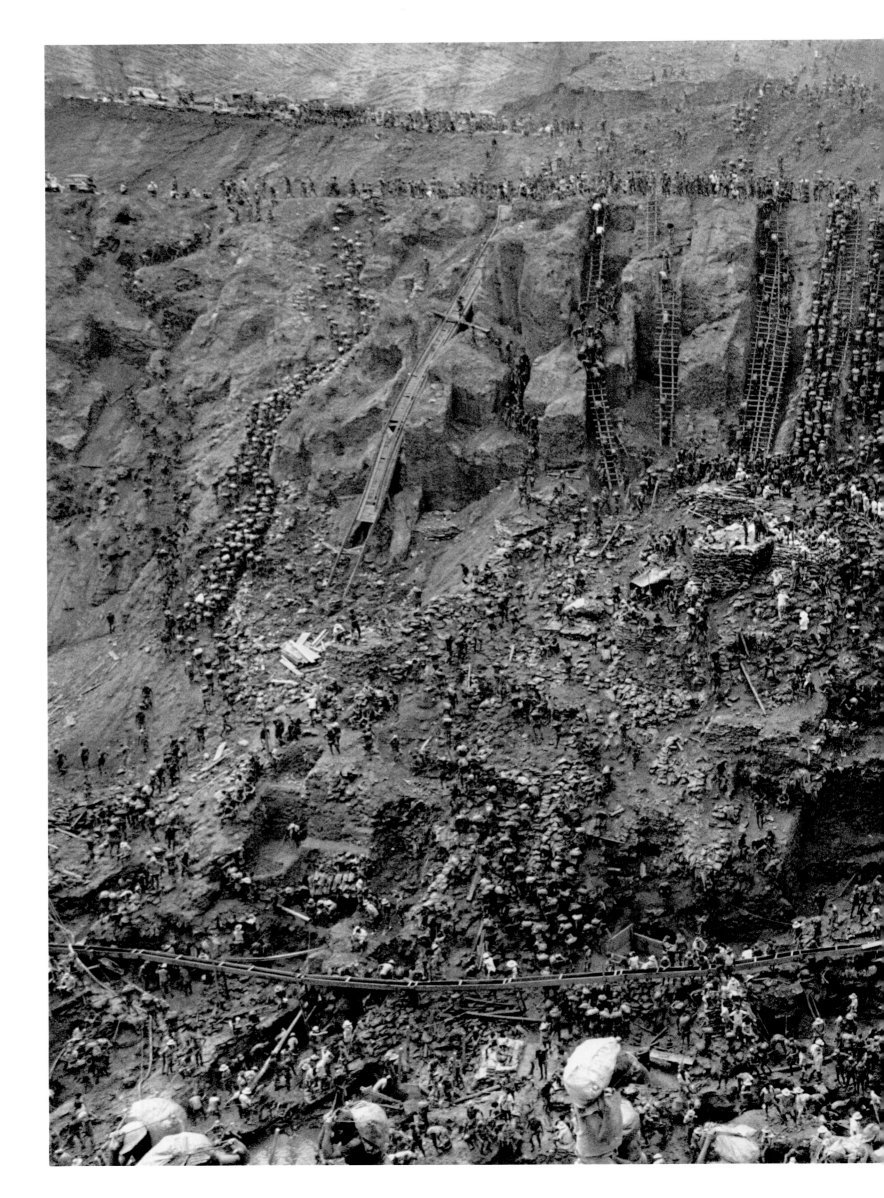

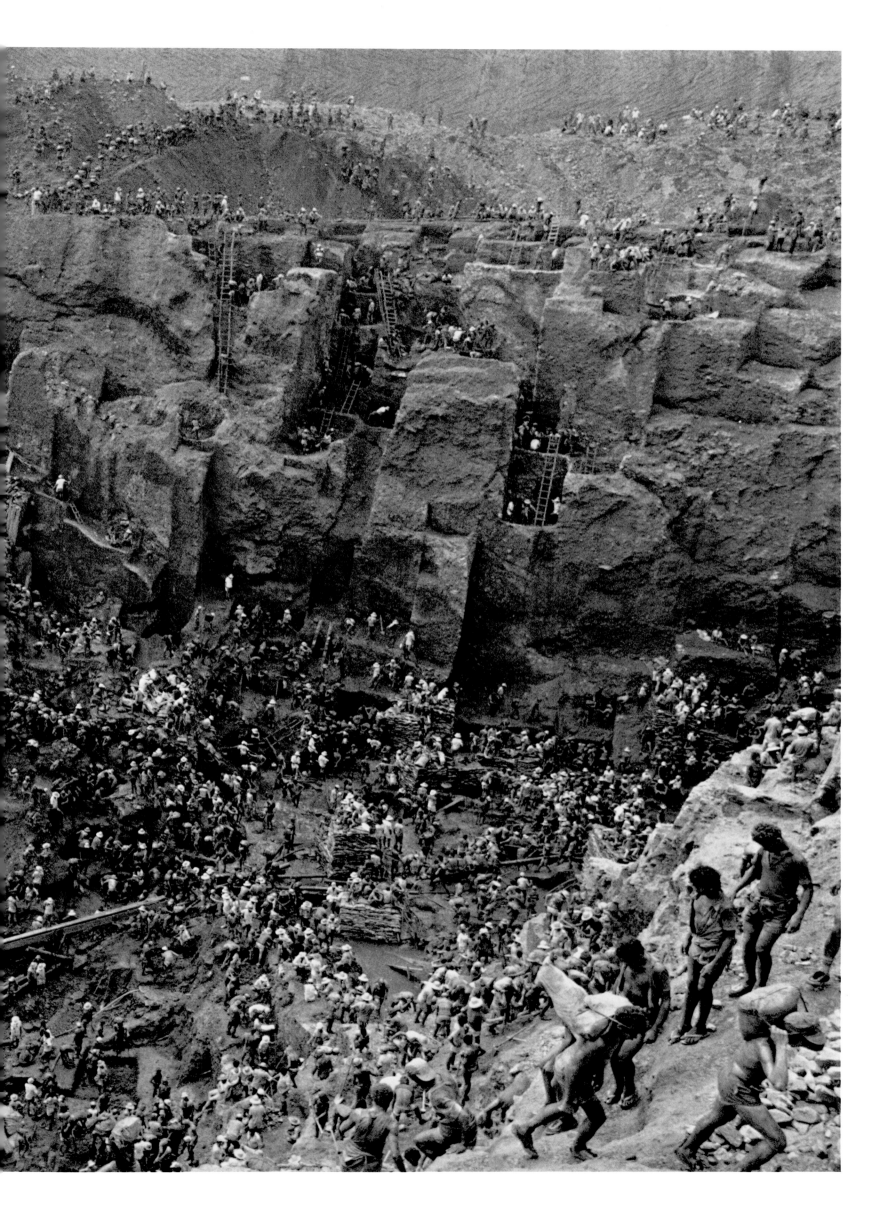

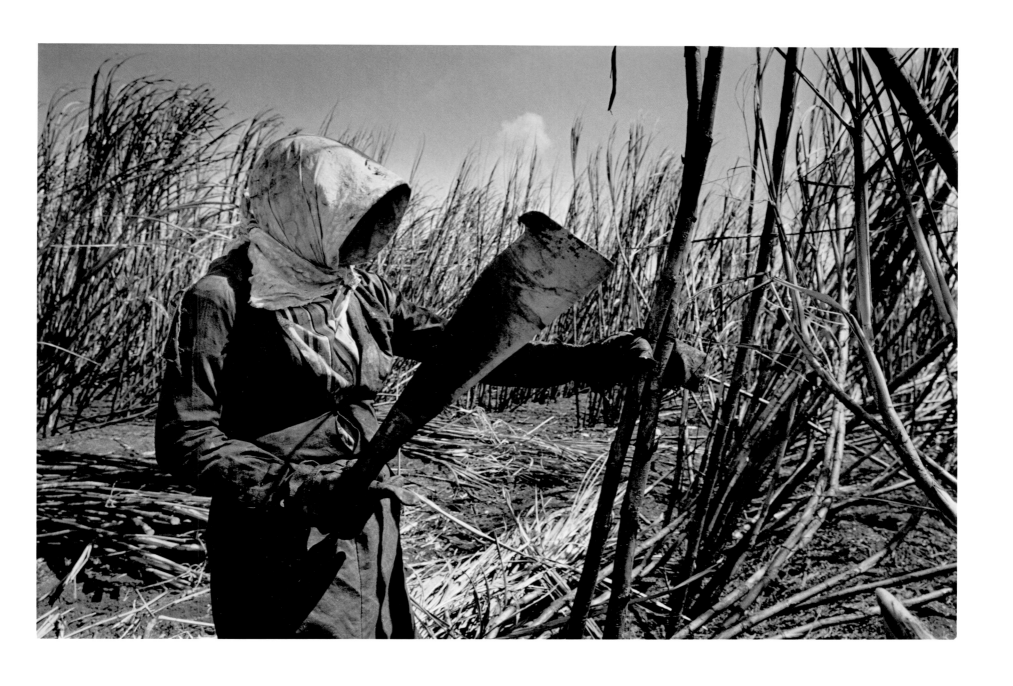

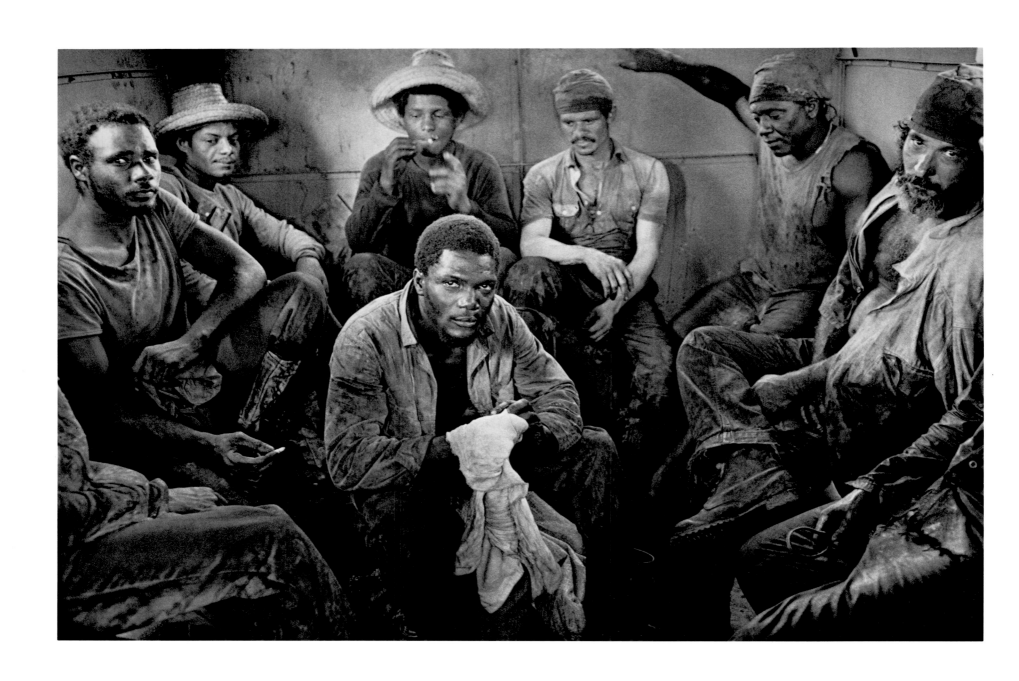

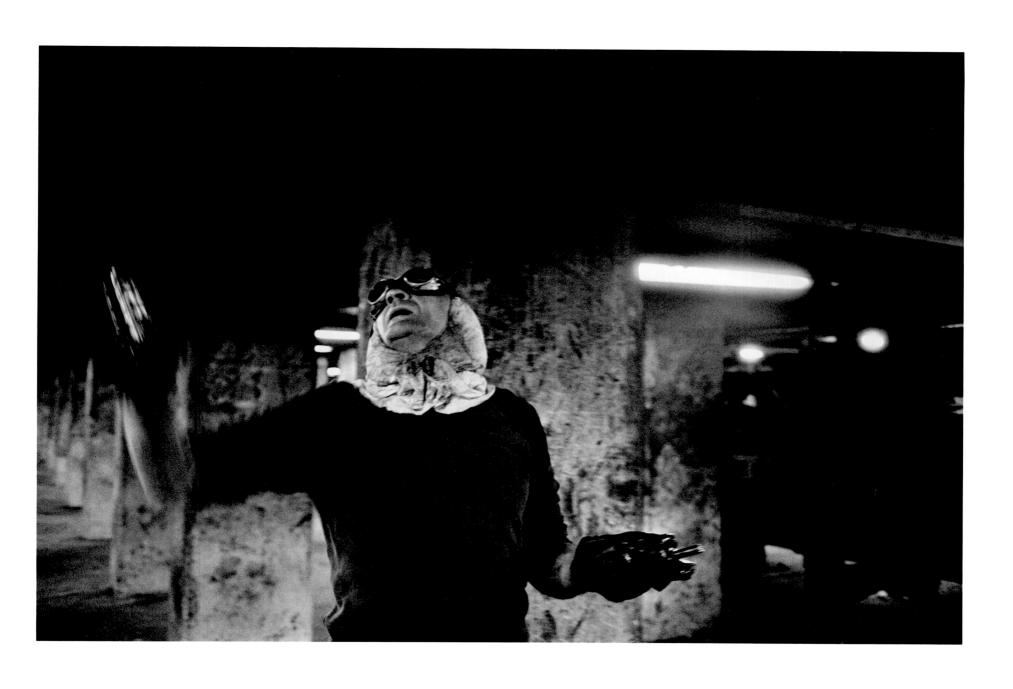

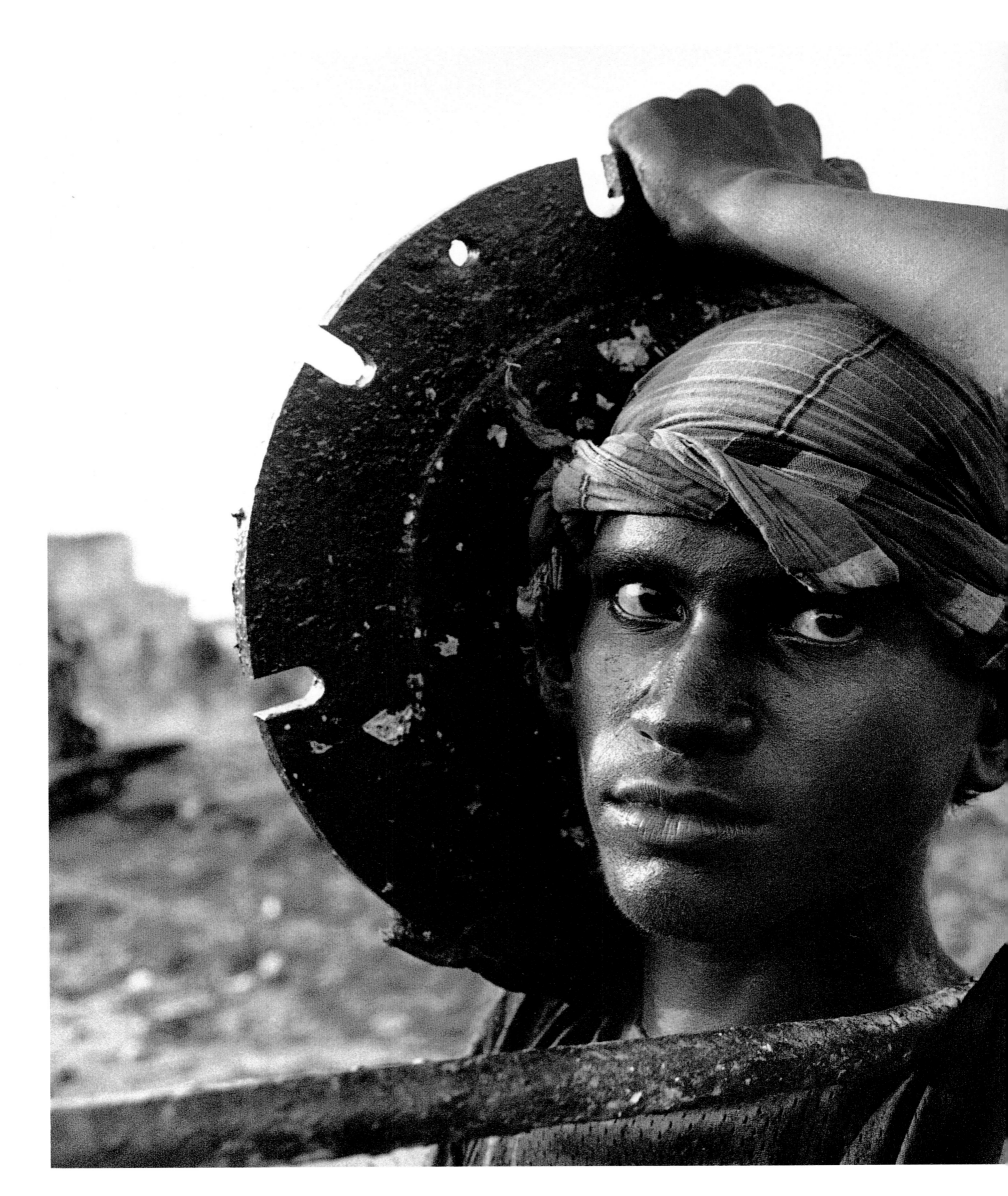

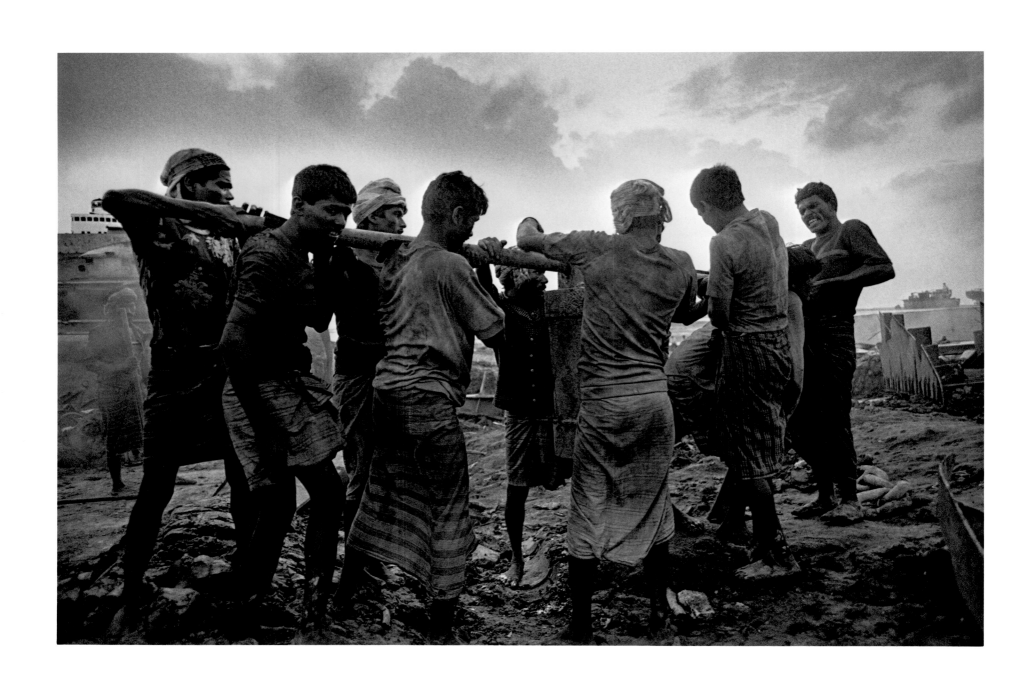

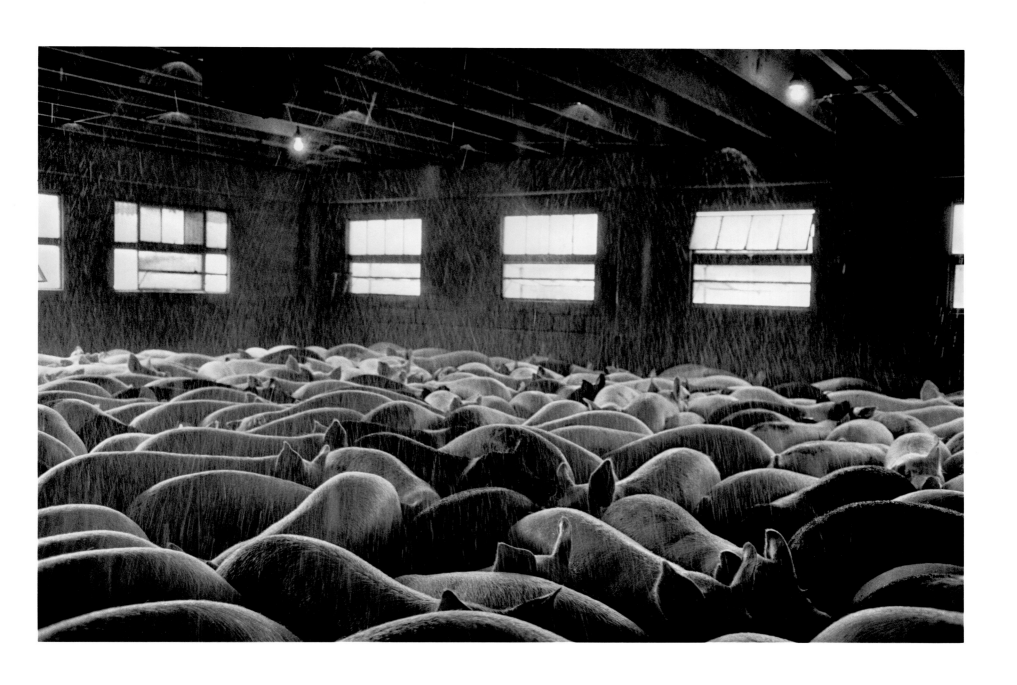

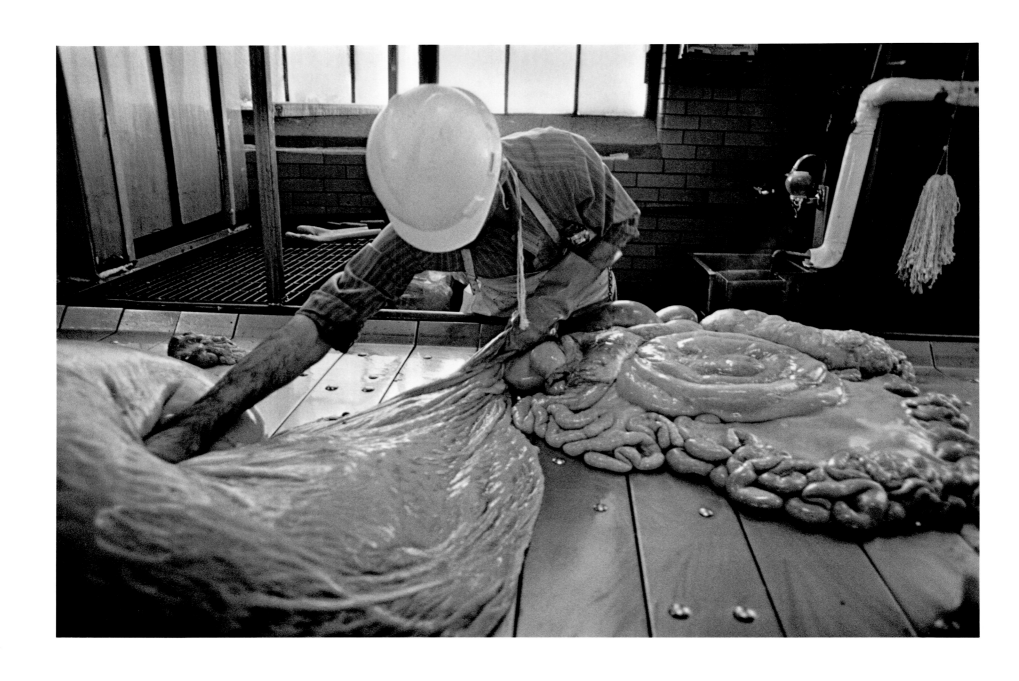

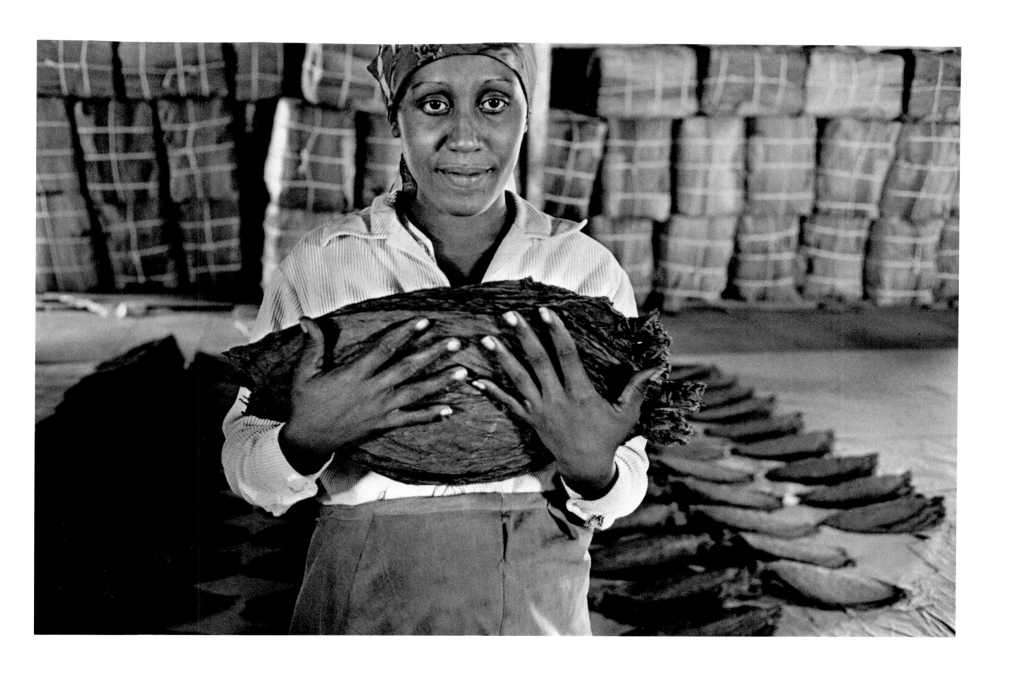

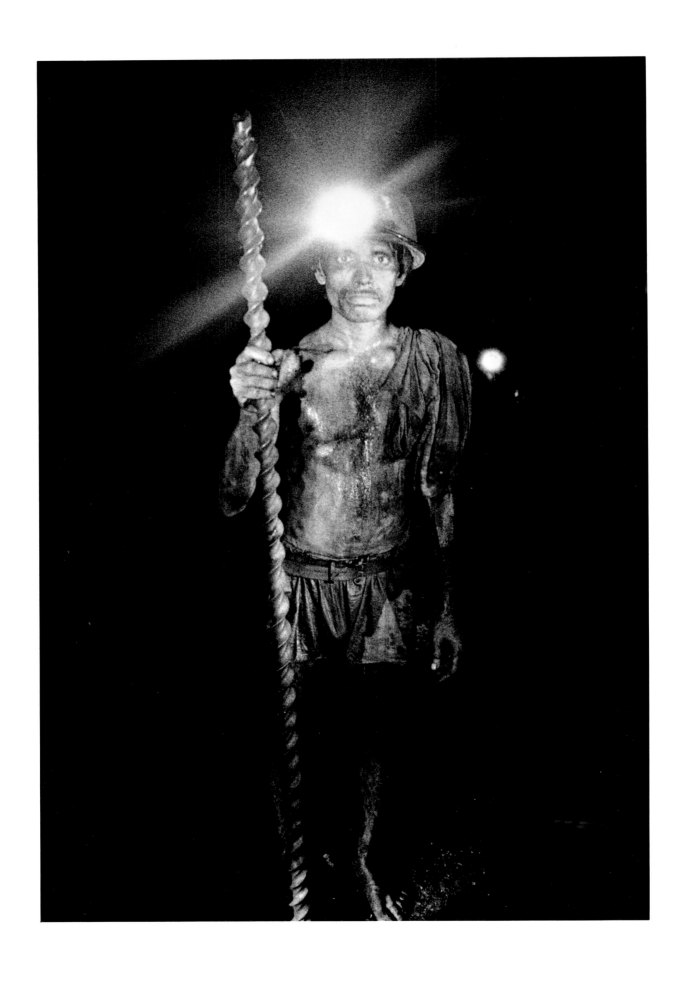

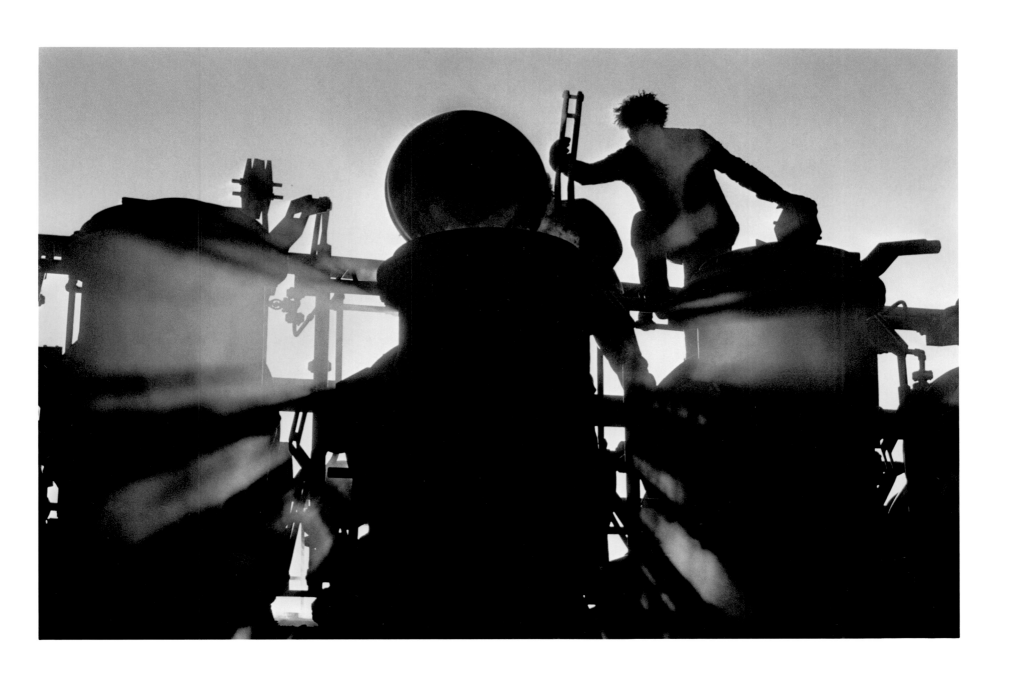

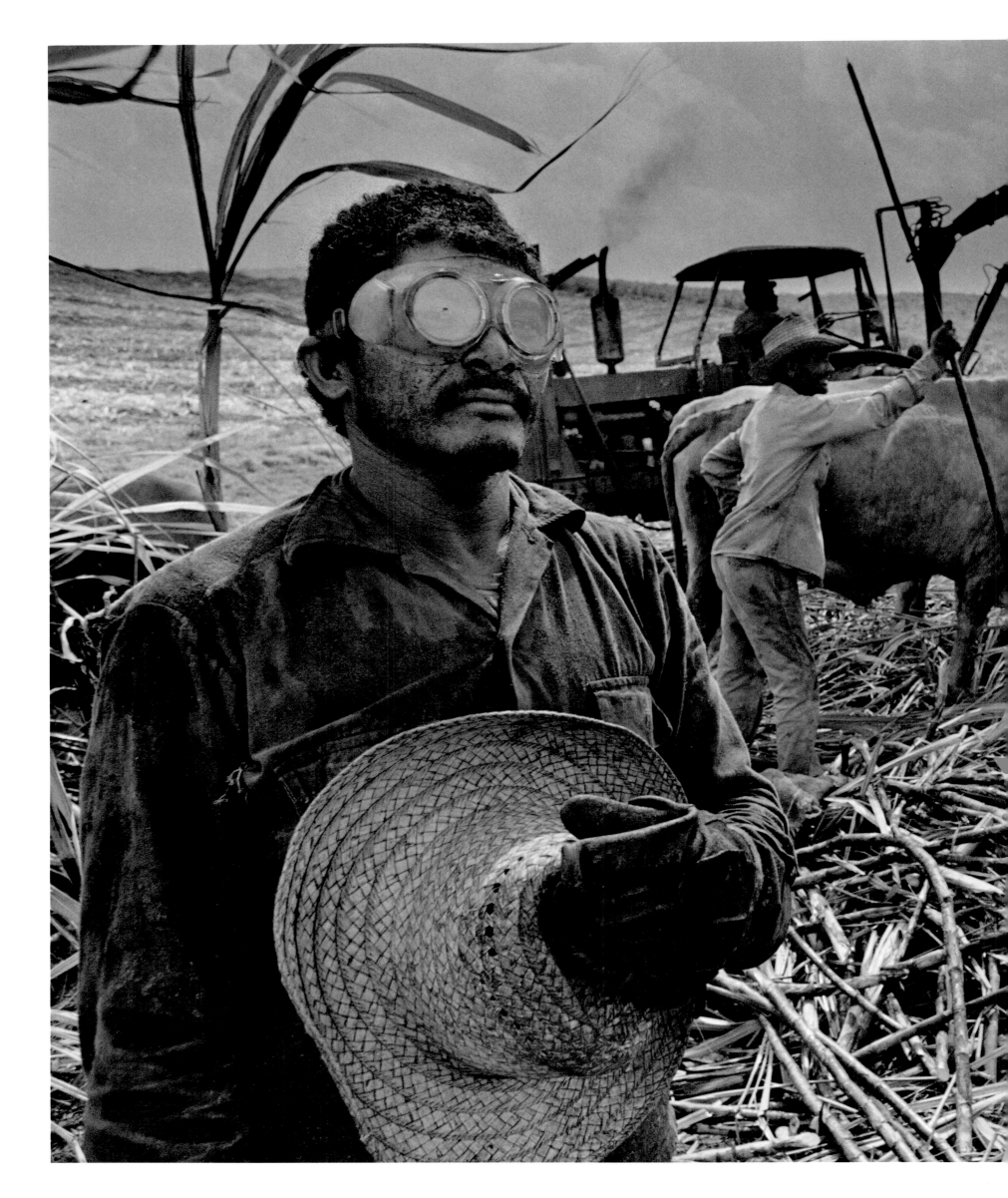

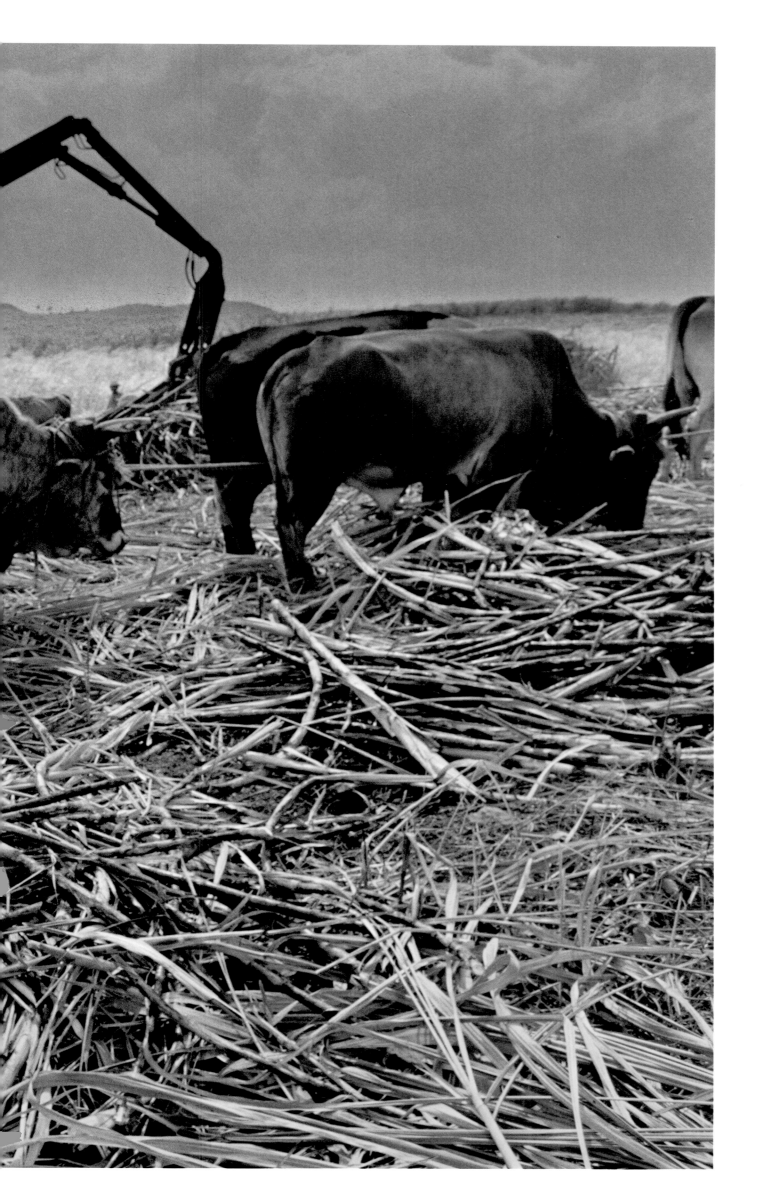

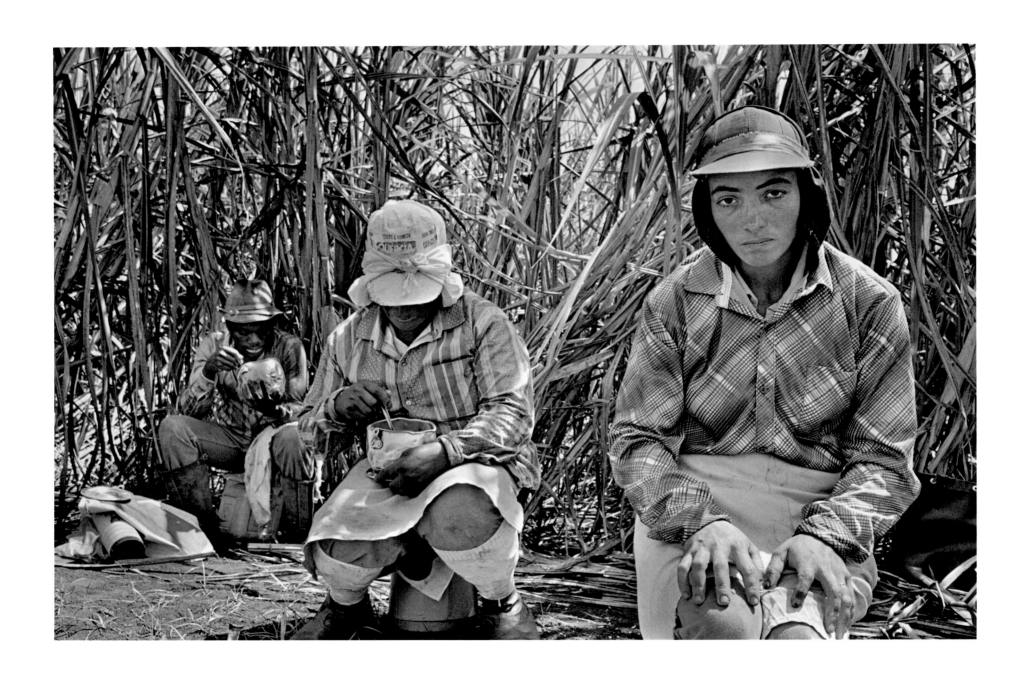

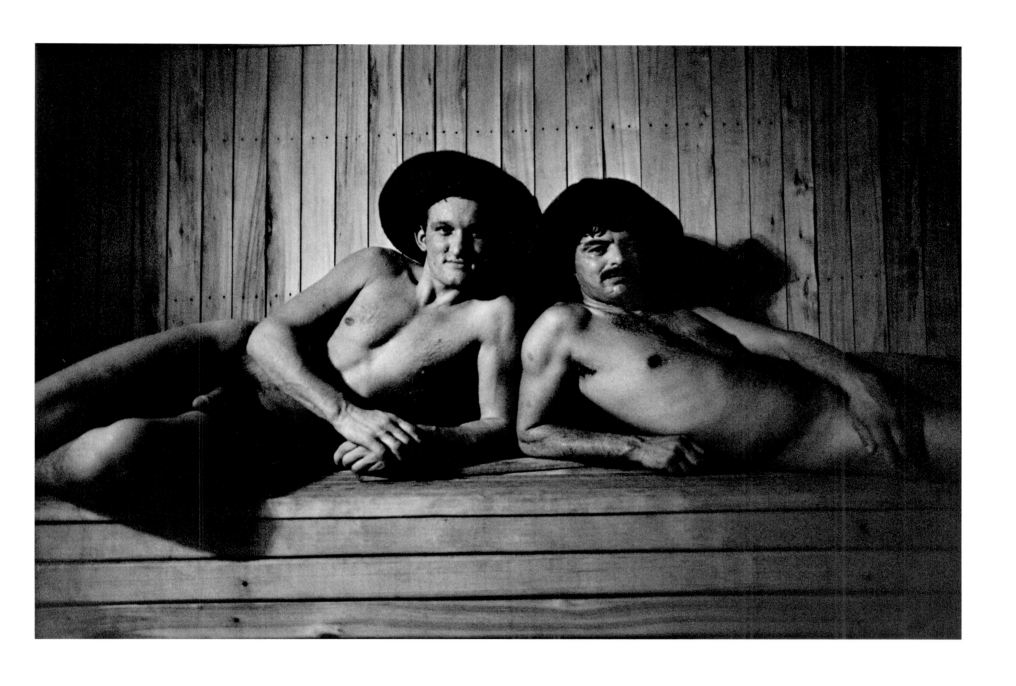

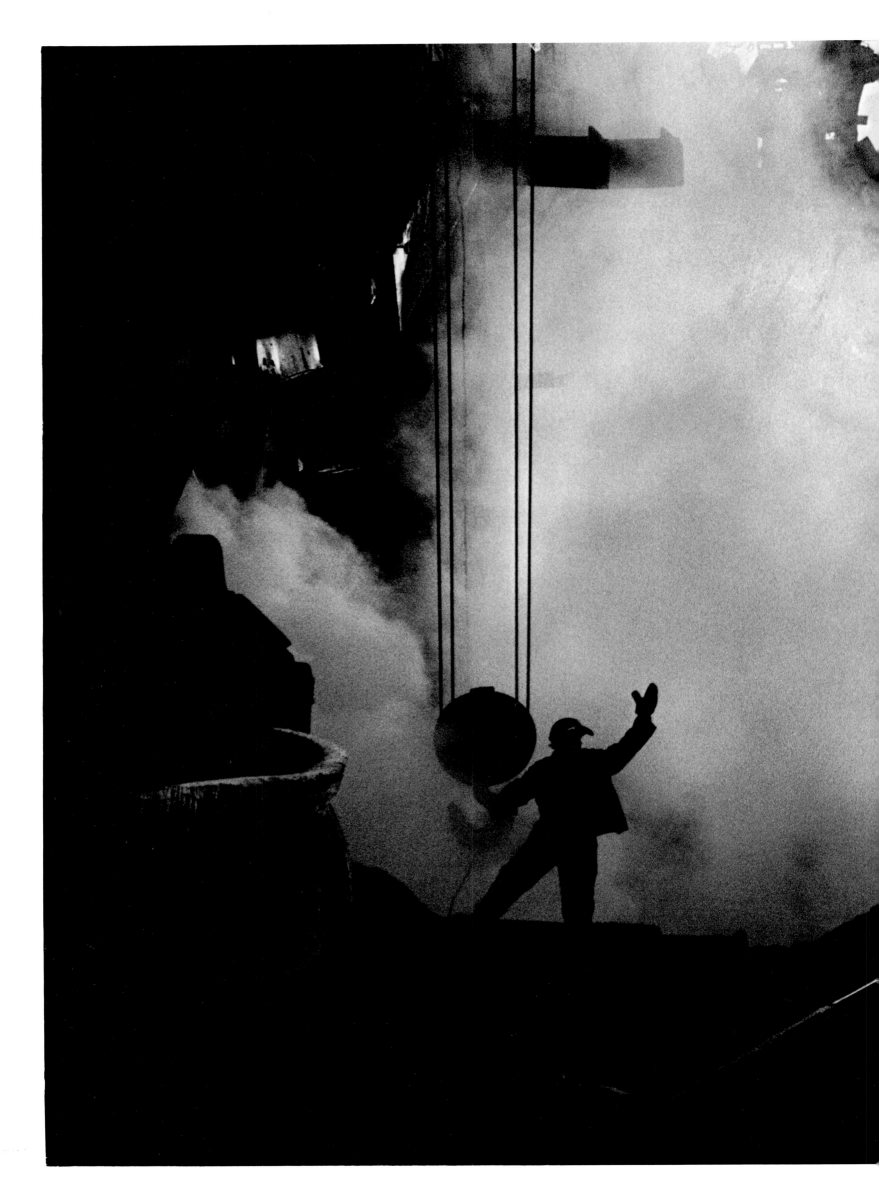

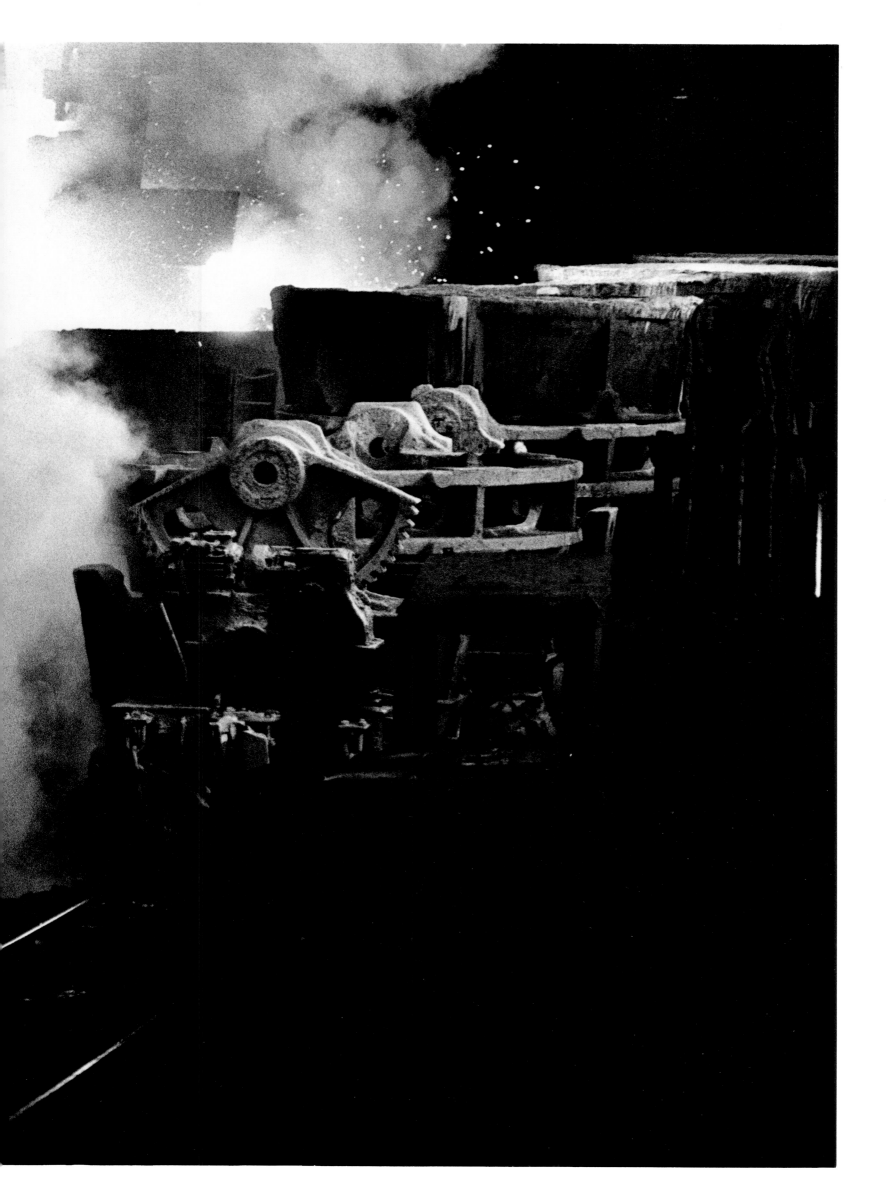

II.

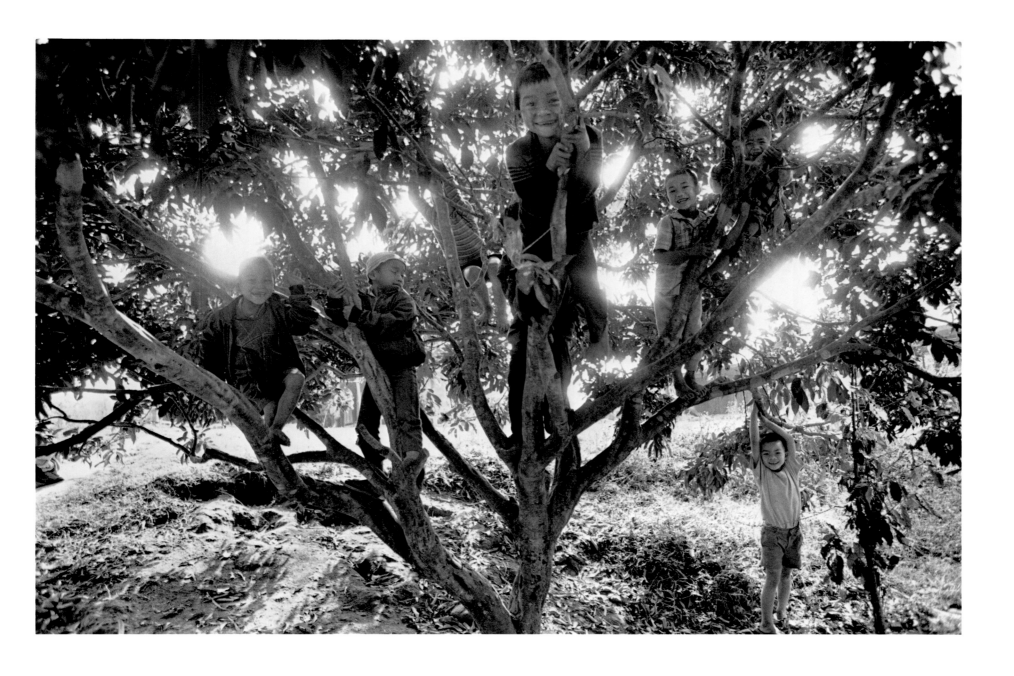

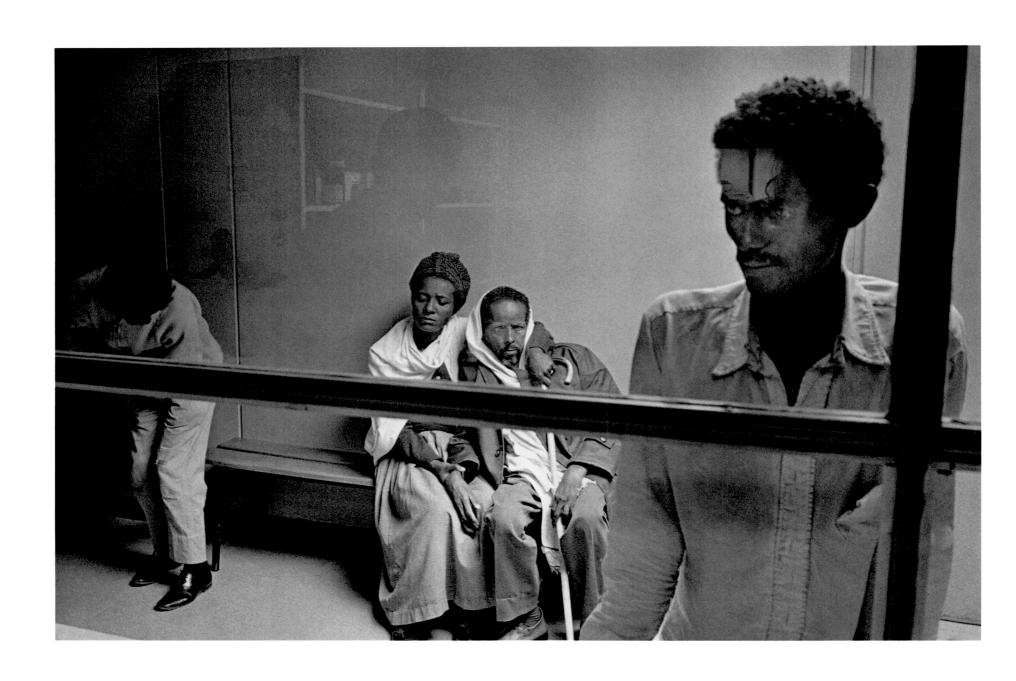

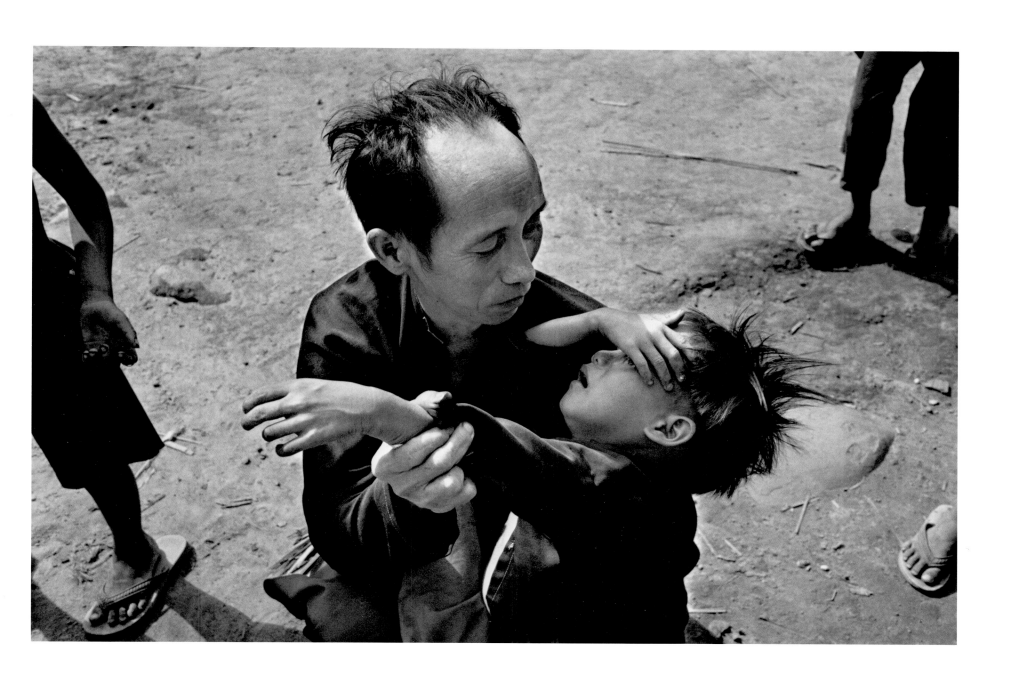

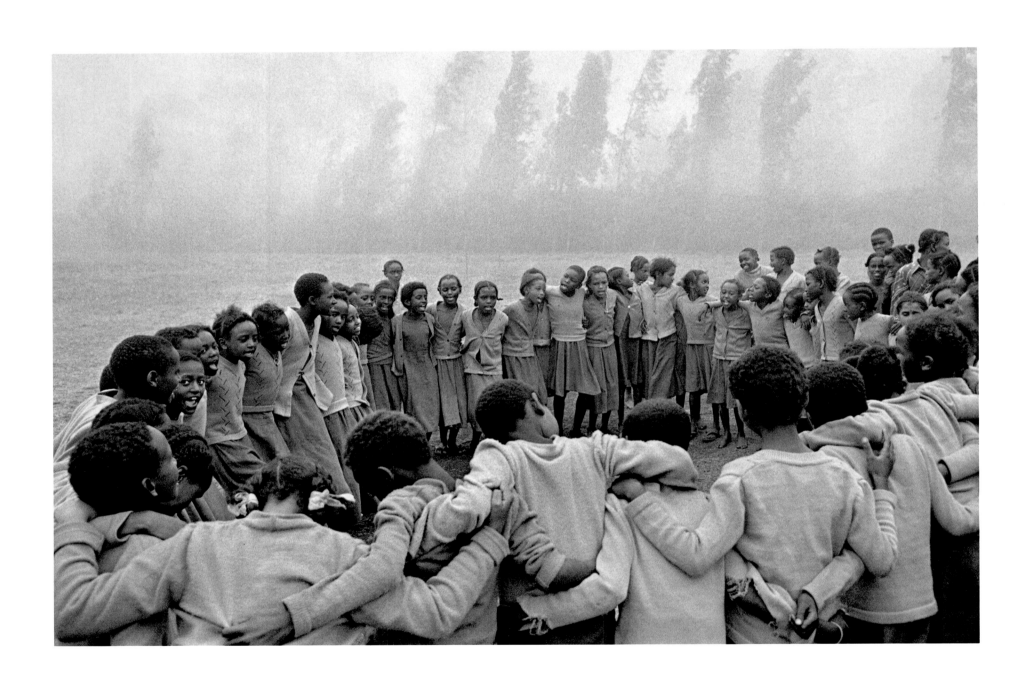

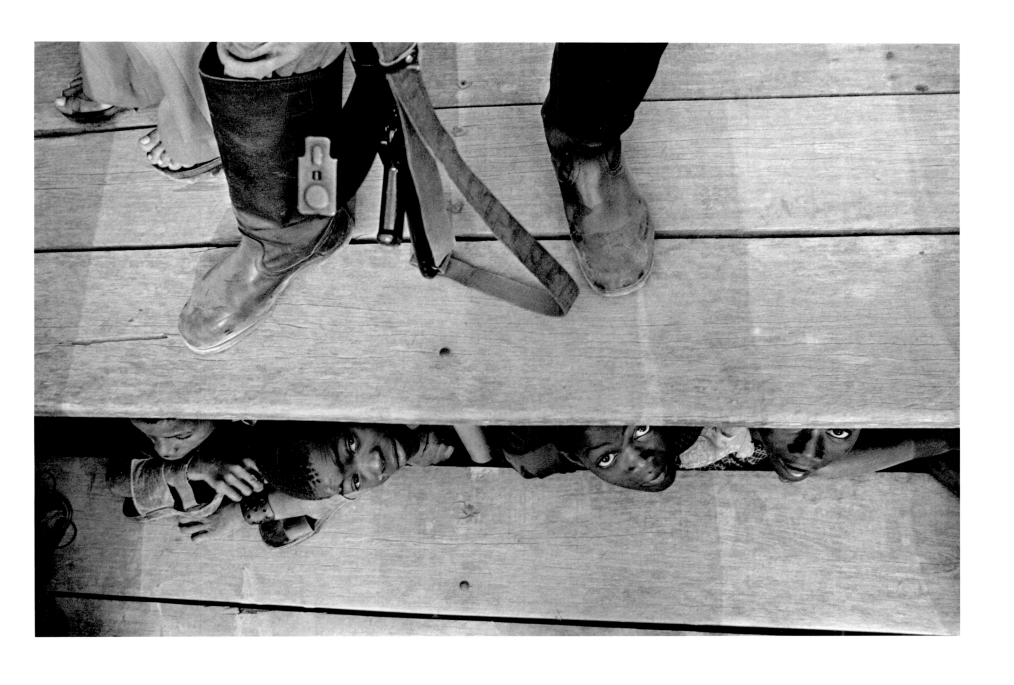

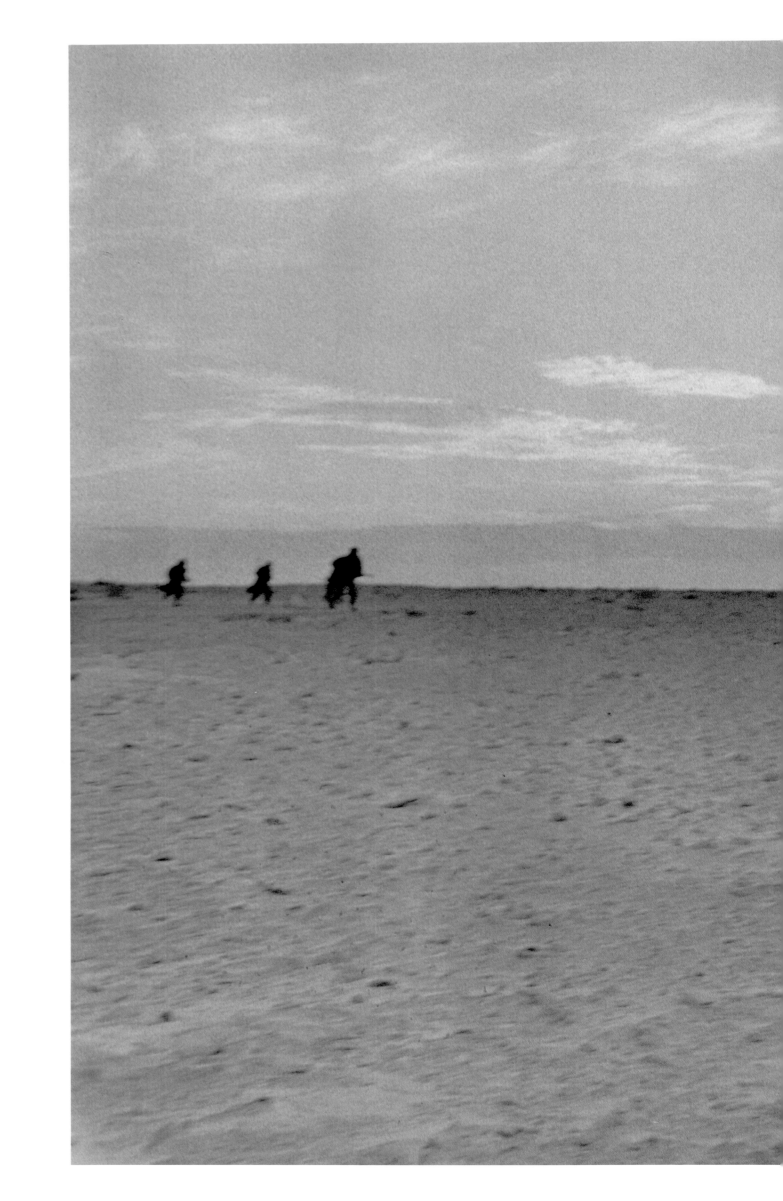

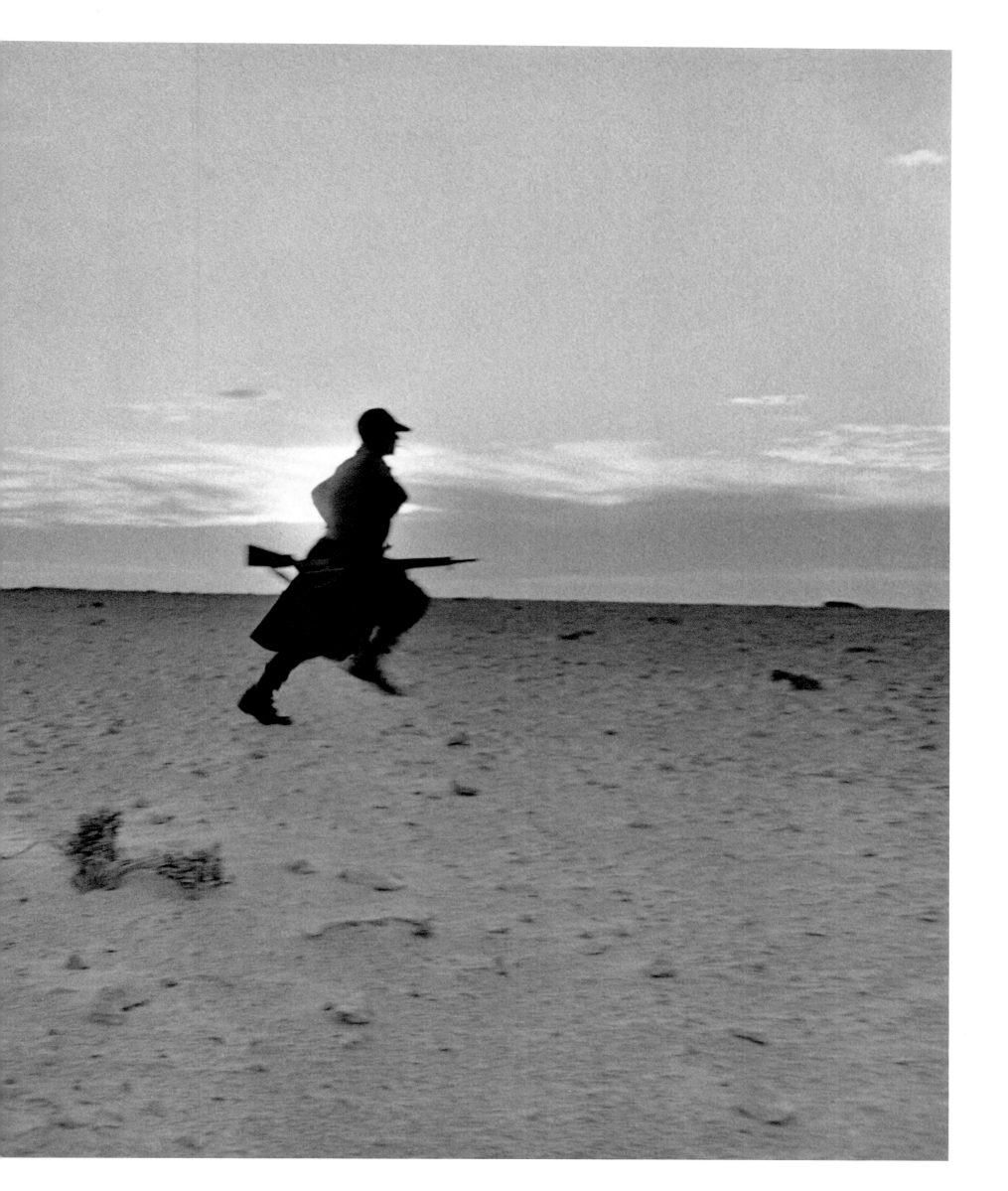

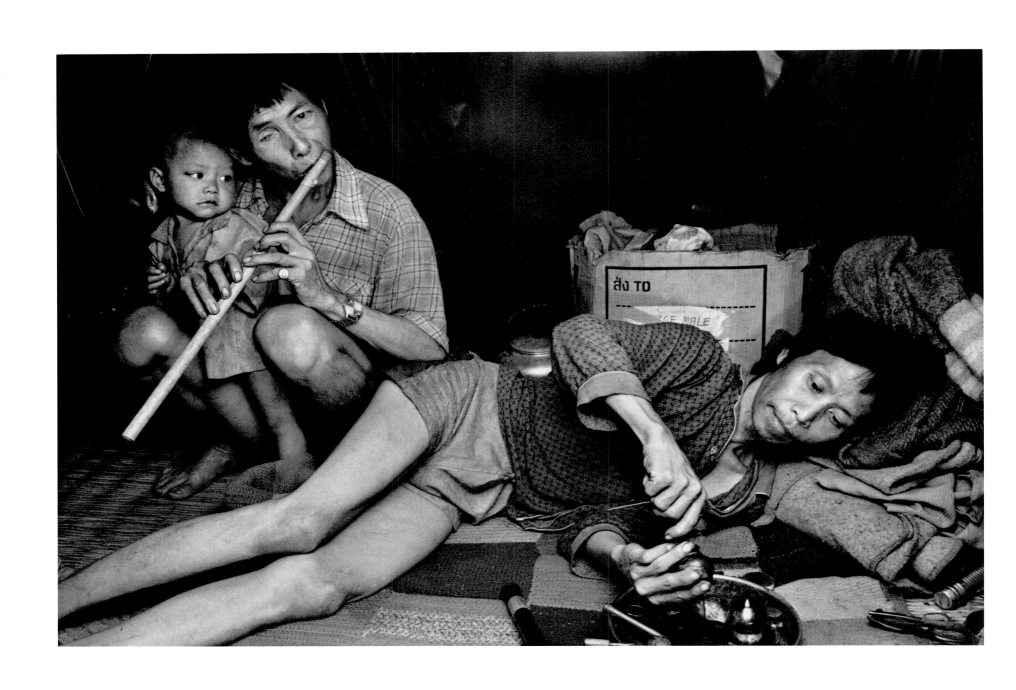

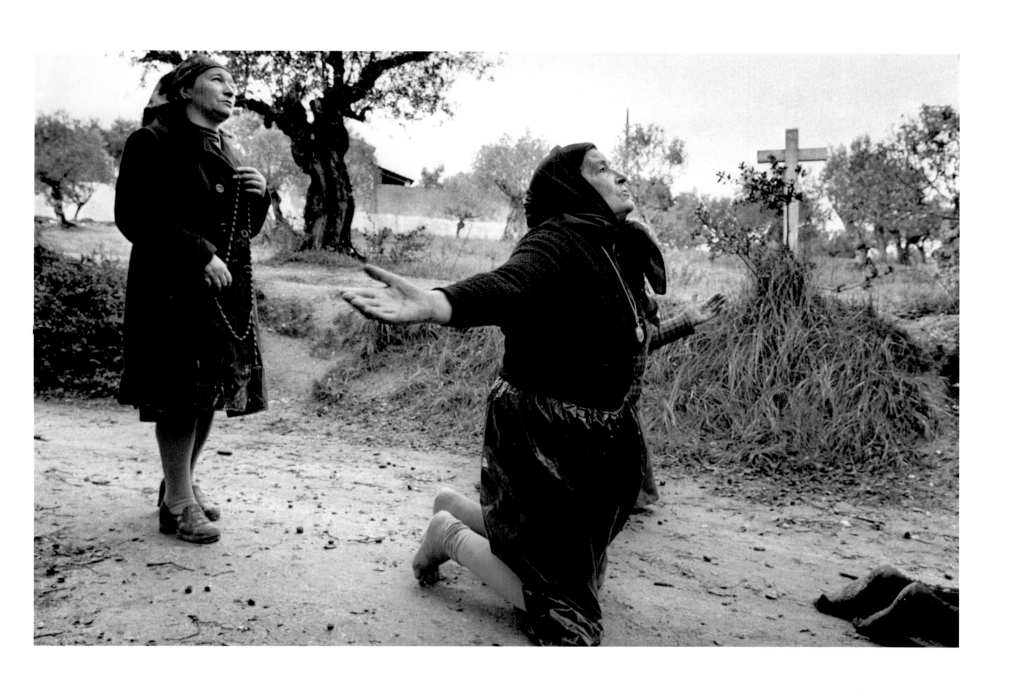

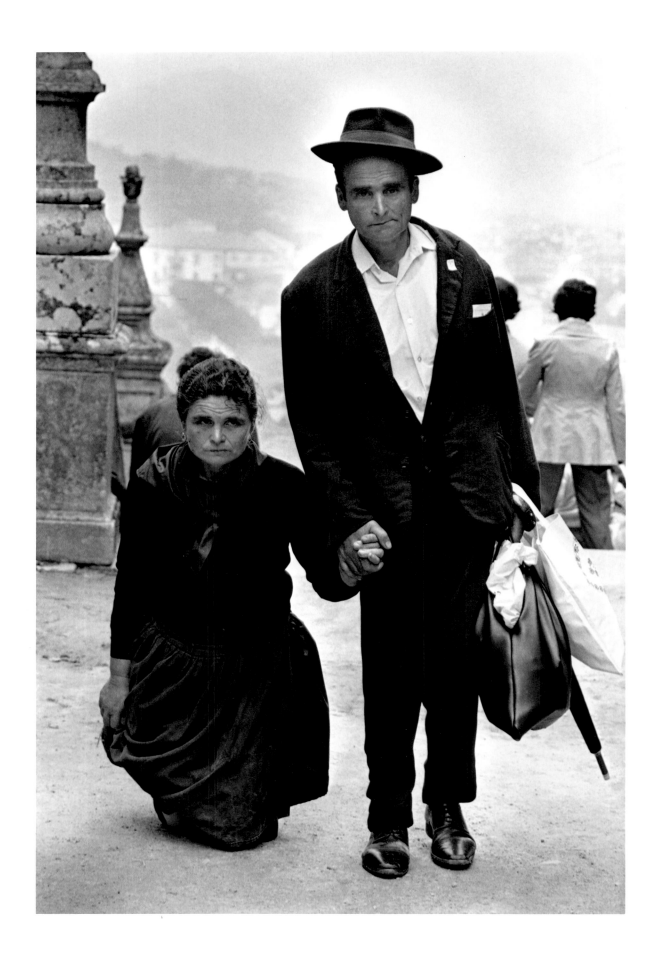

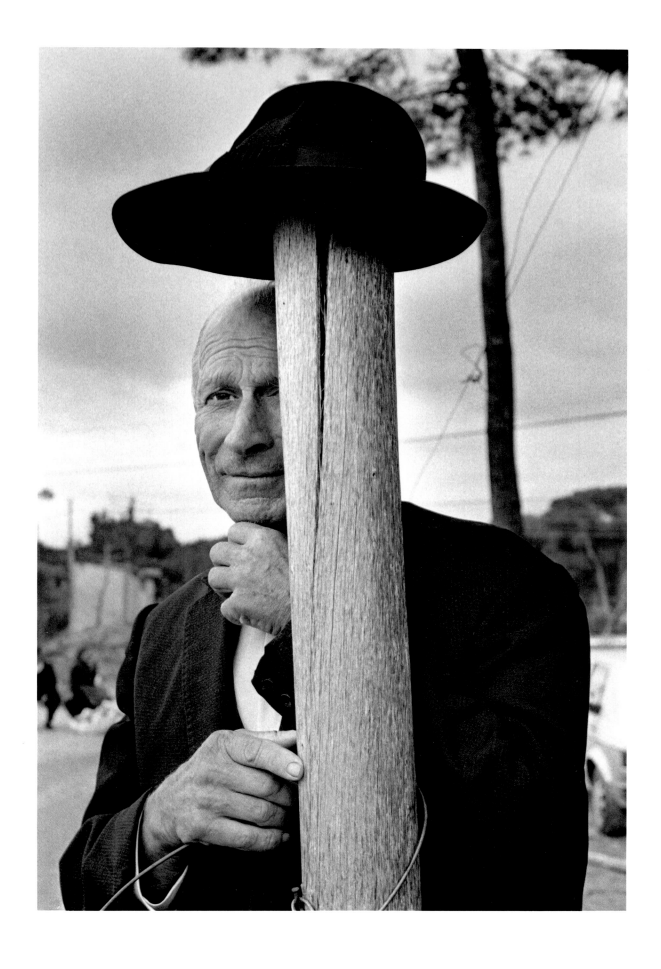

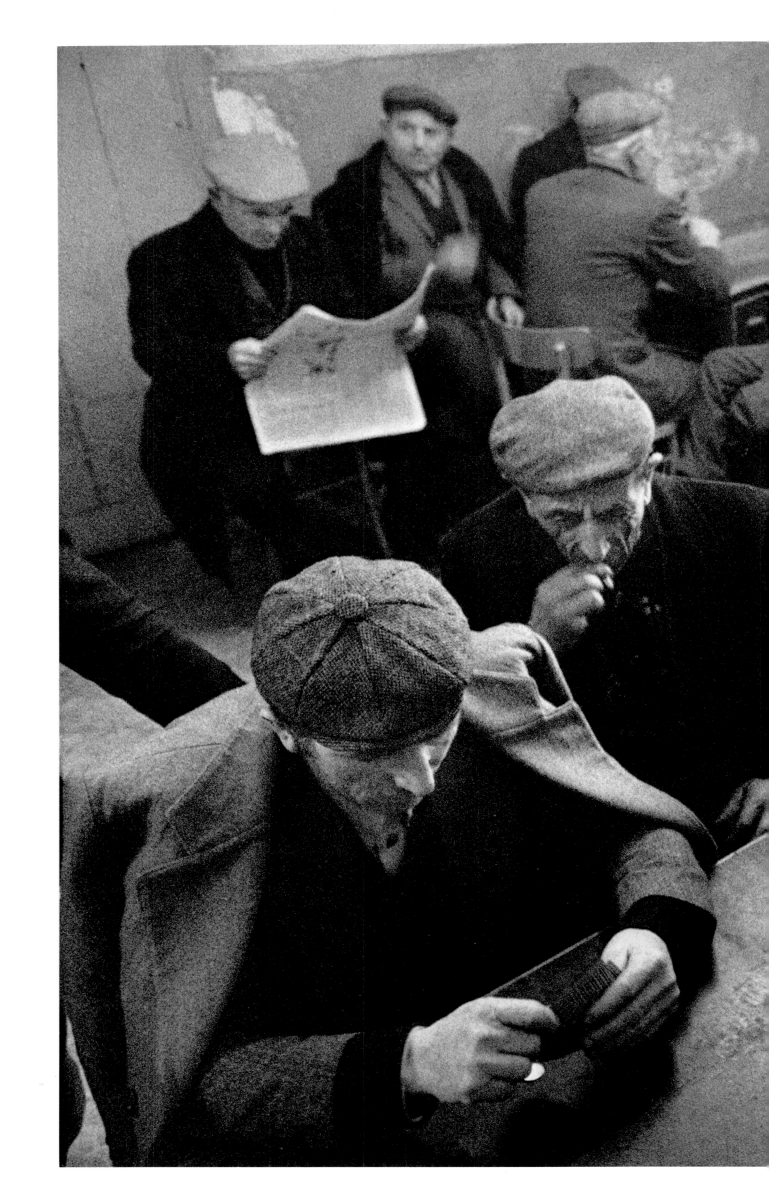

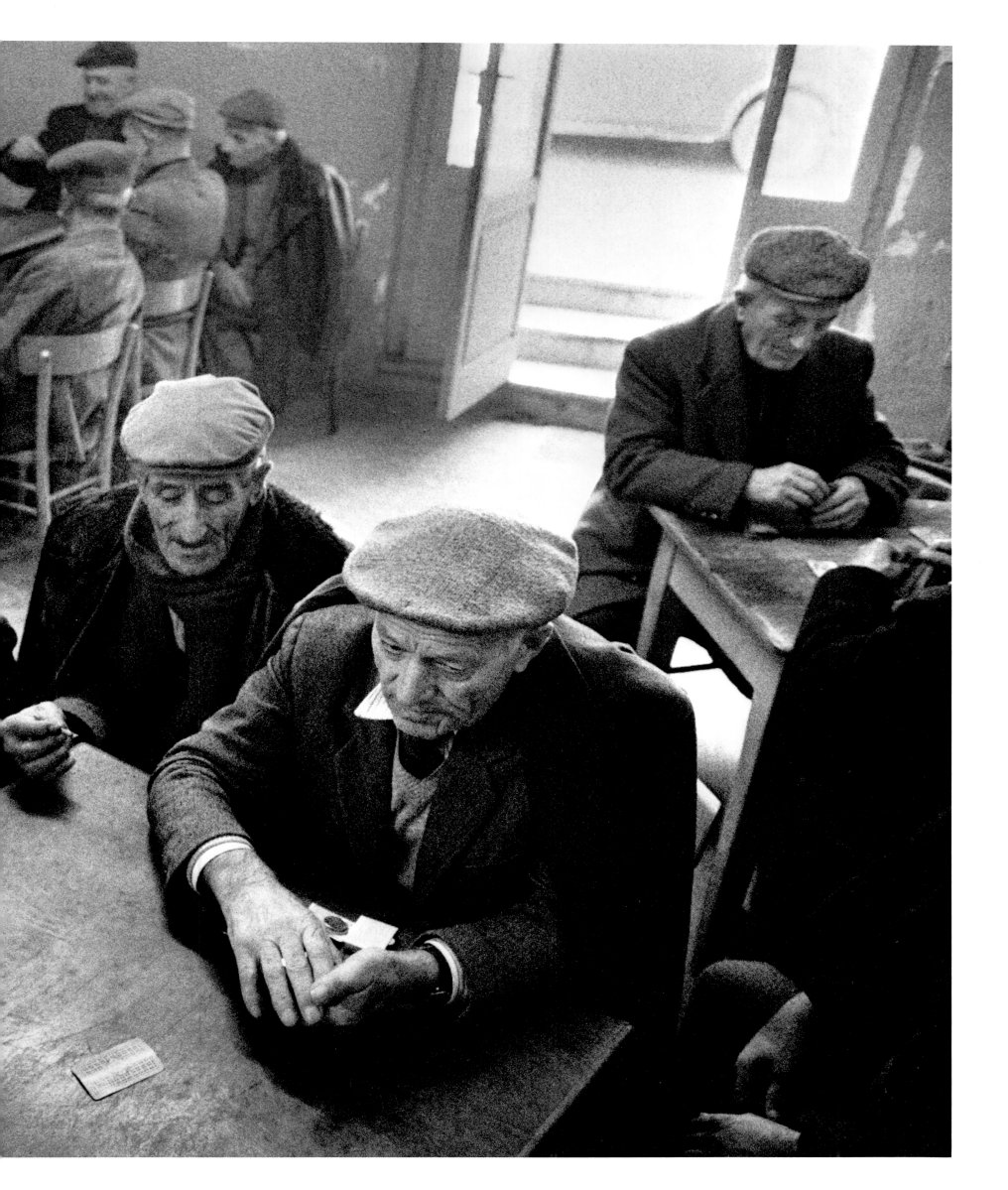

III.

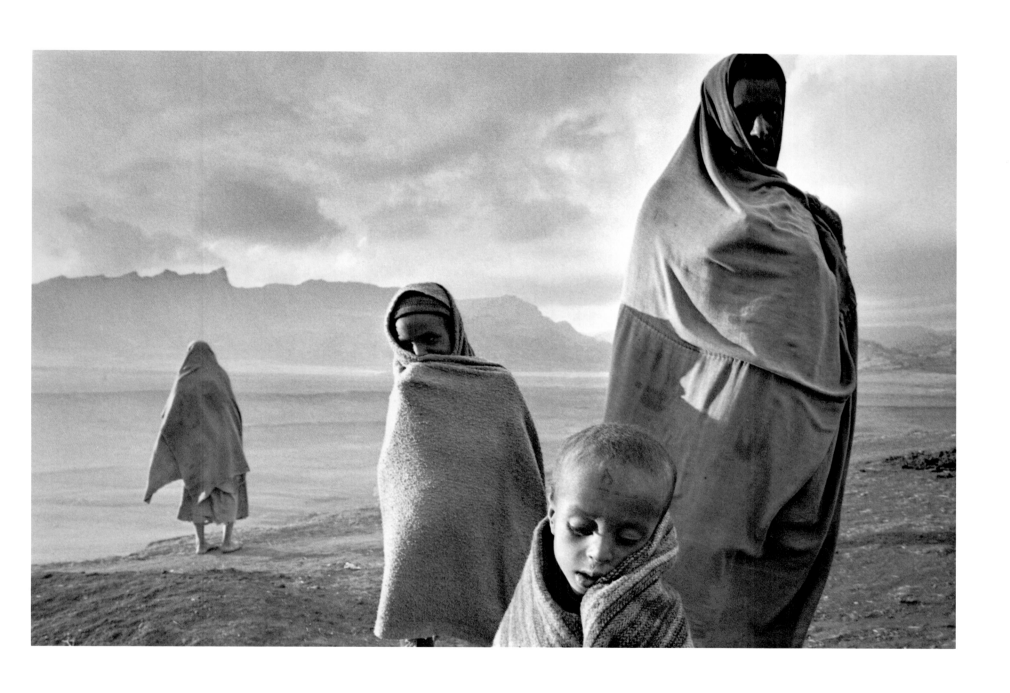

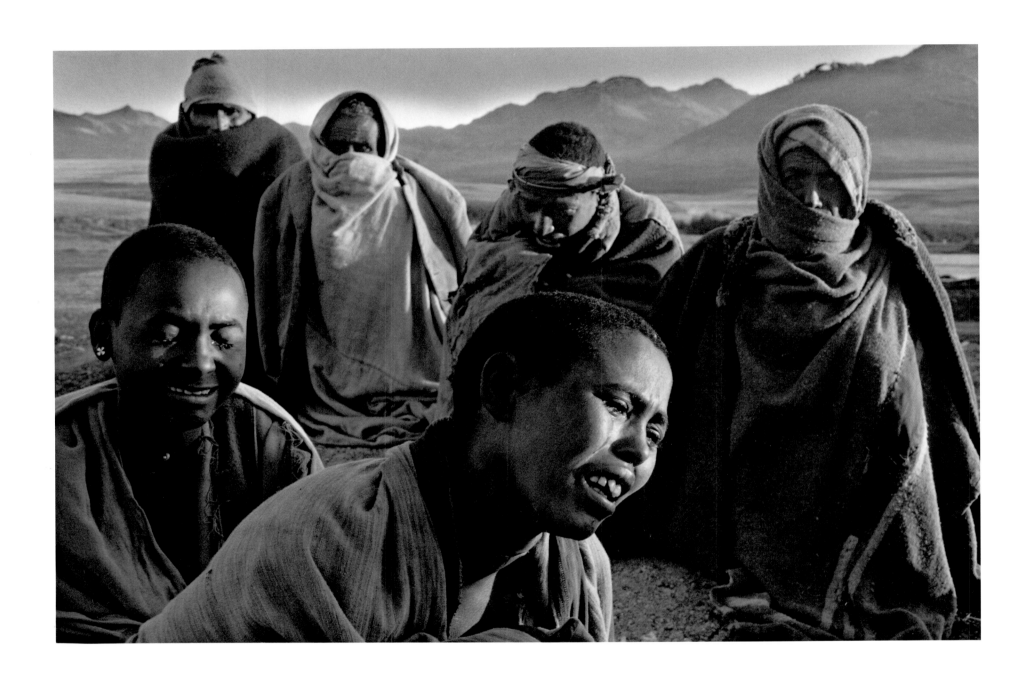

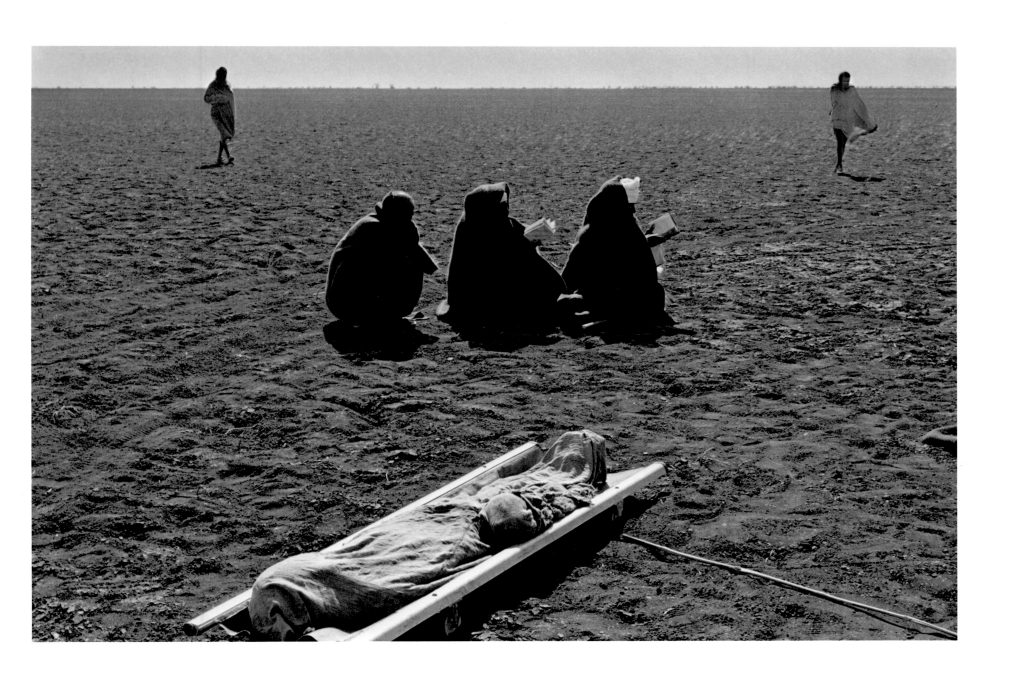

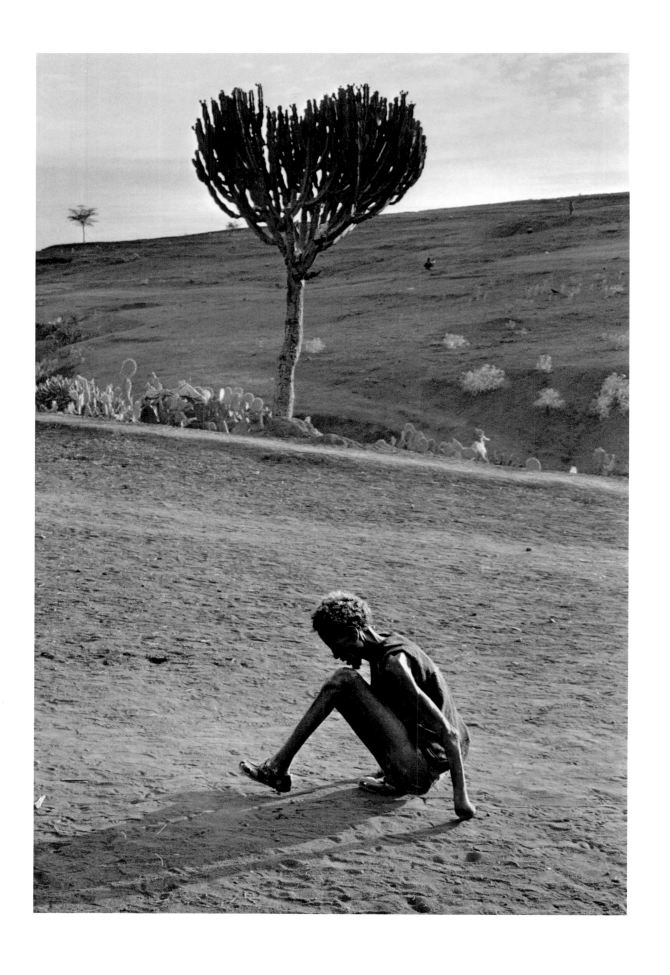

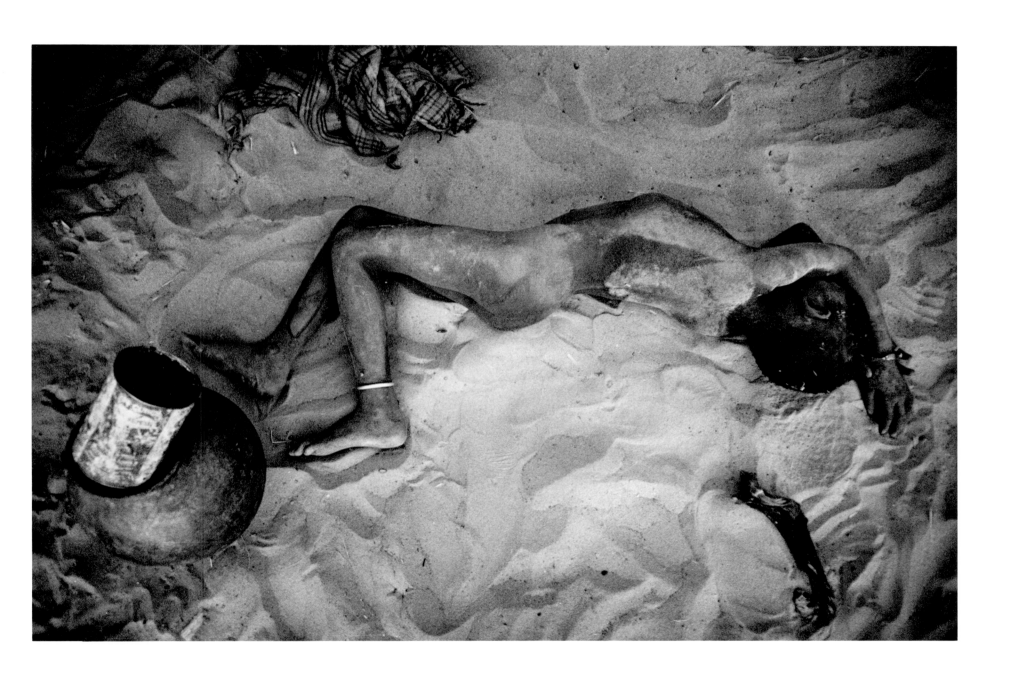

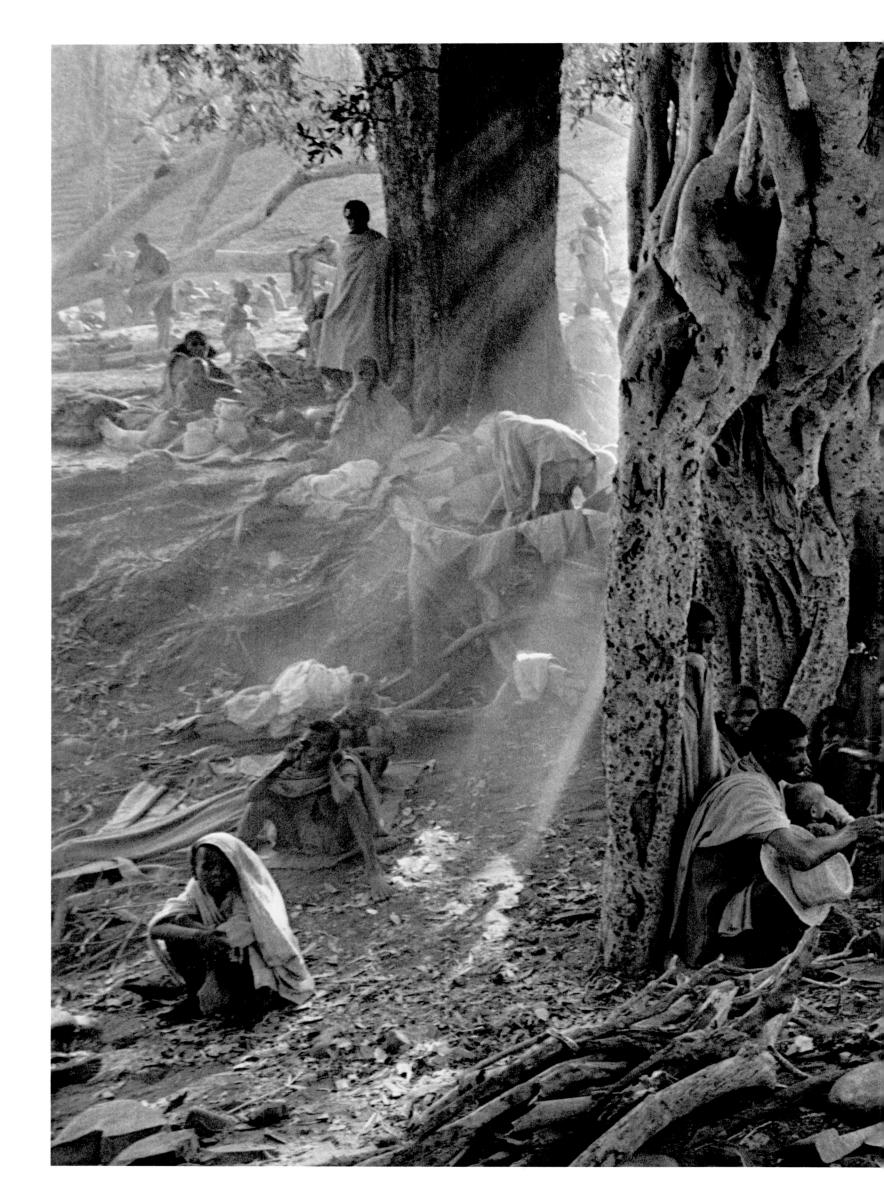

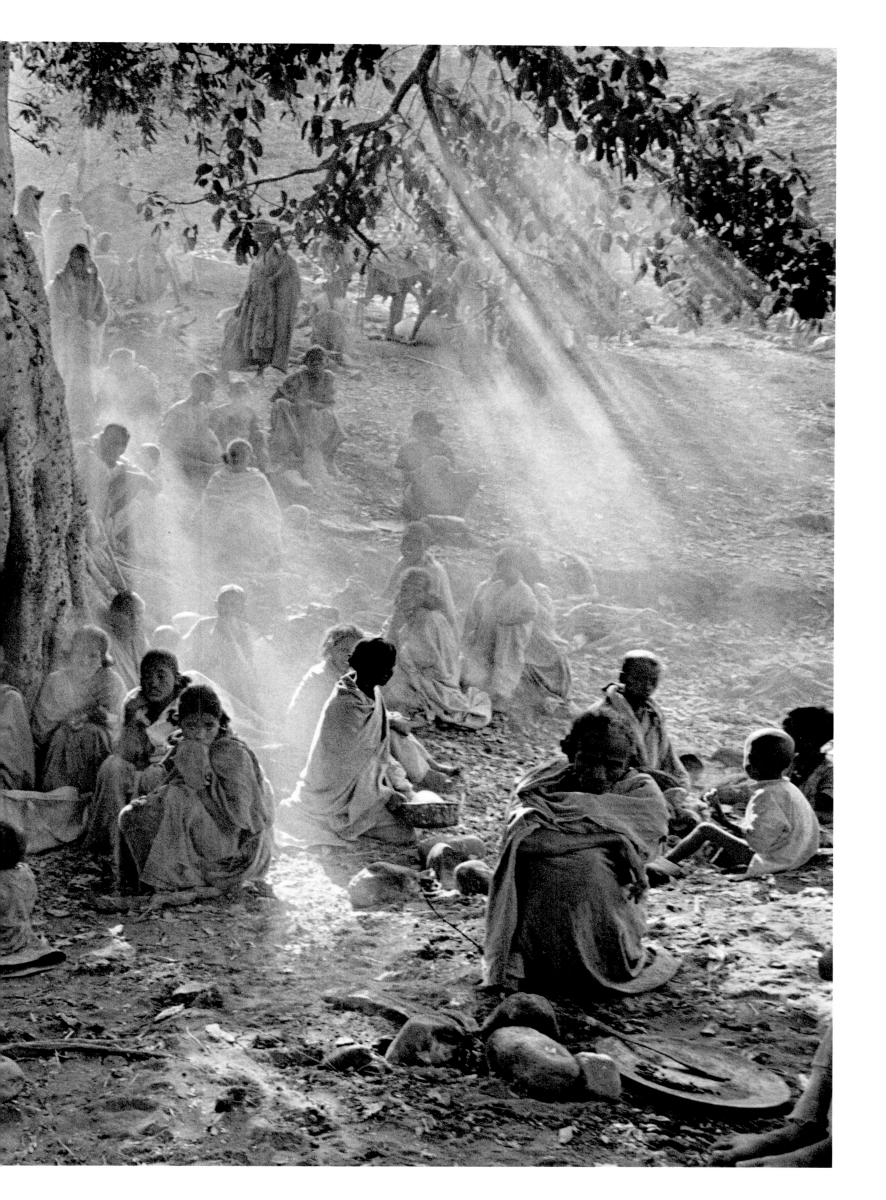

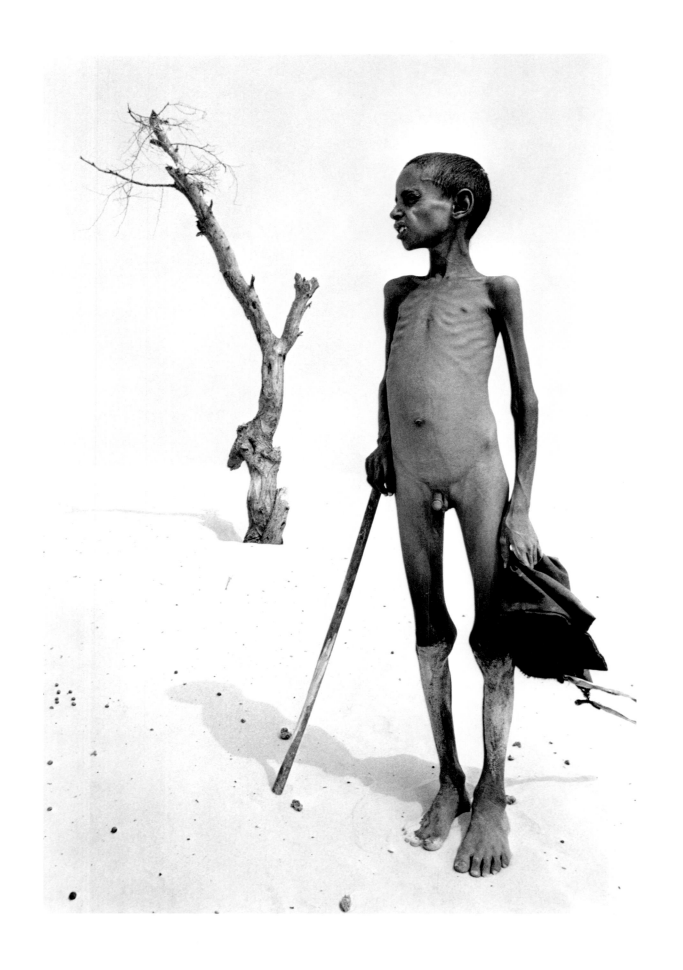

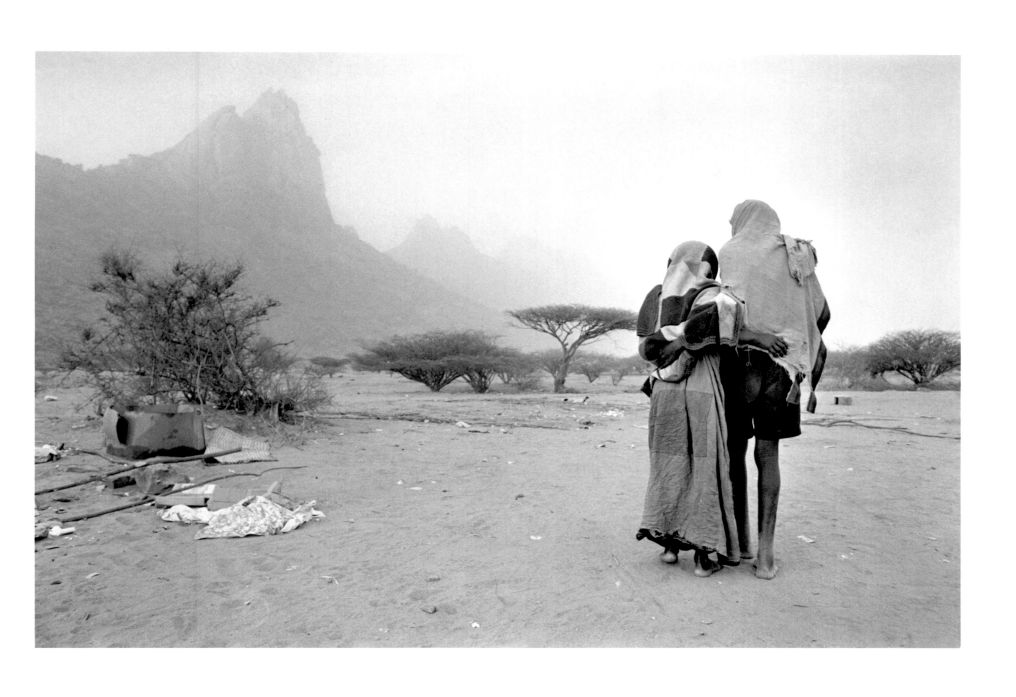

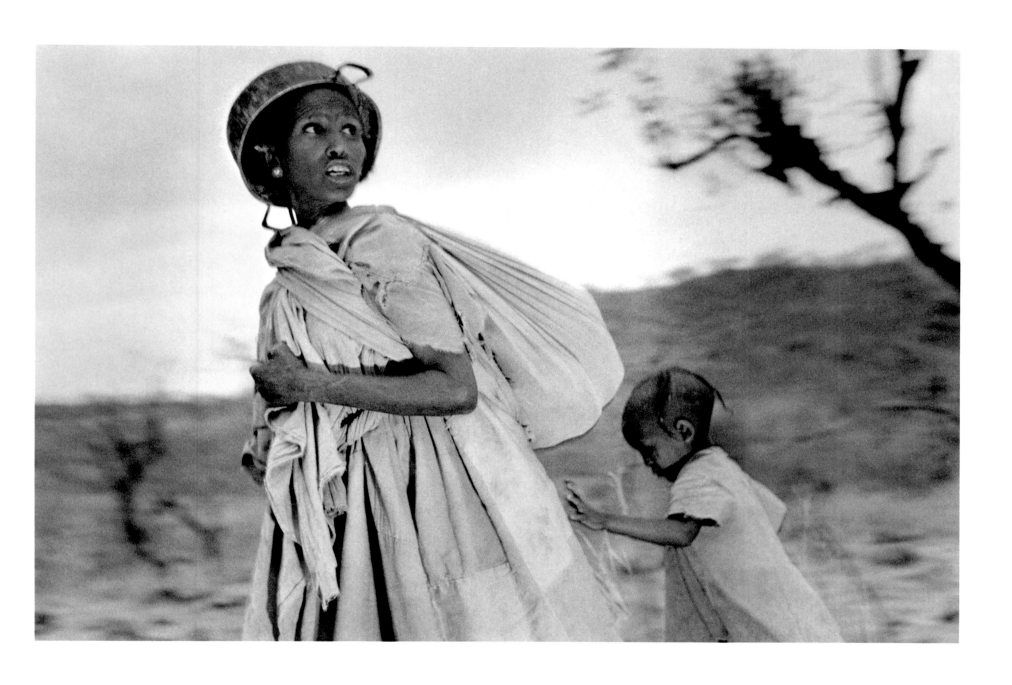

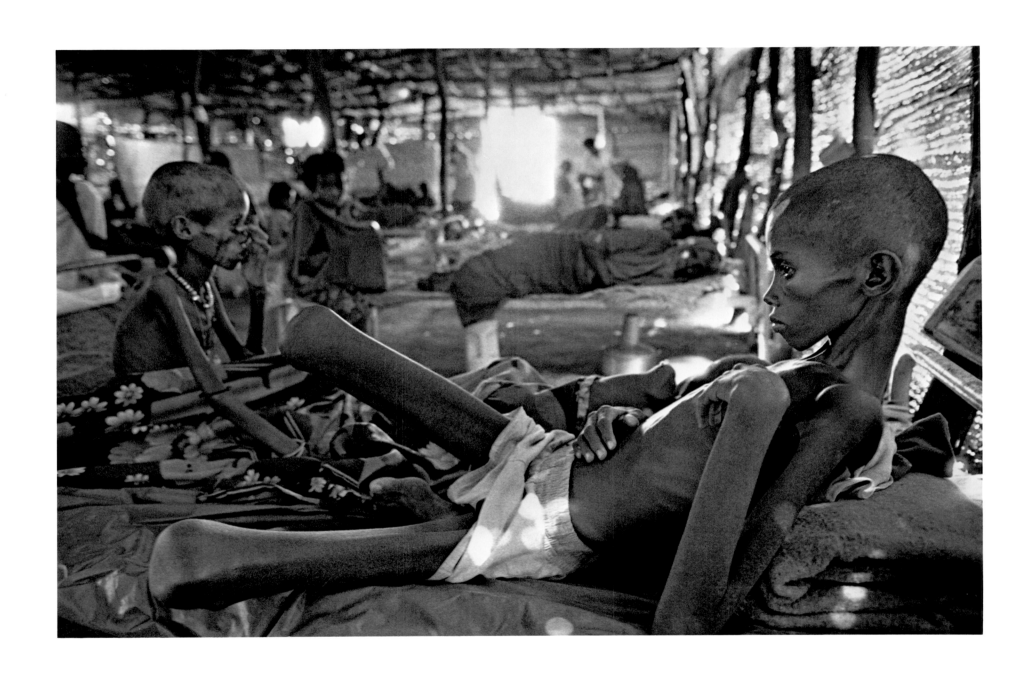

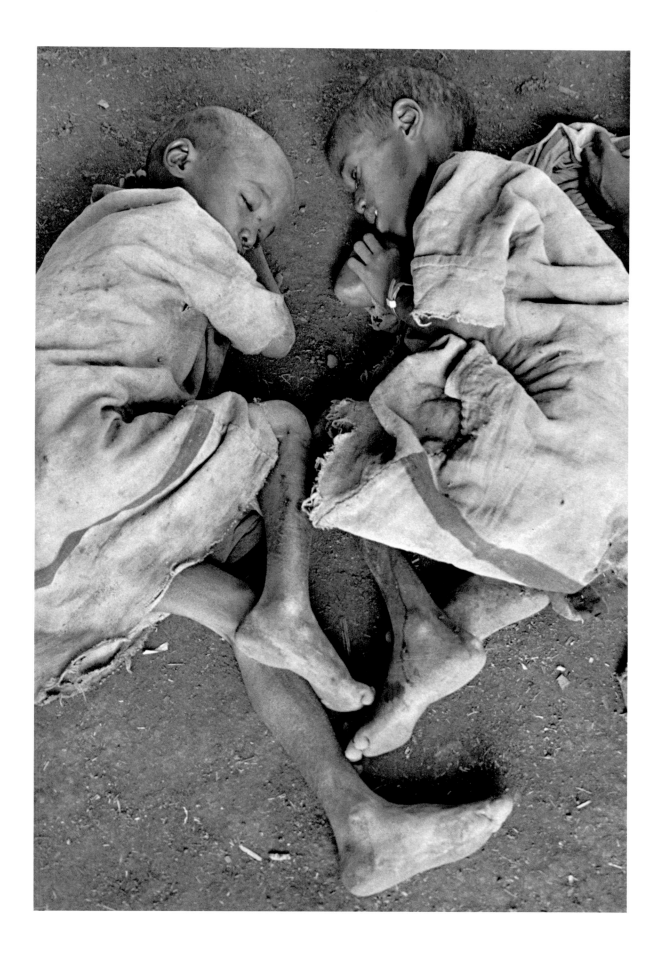

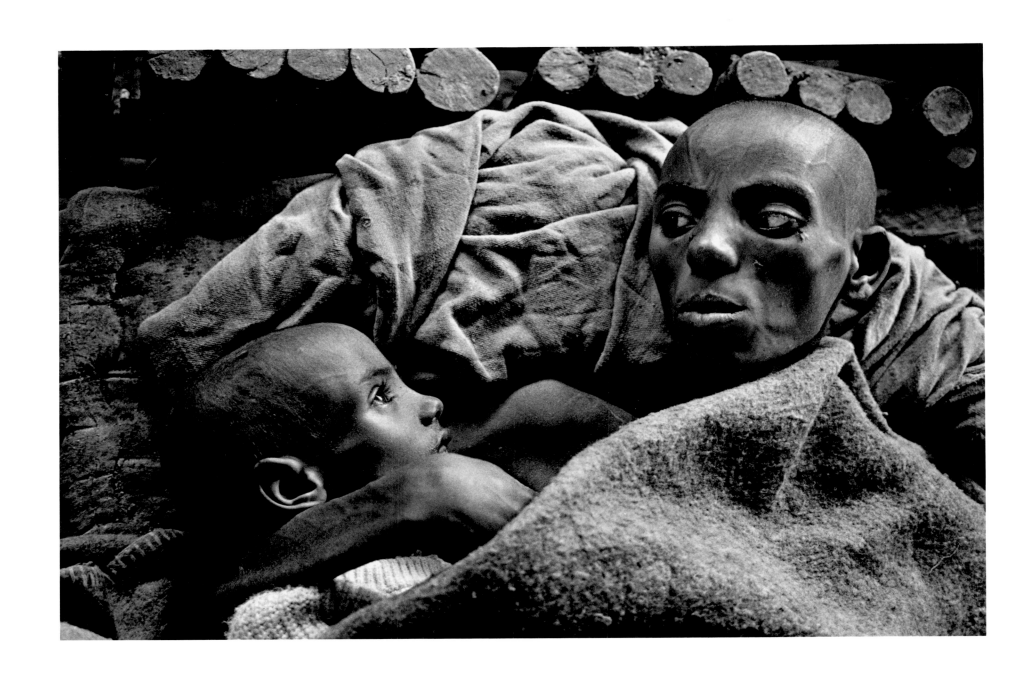

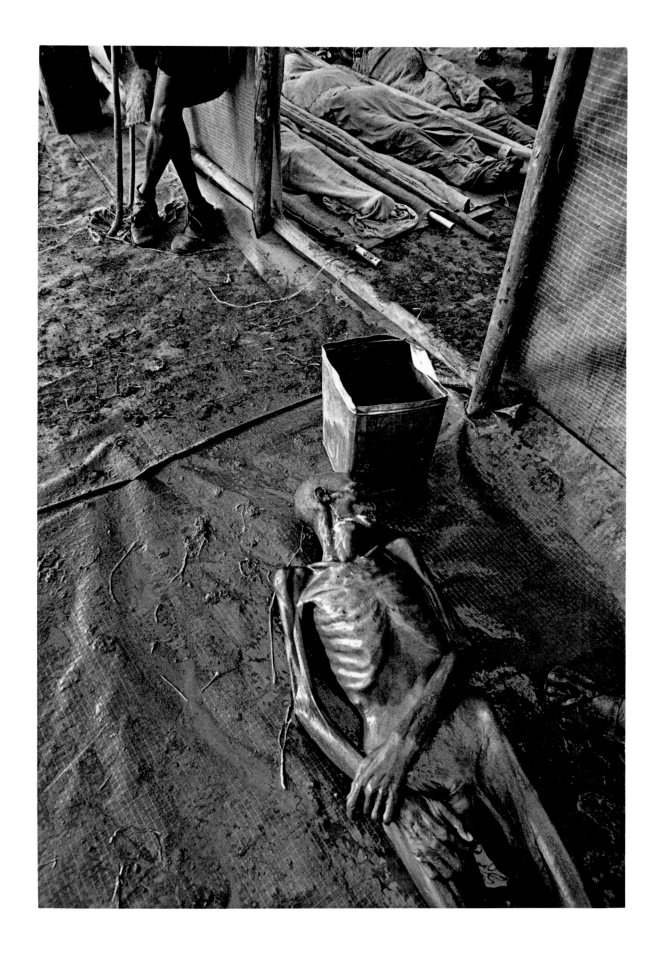

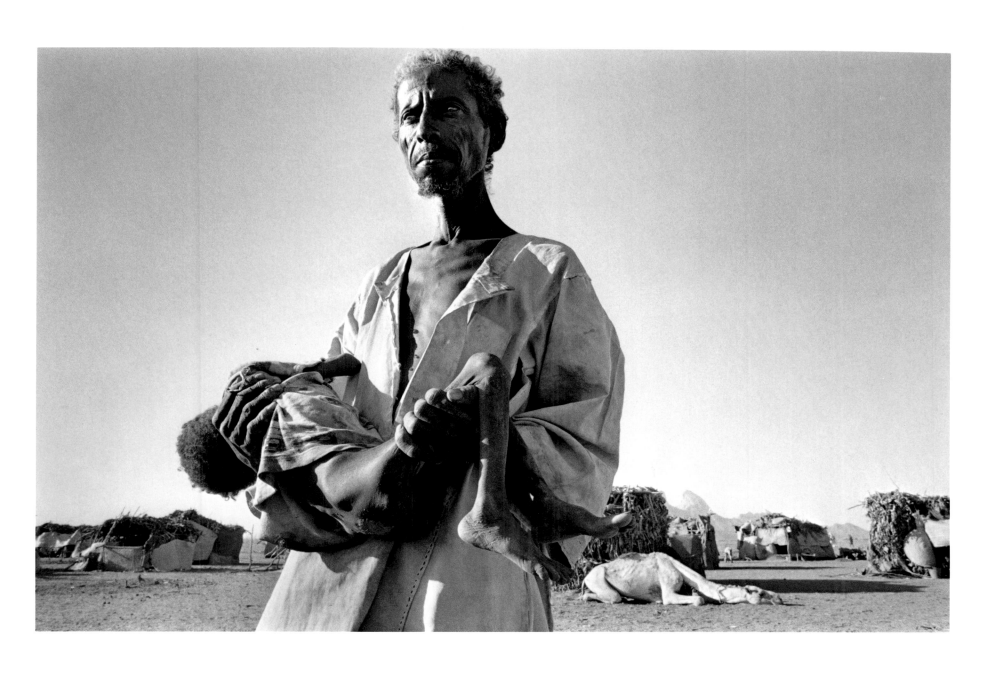

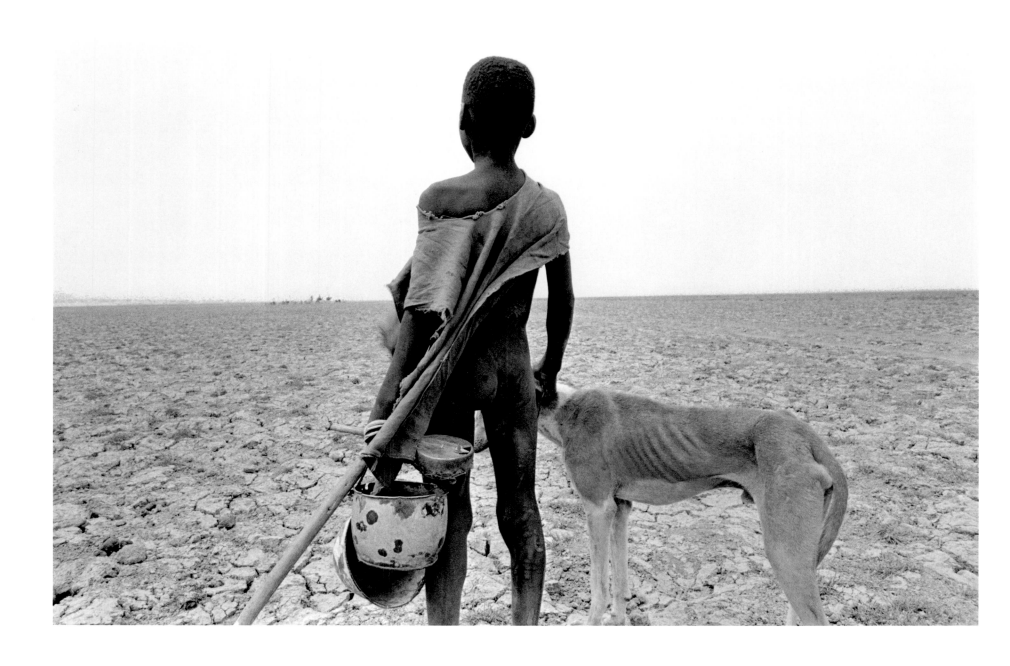

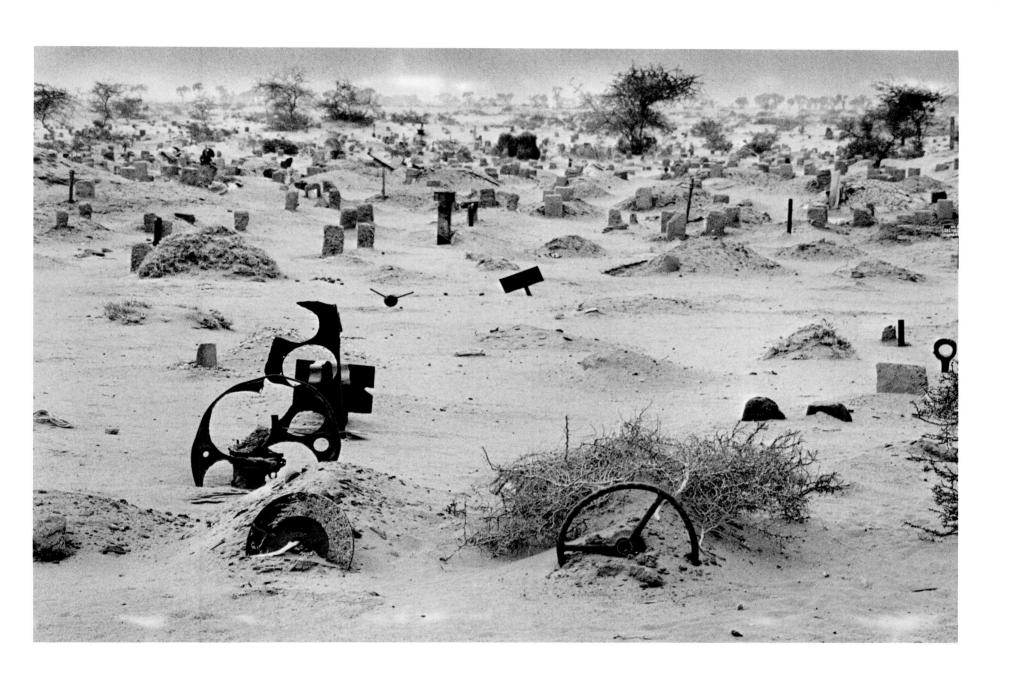

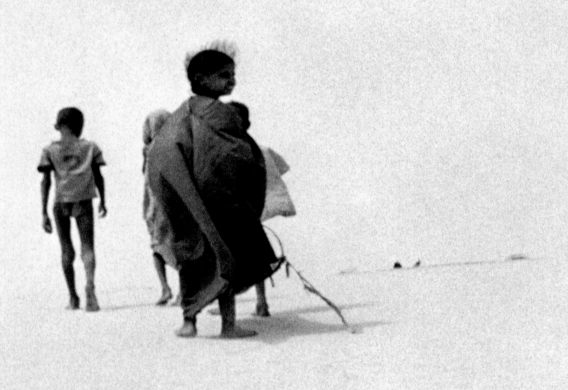

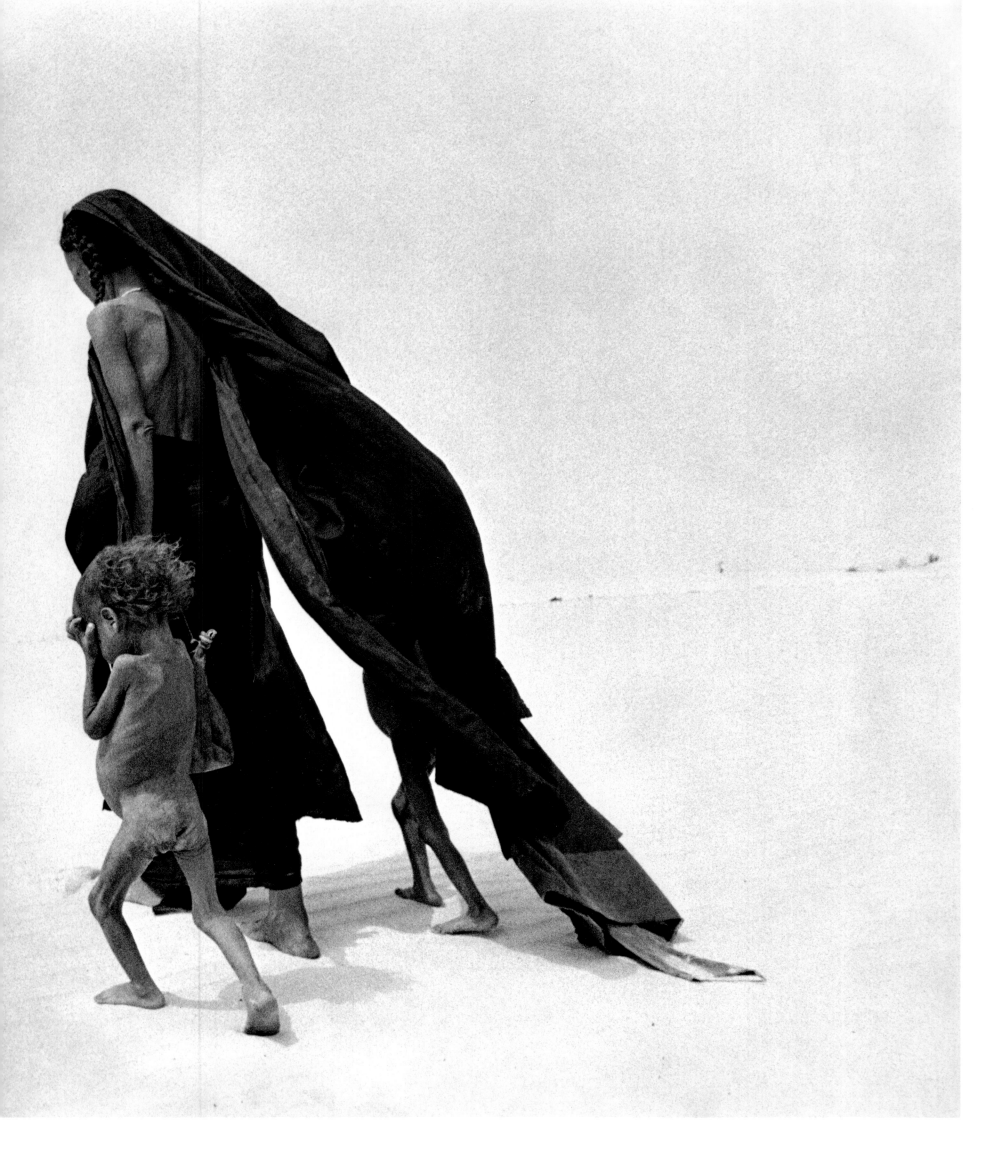

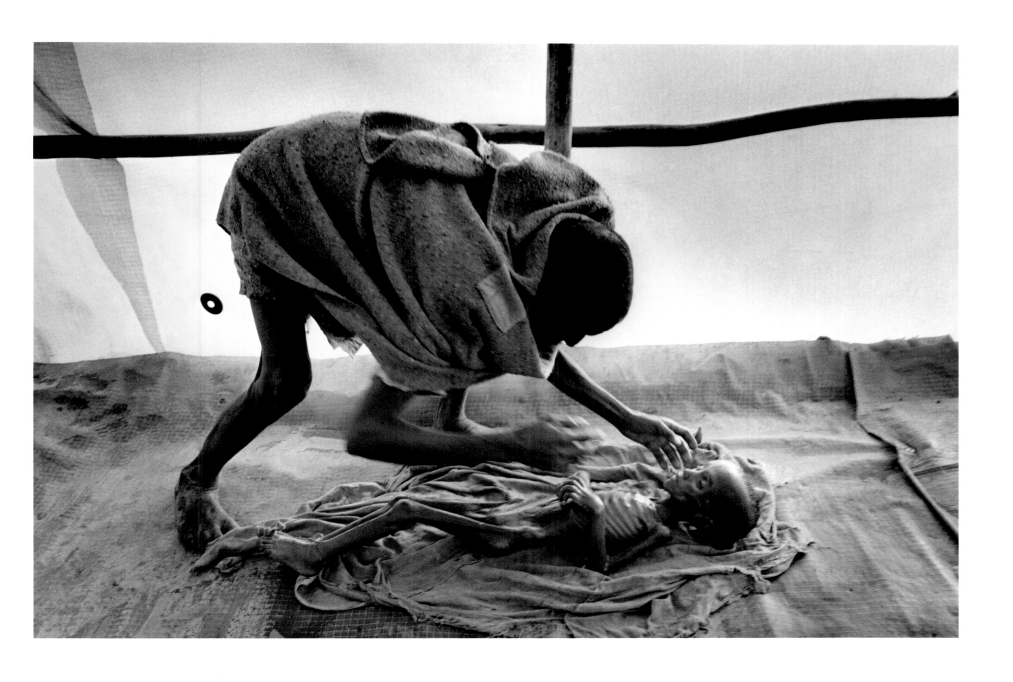

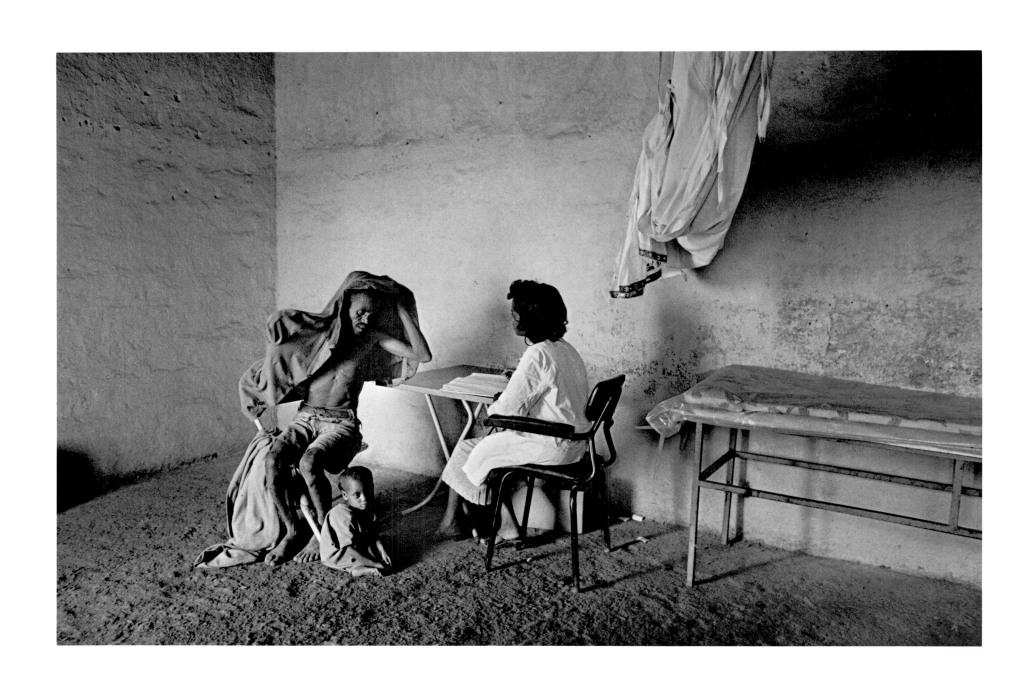

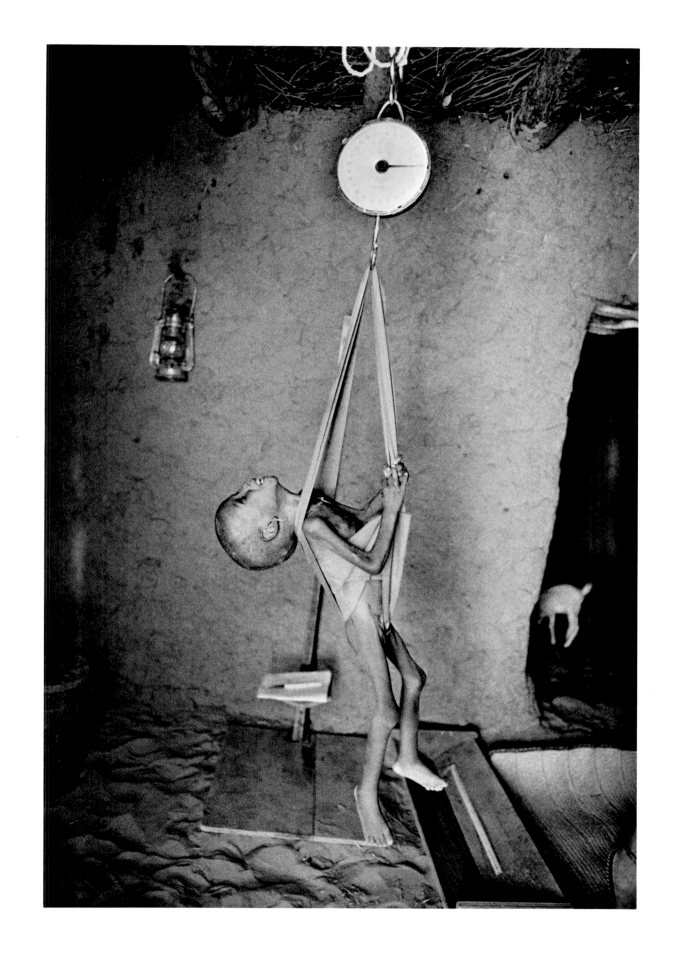

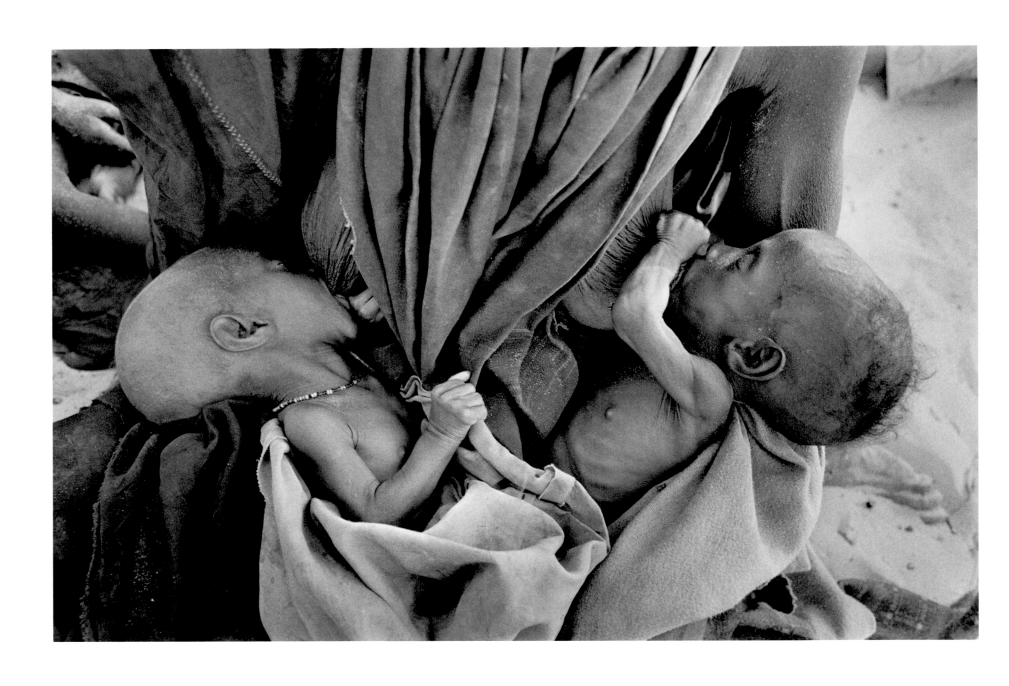

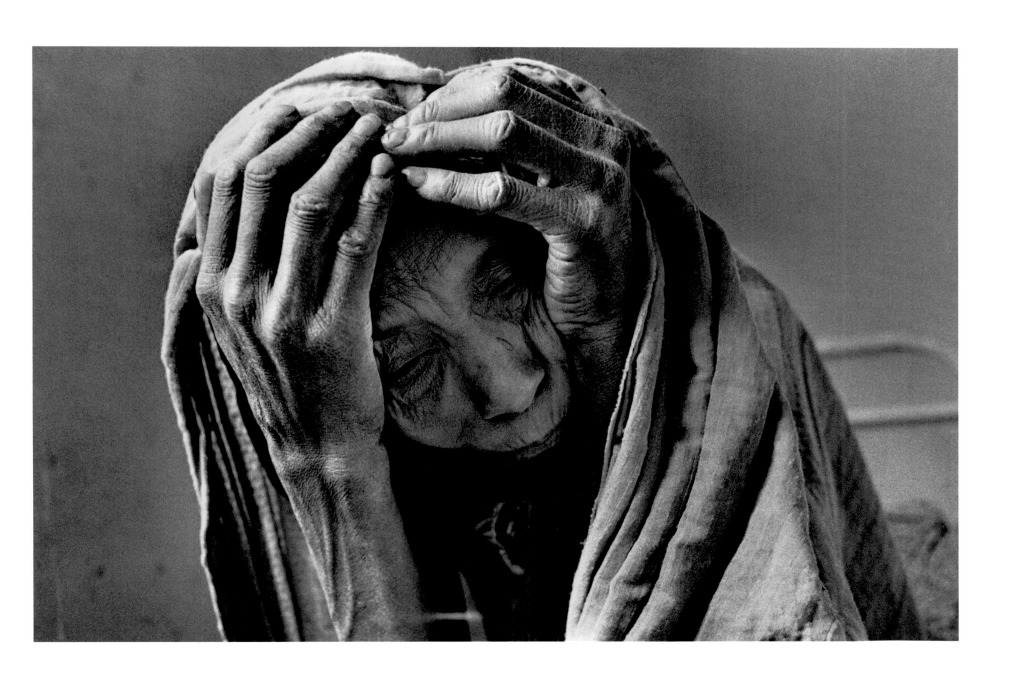

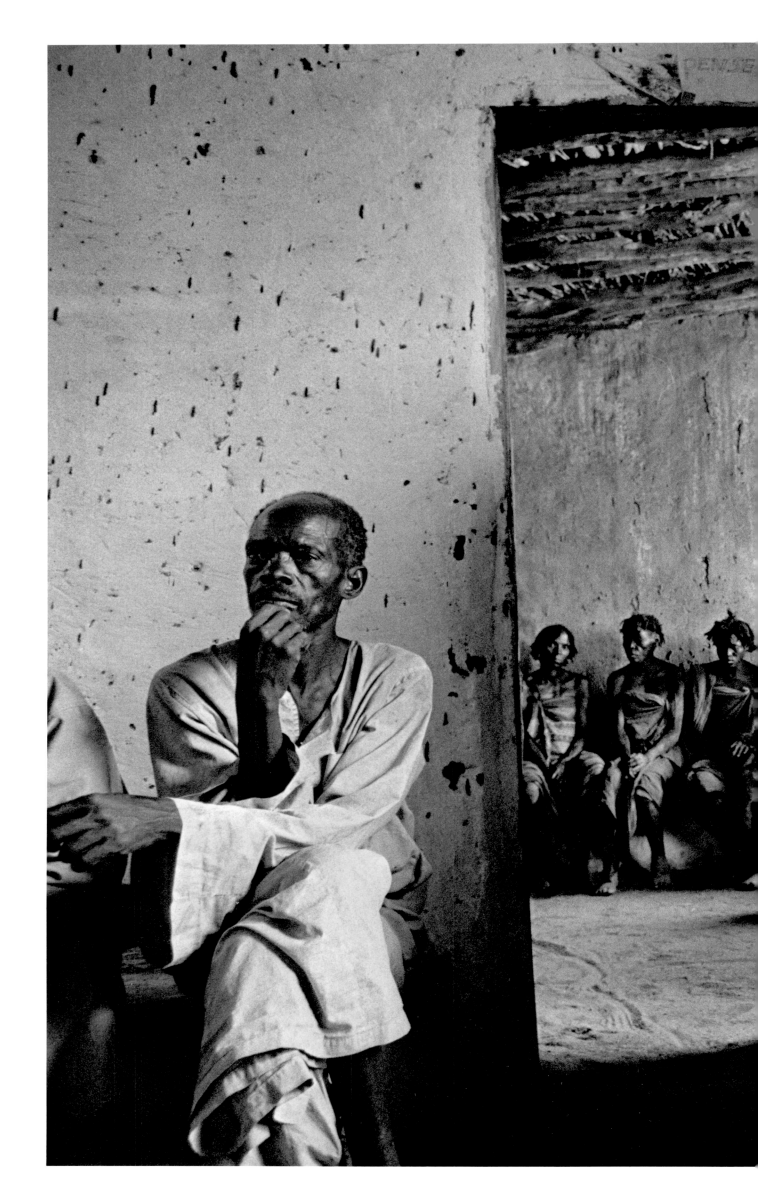

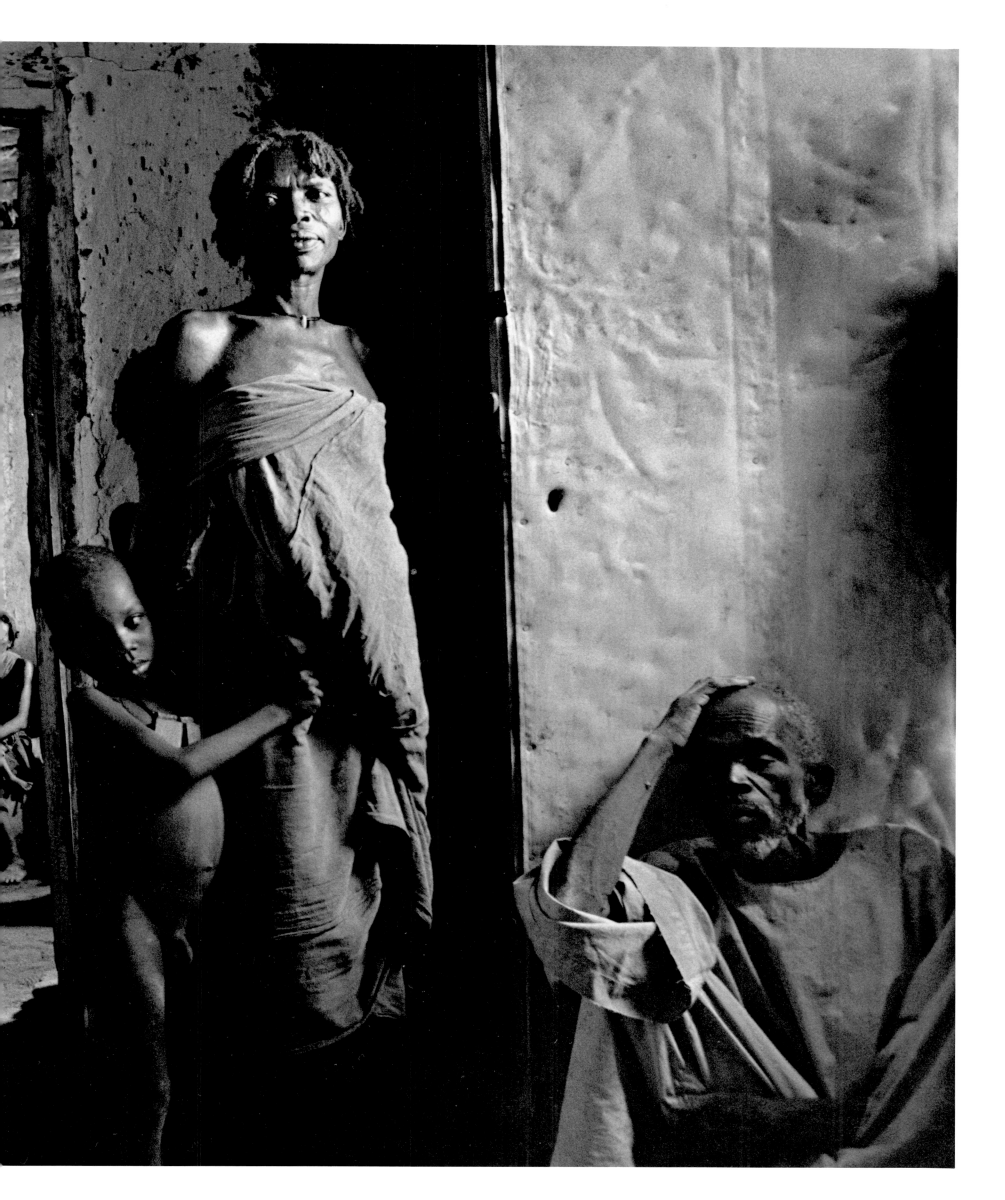

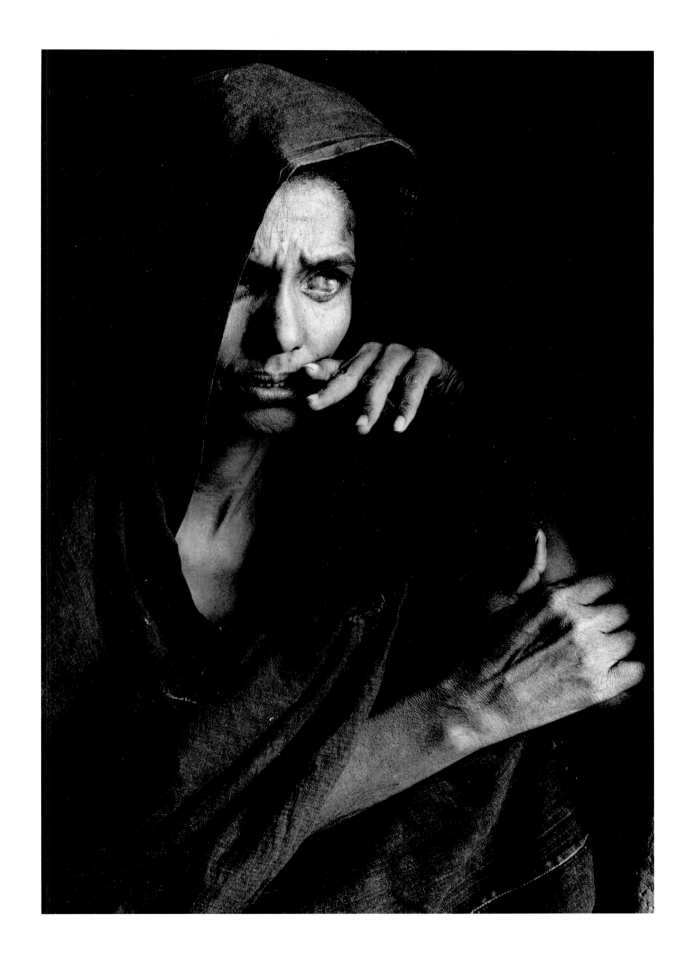

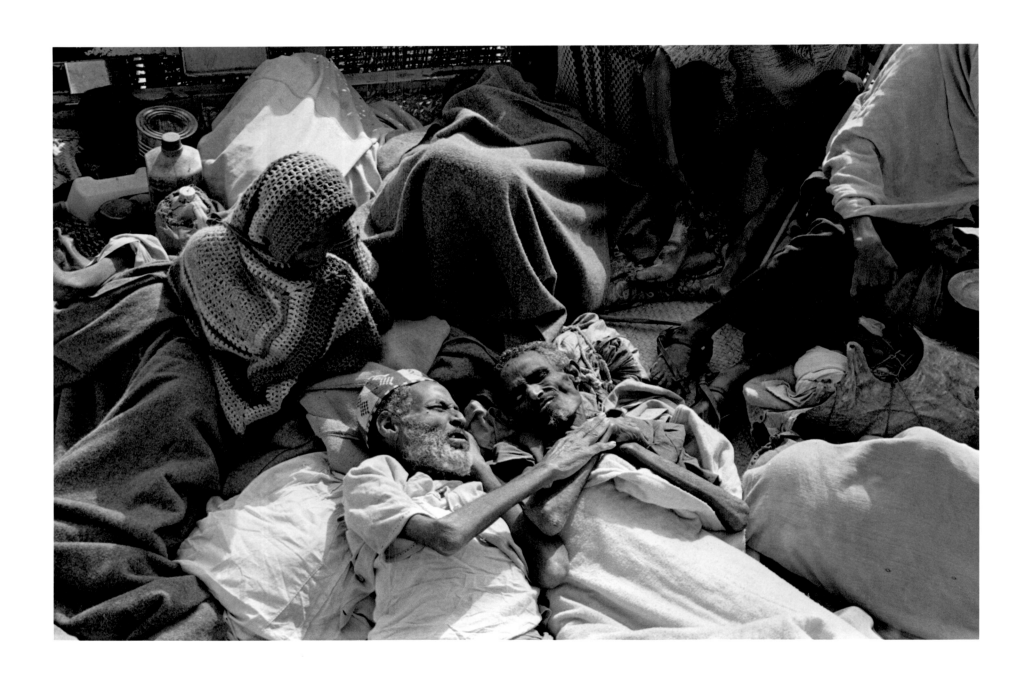

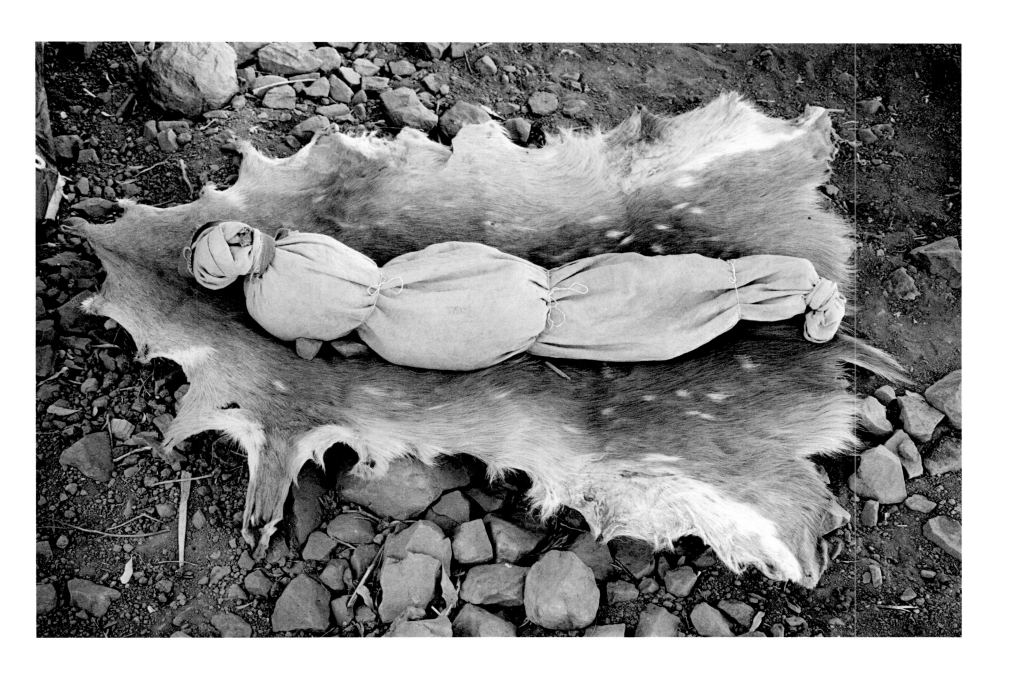

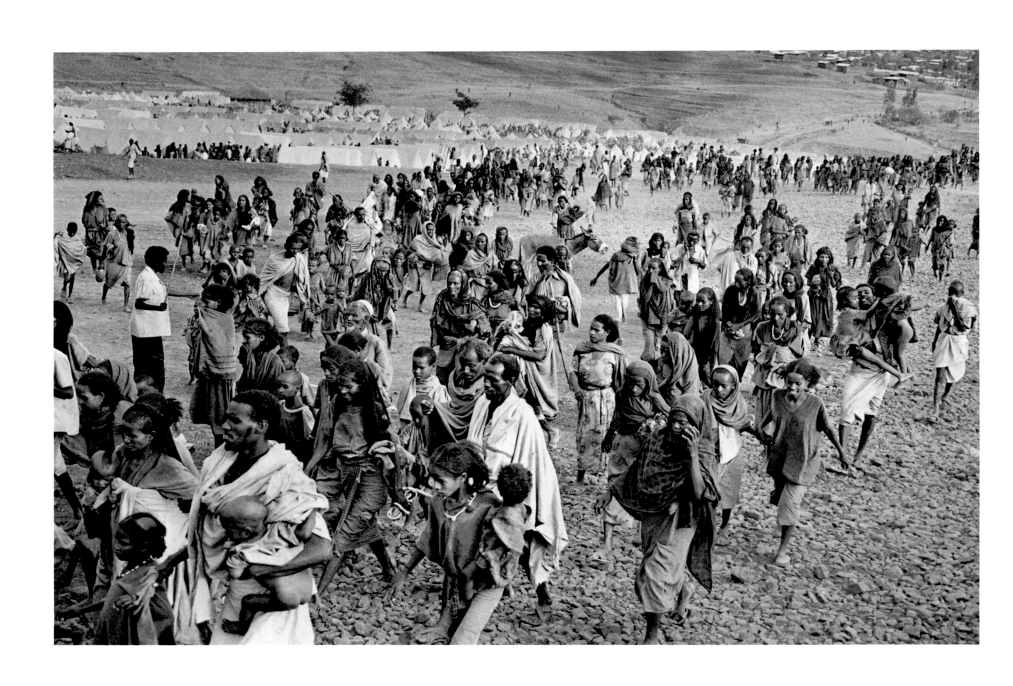

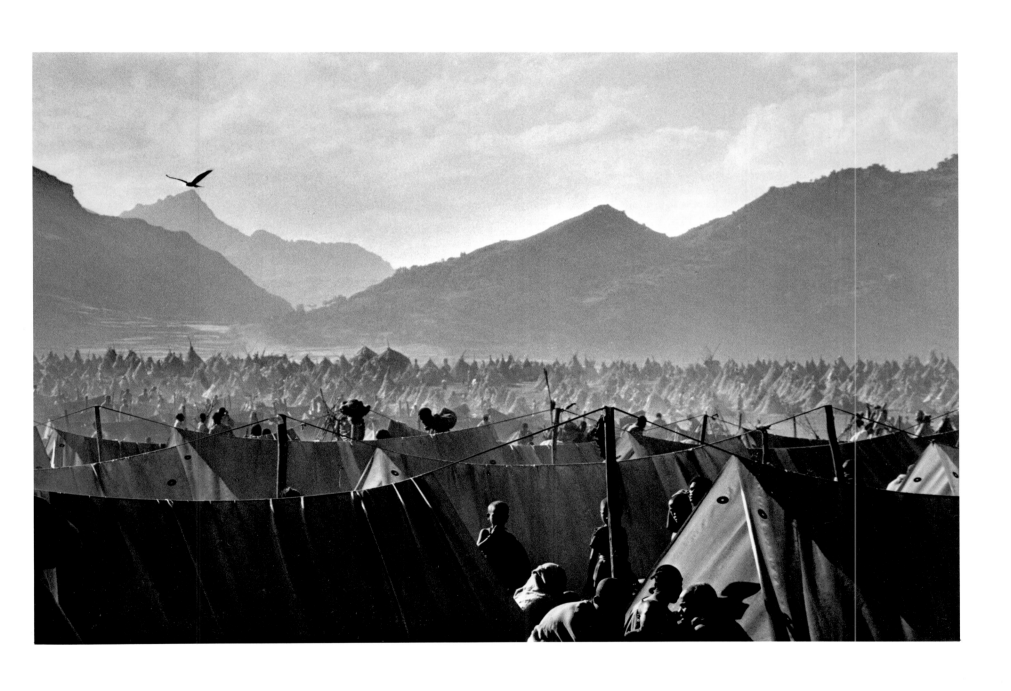

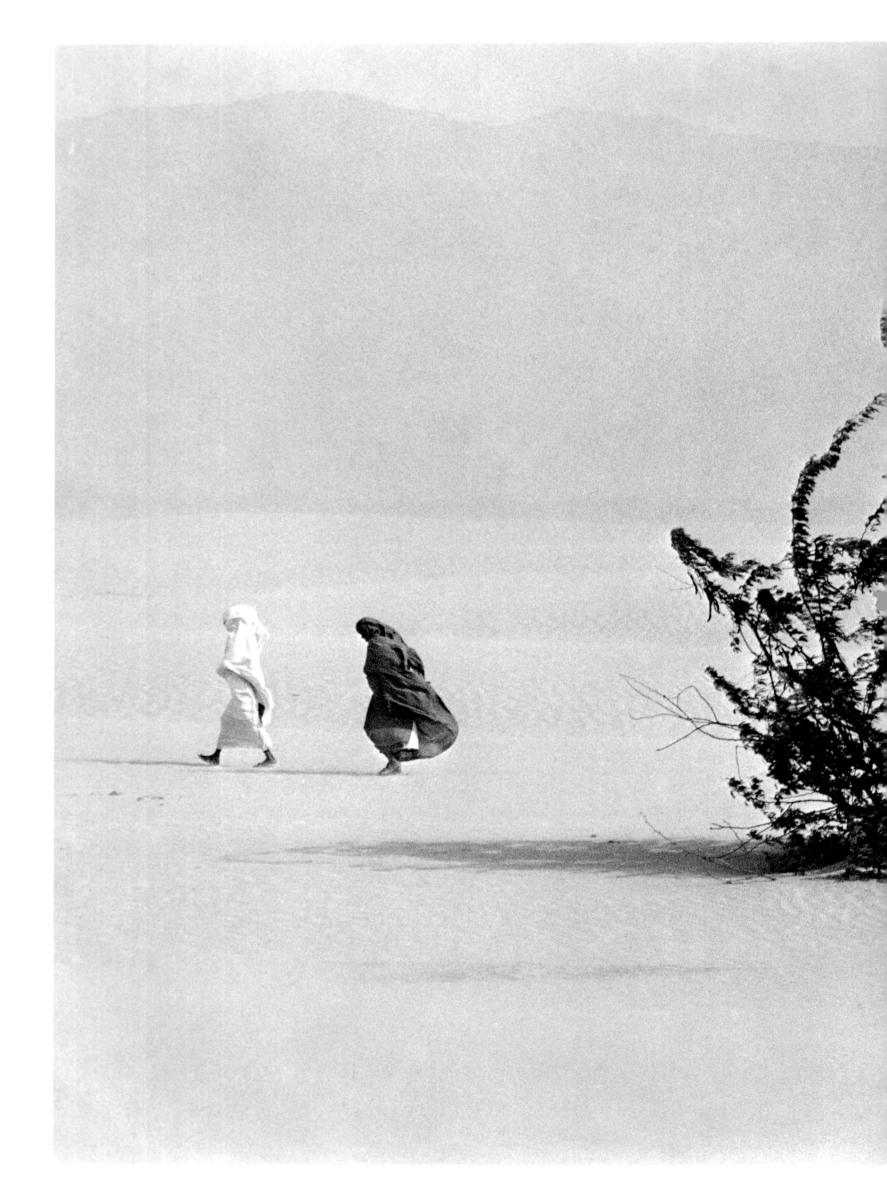

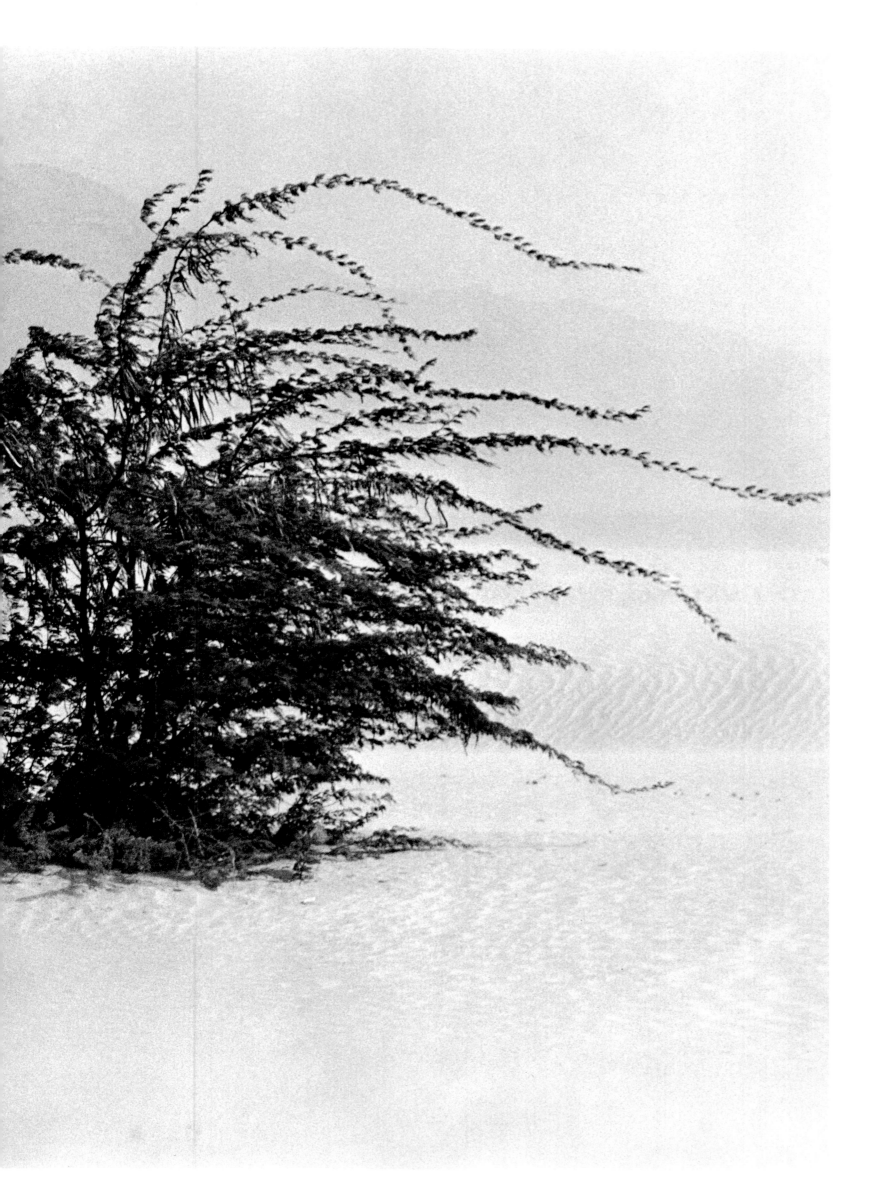

IV.

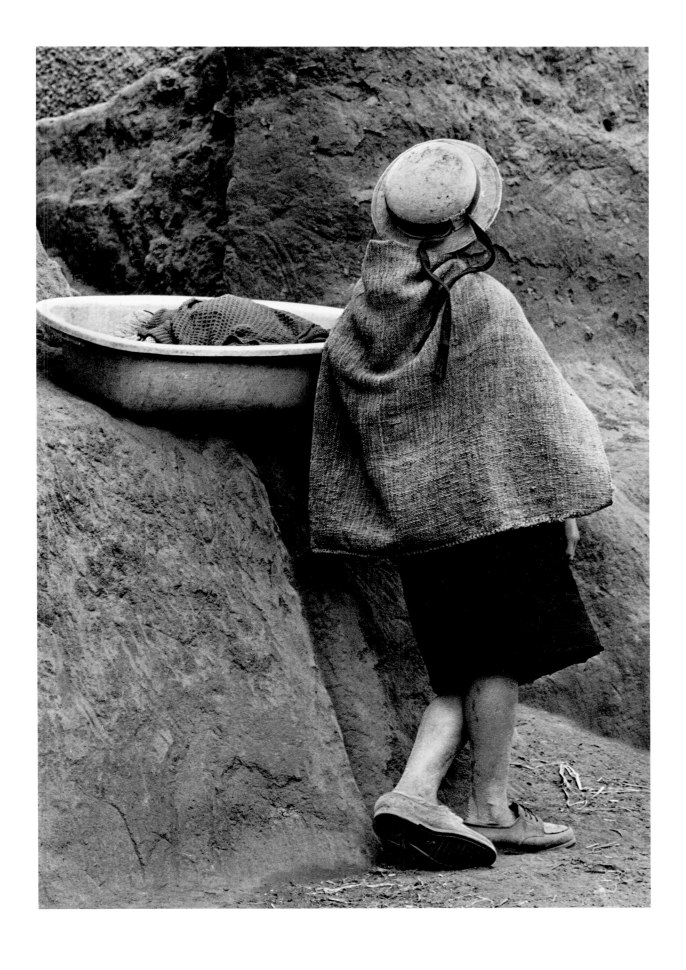

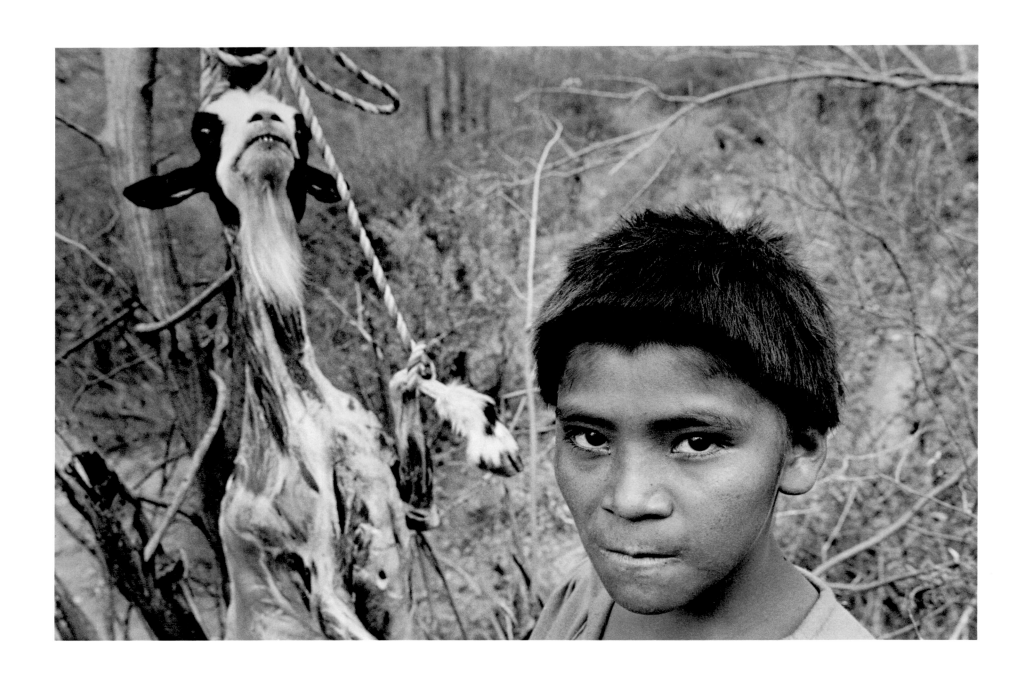

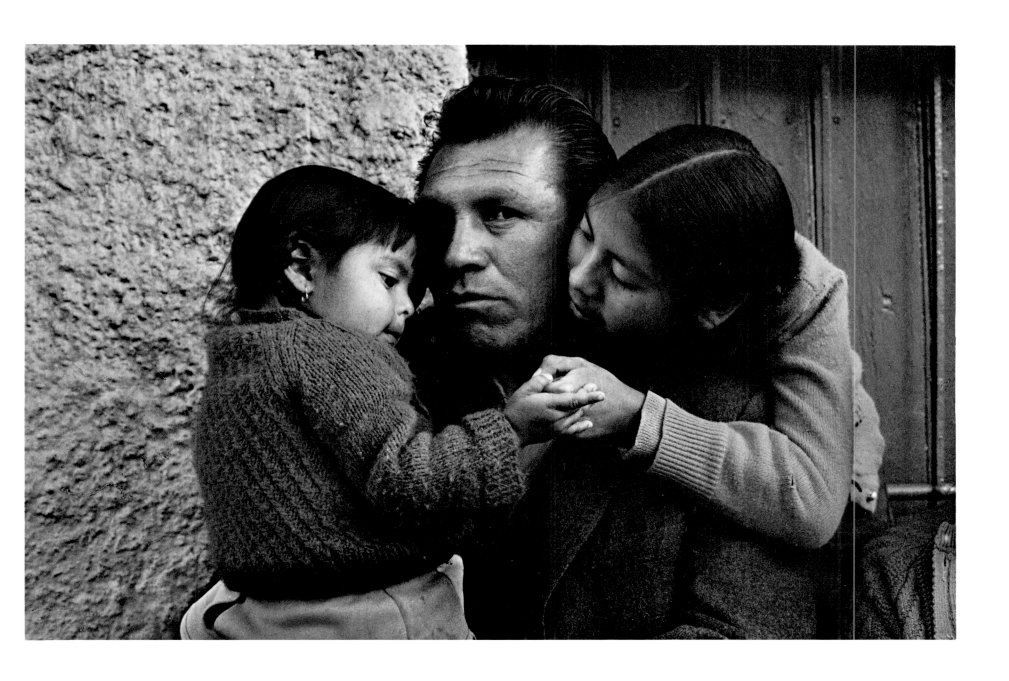

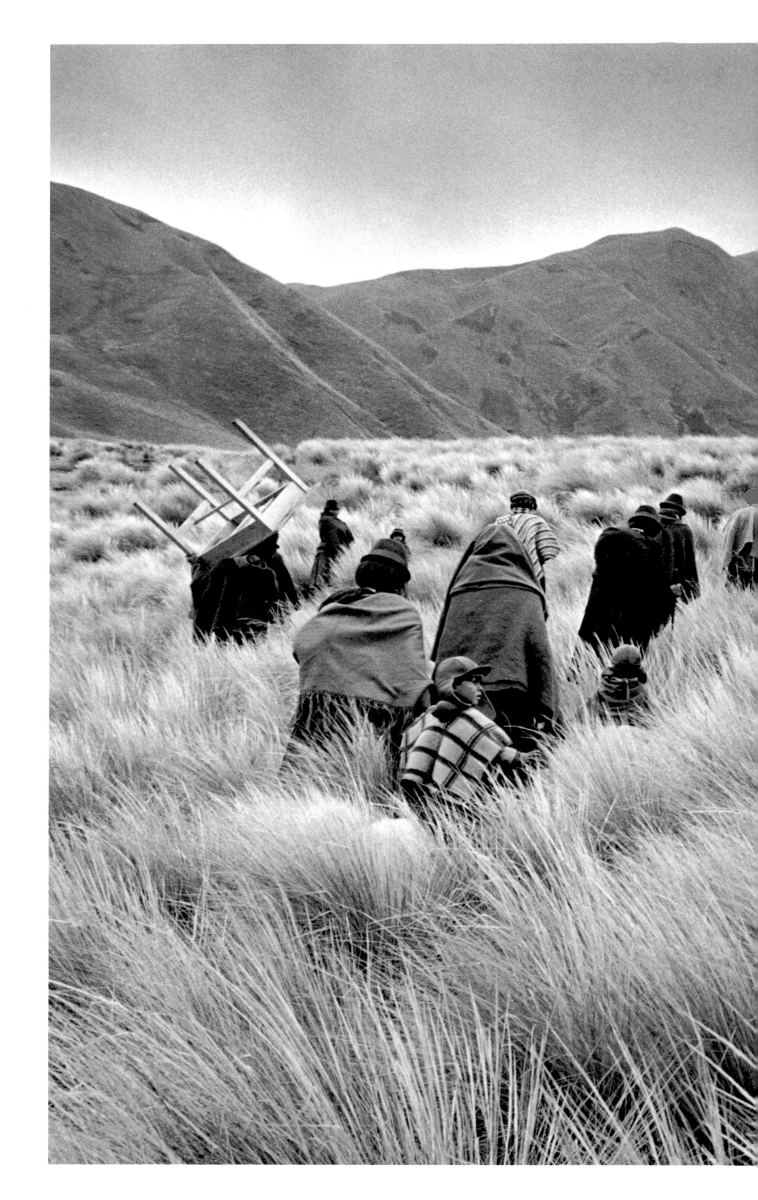

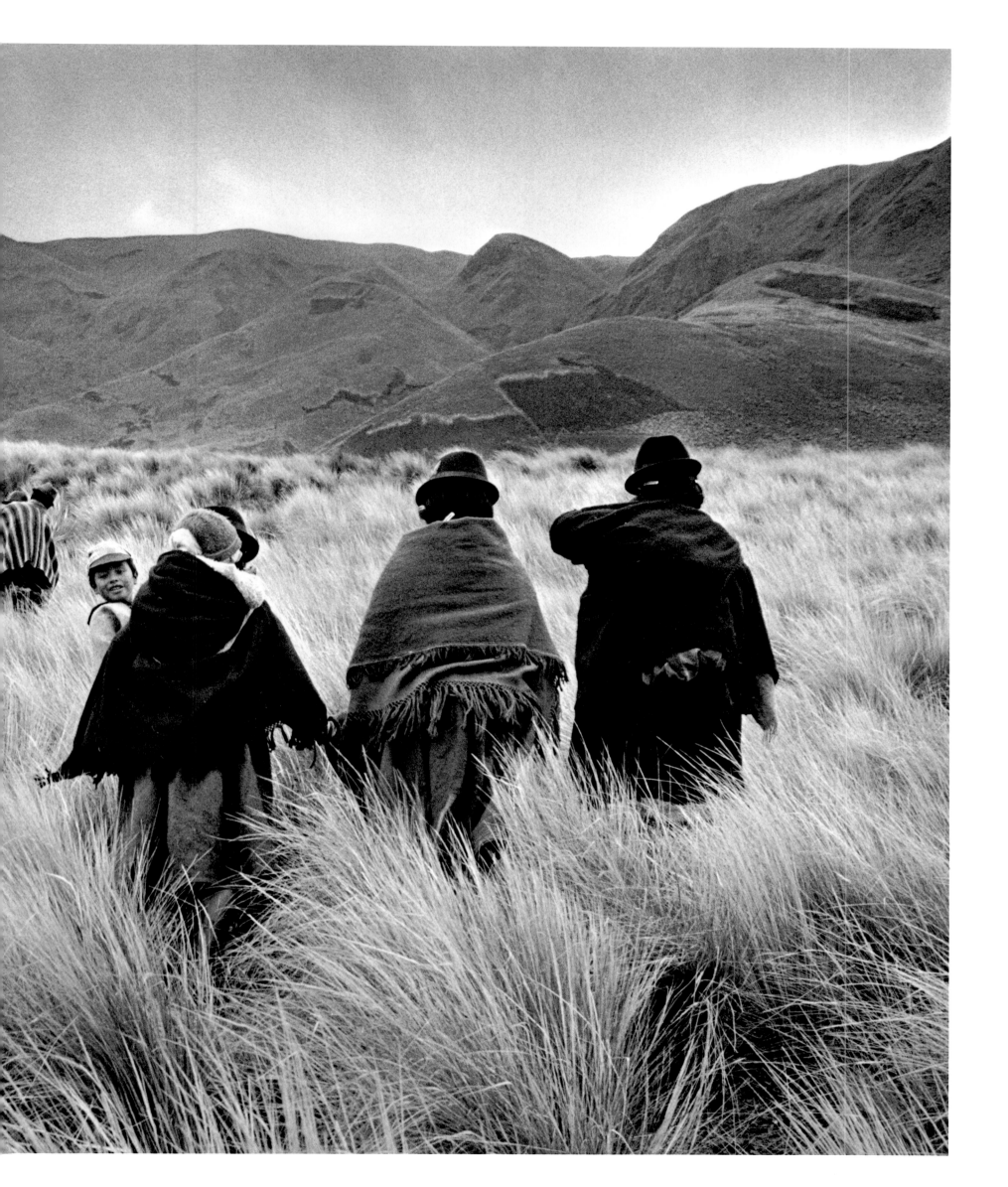

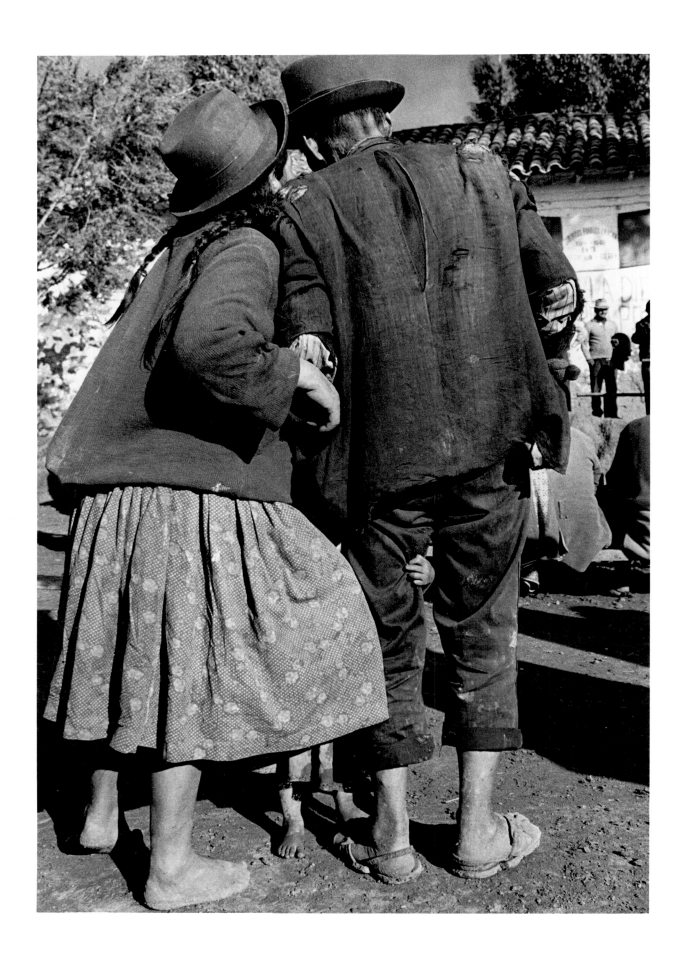

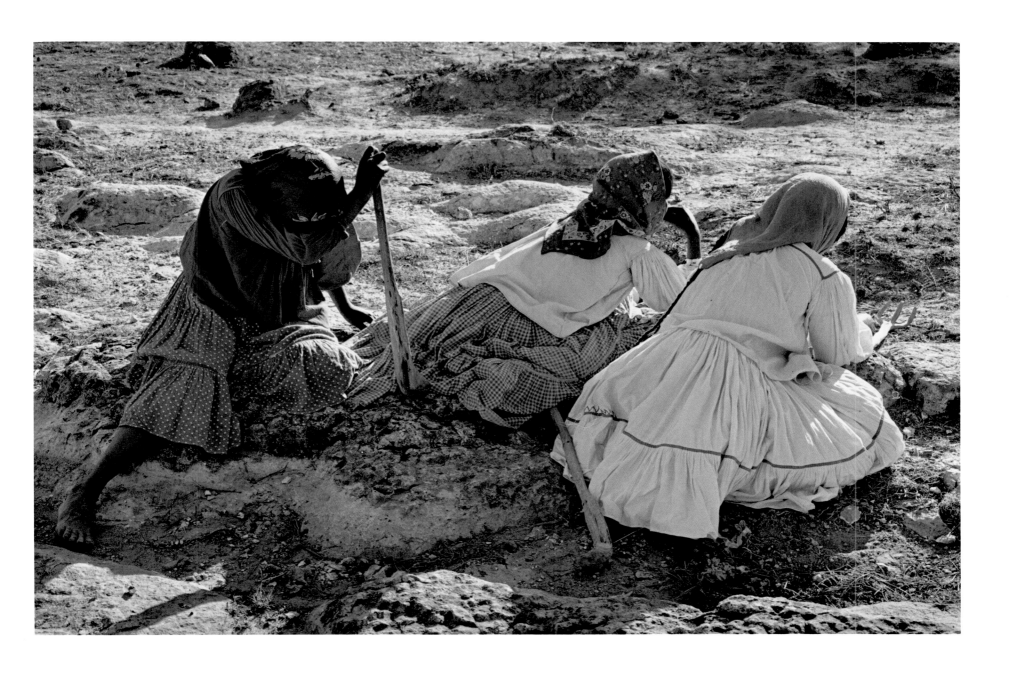

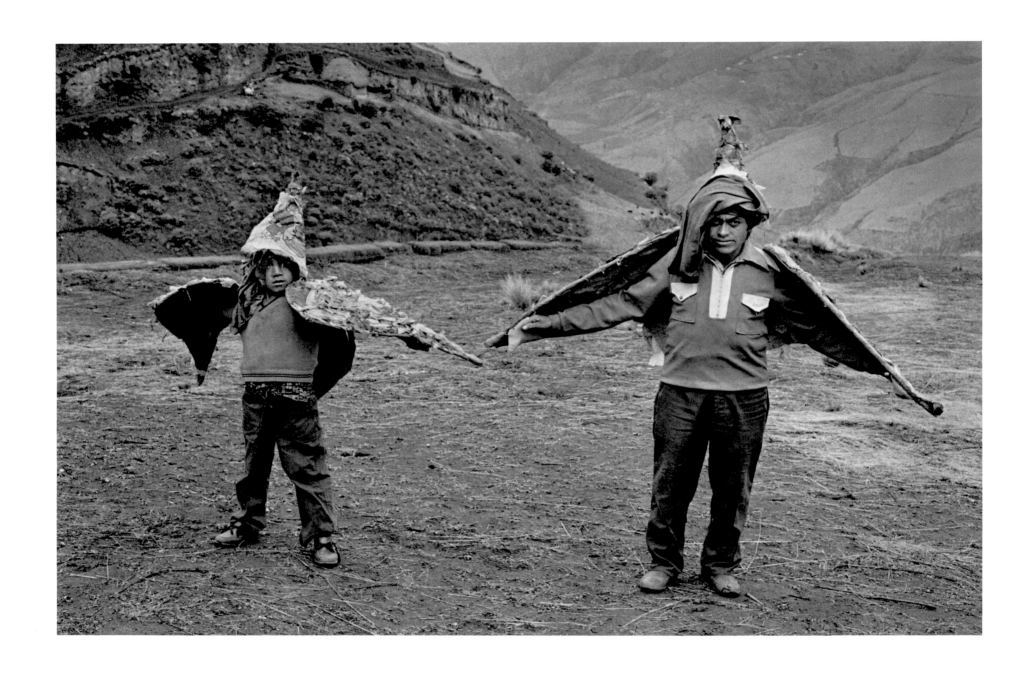

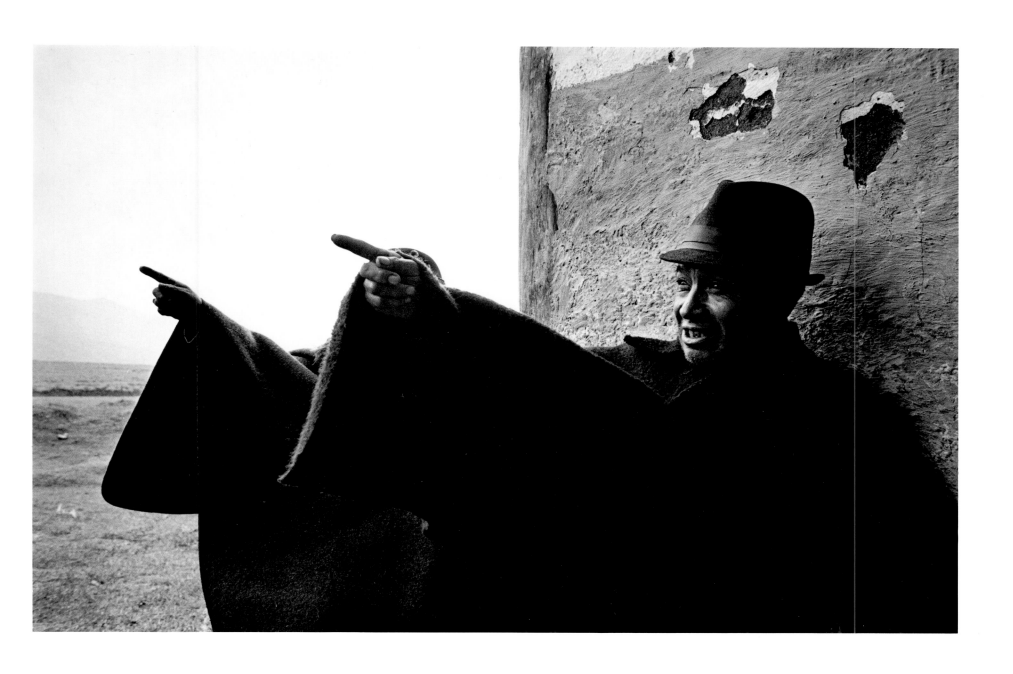

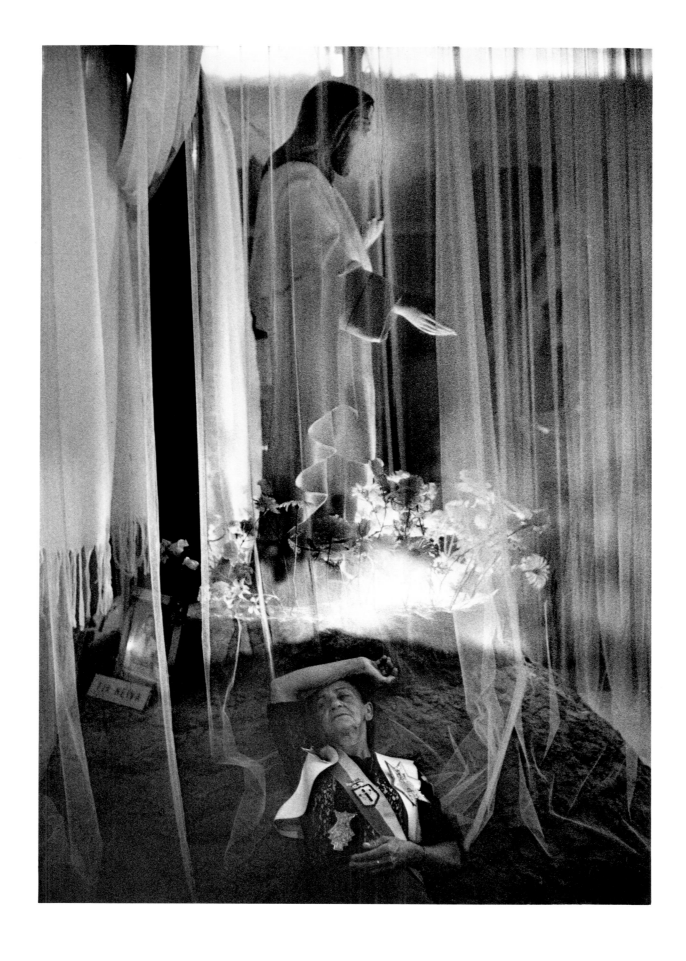

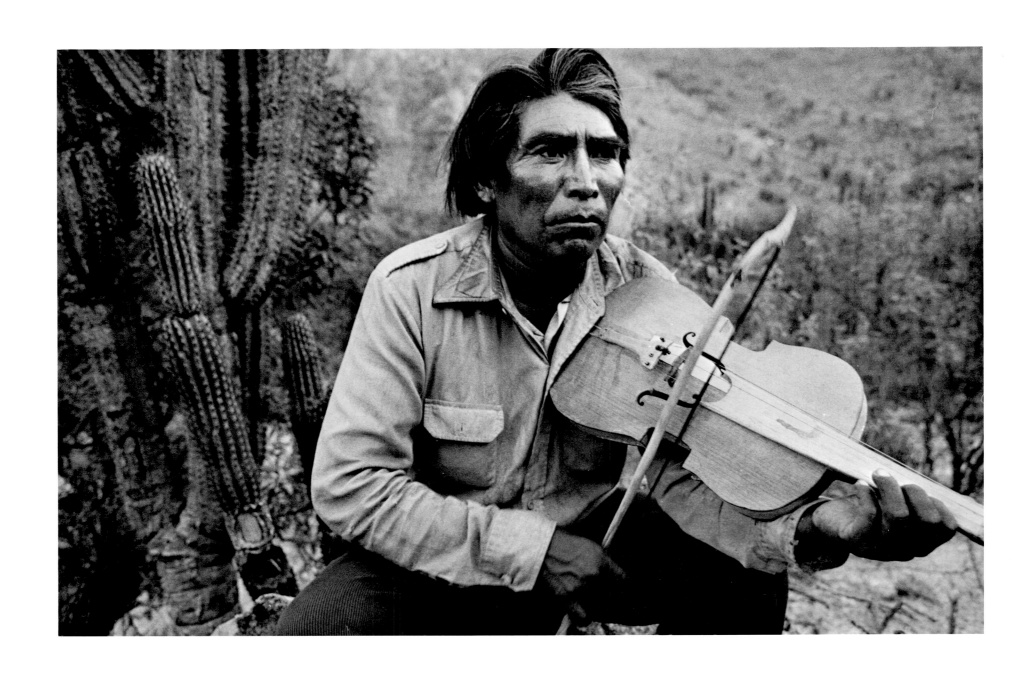

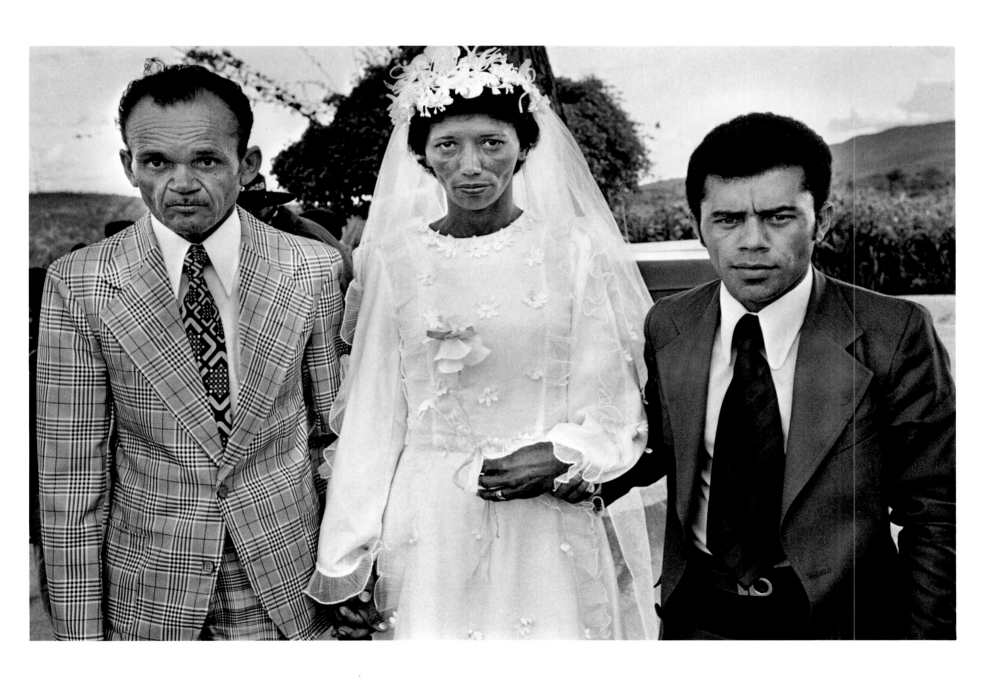

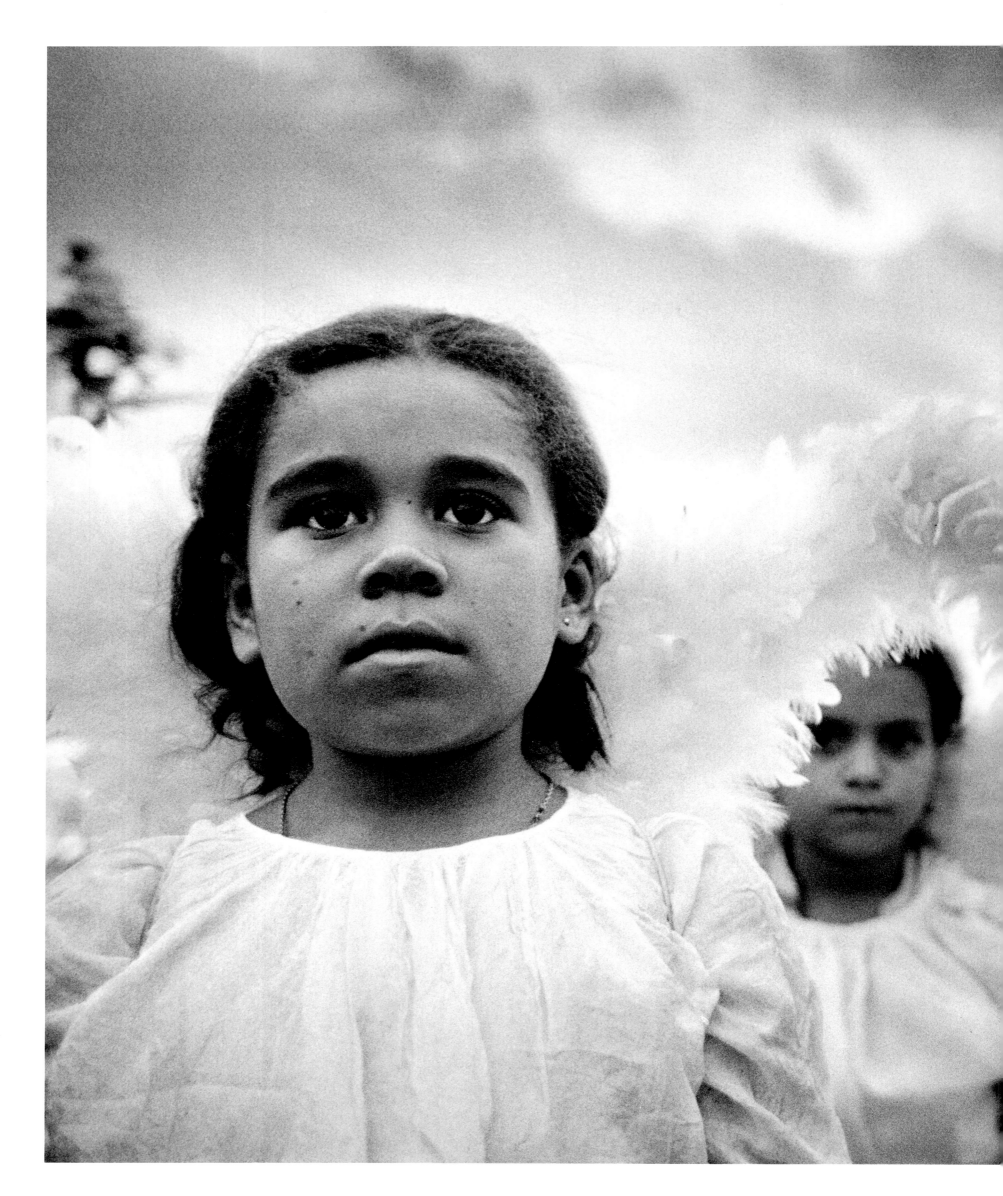

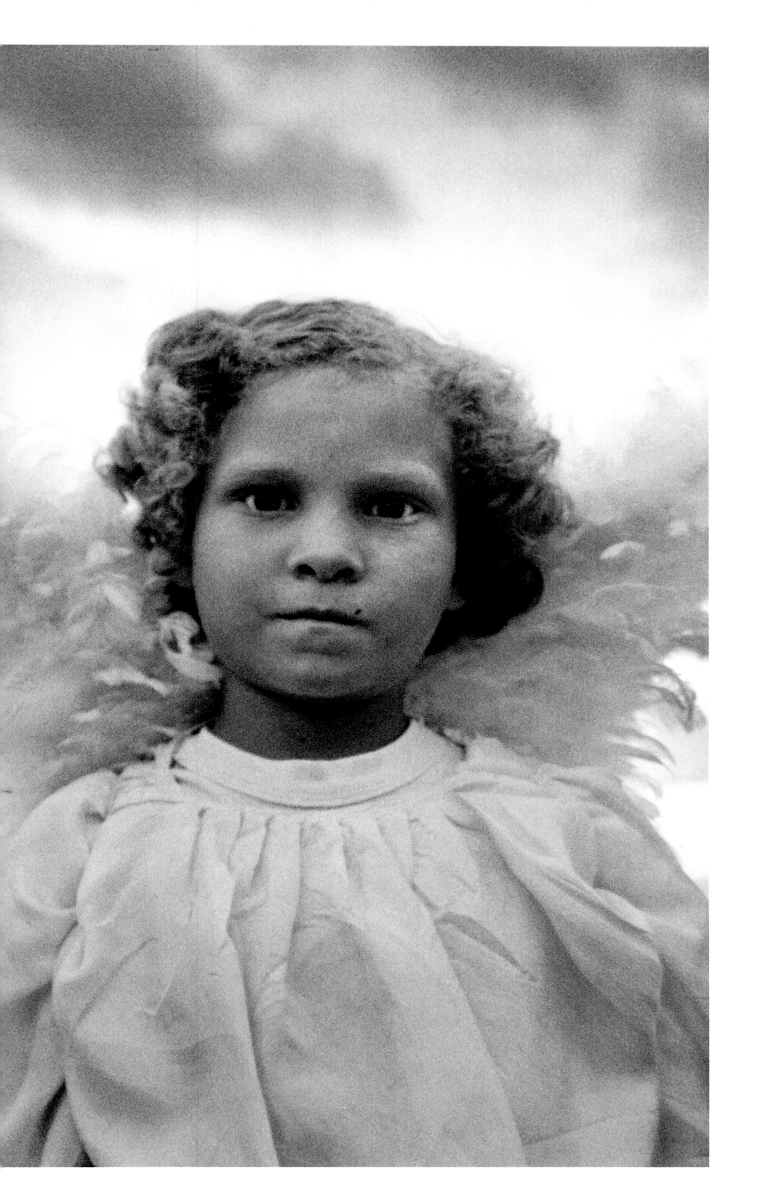

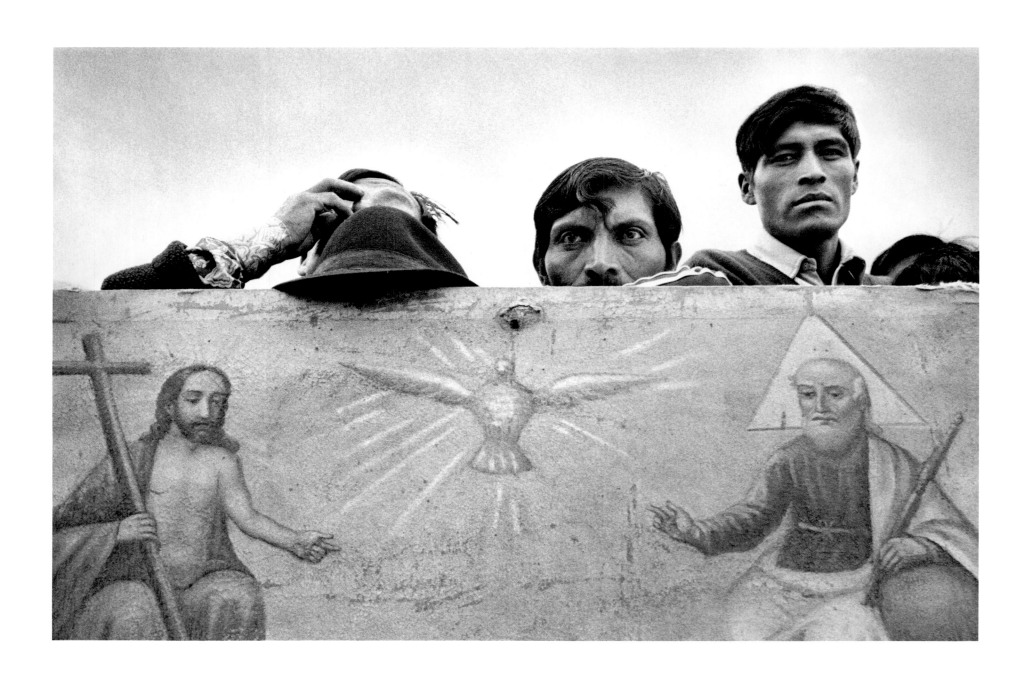

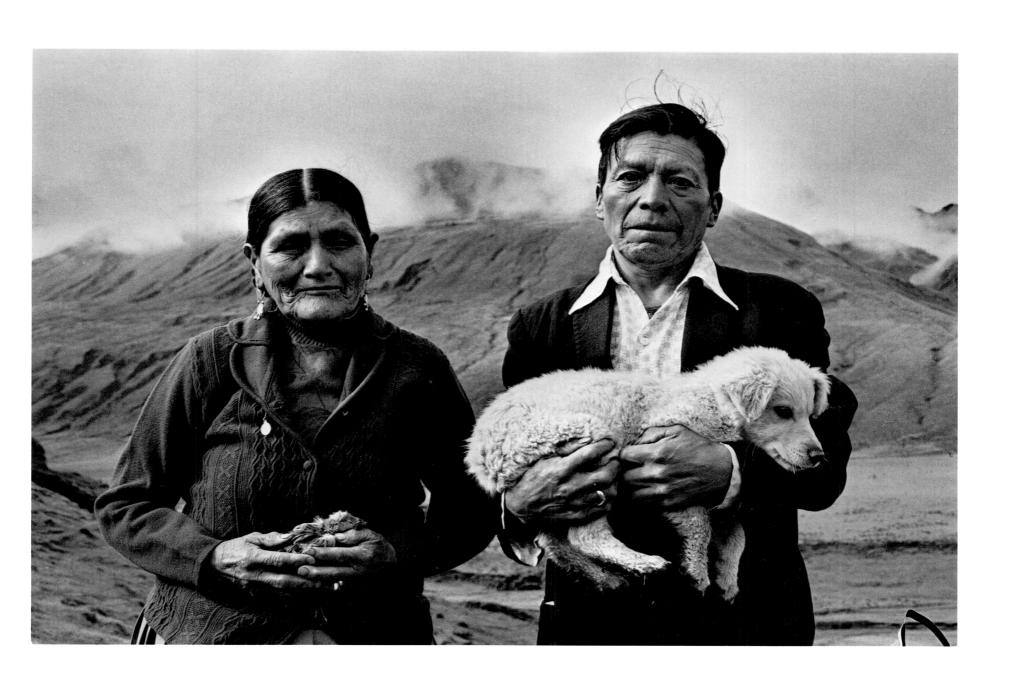

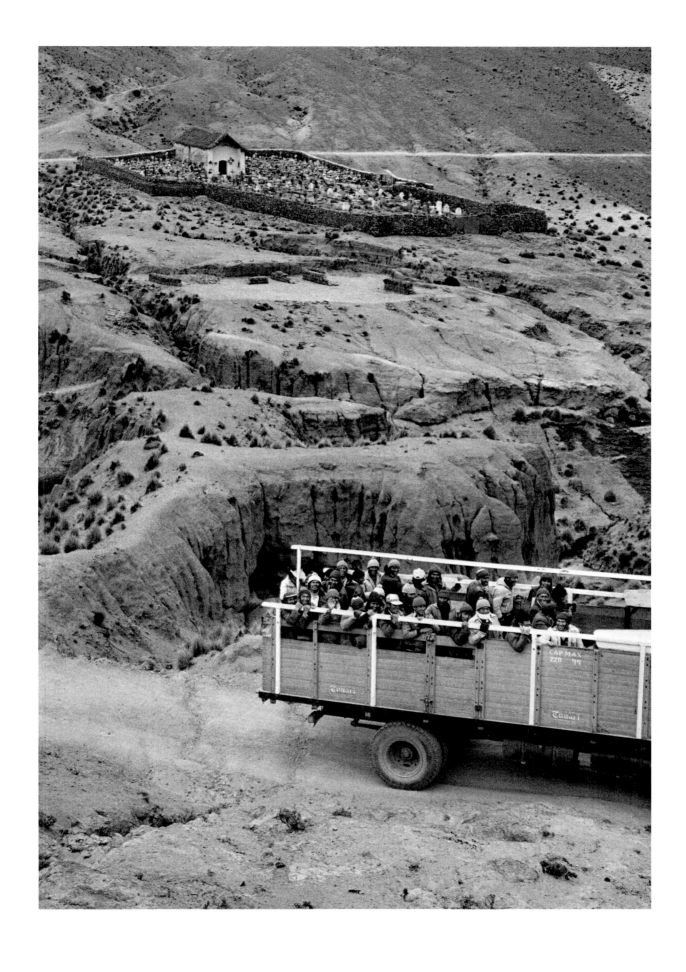

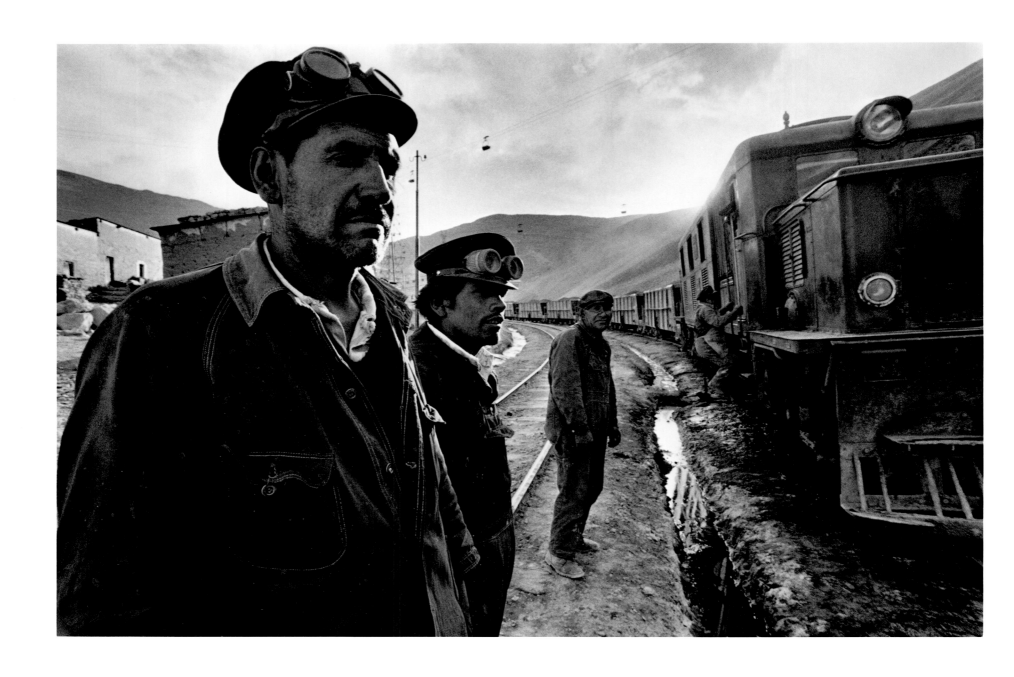

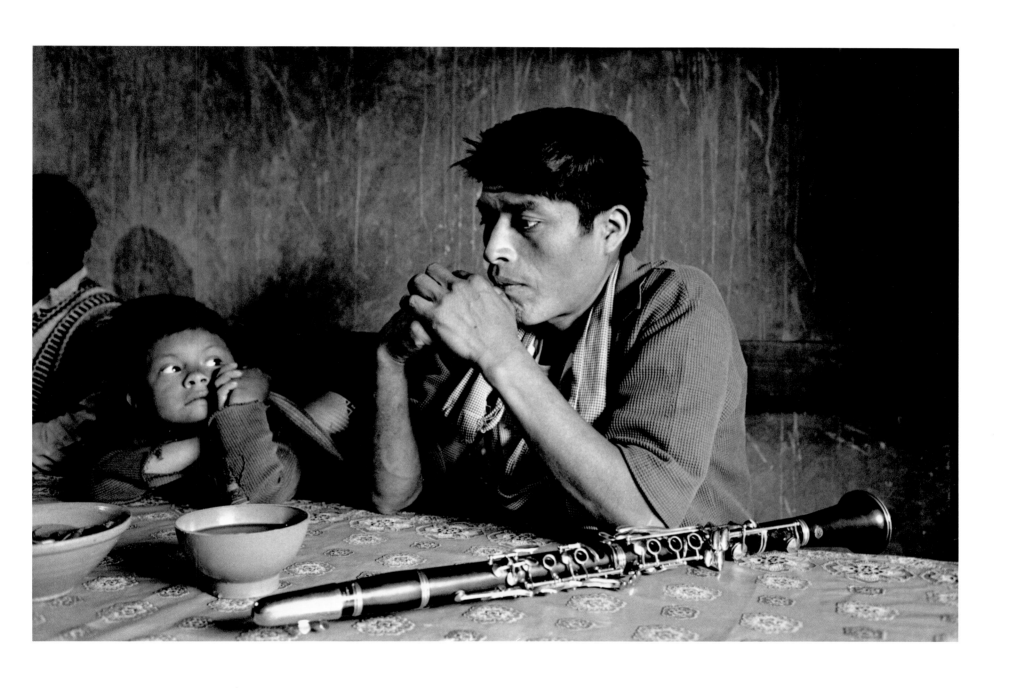

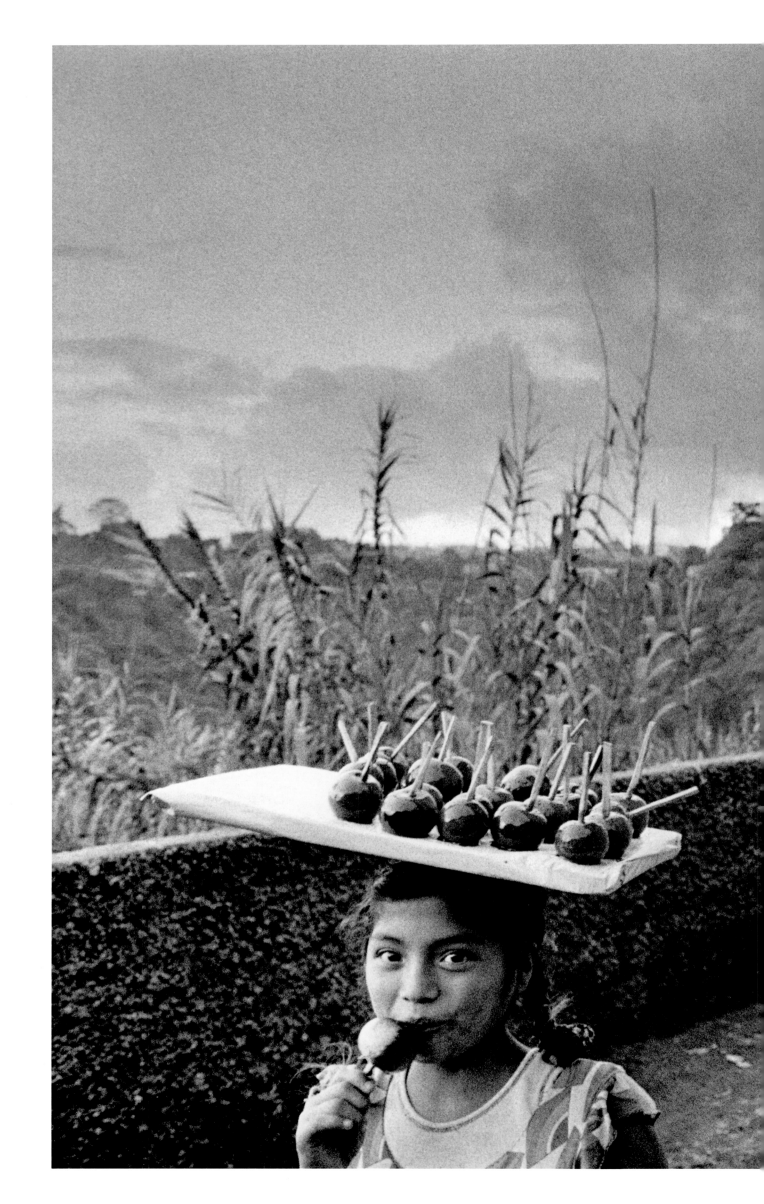

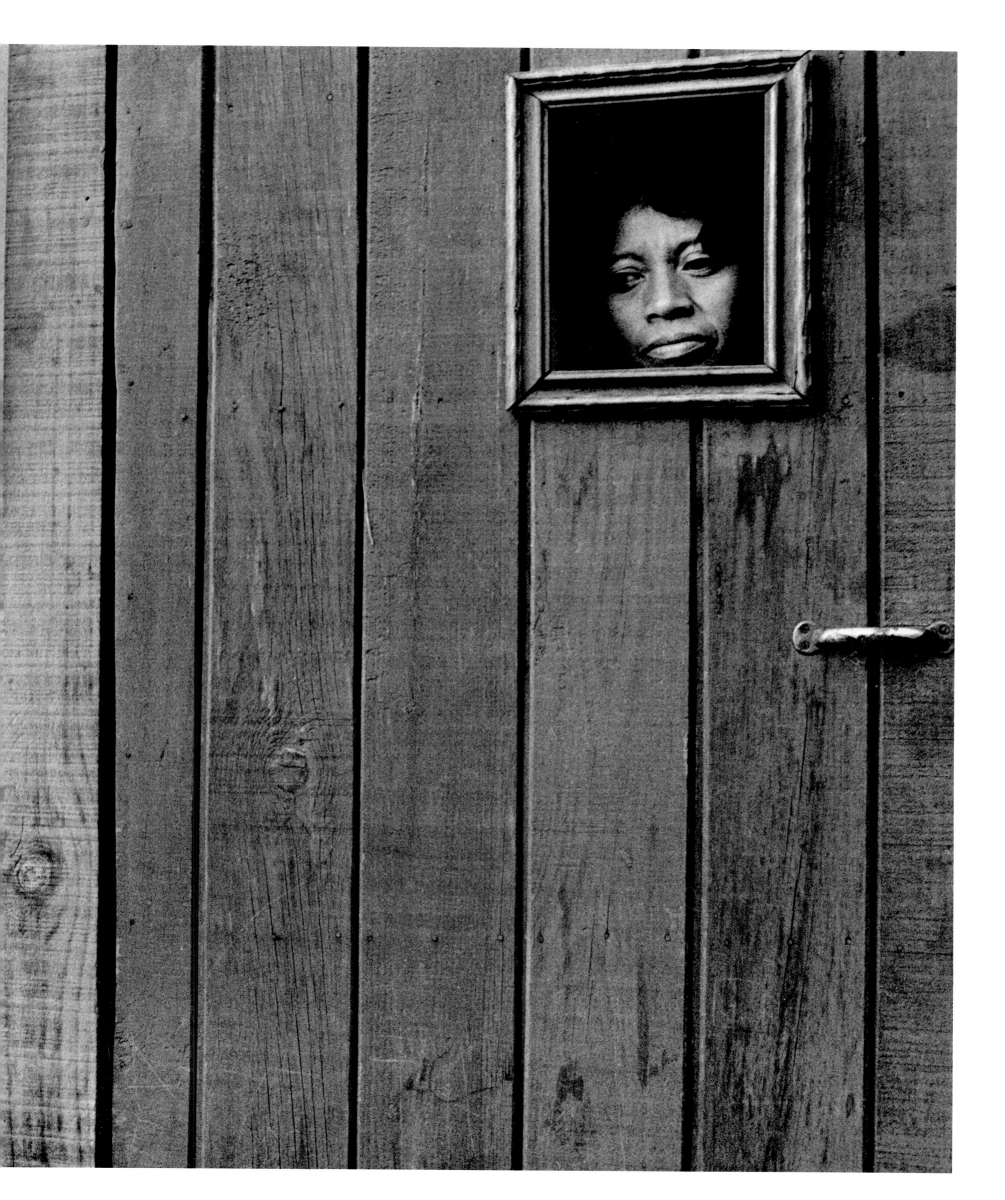

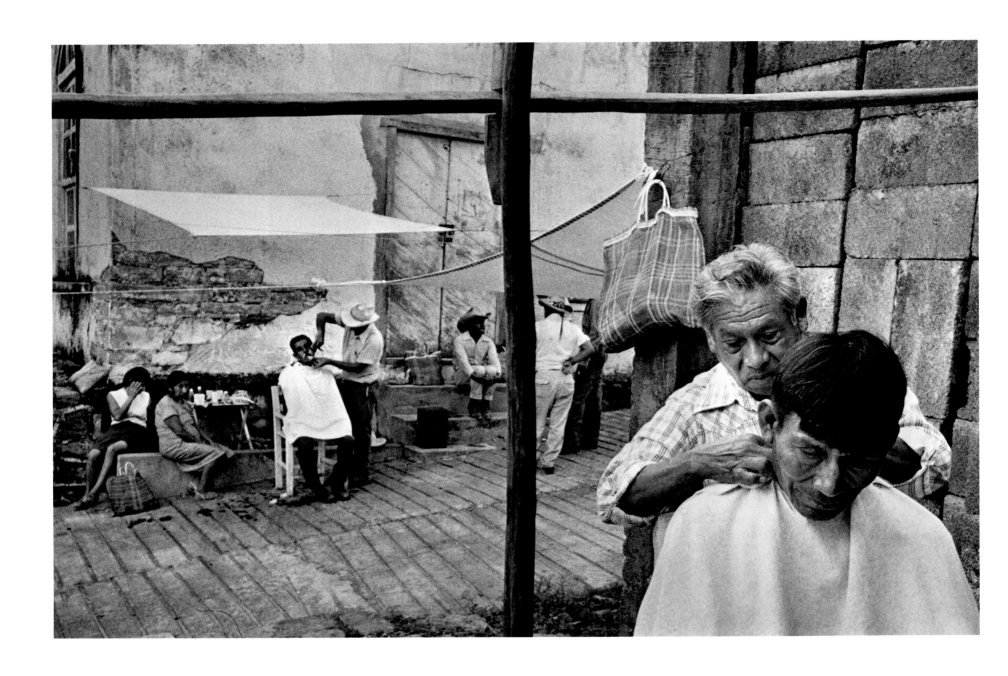

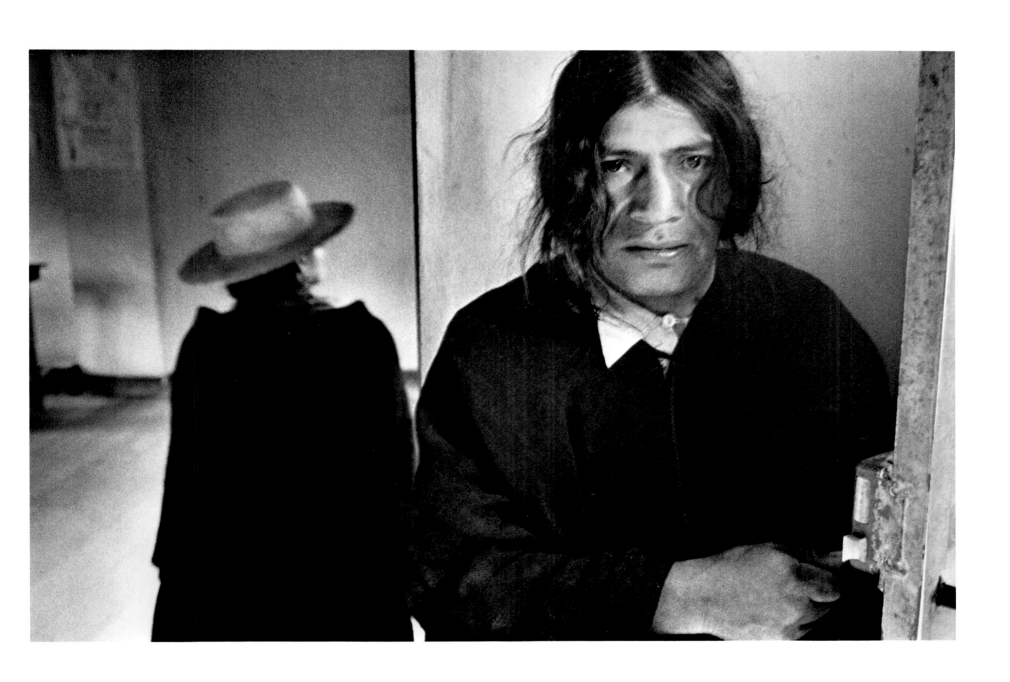

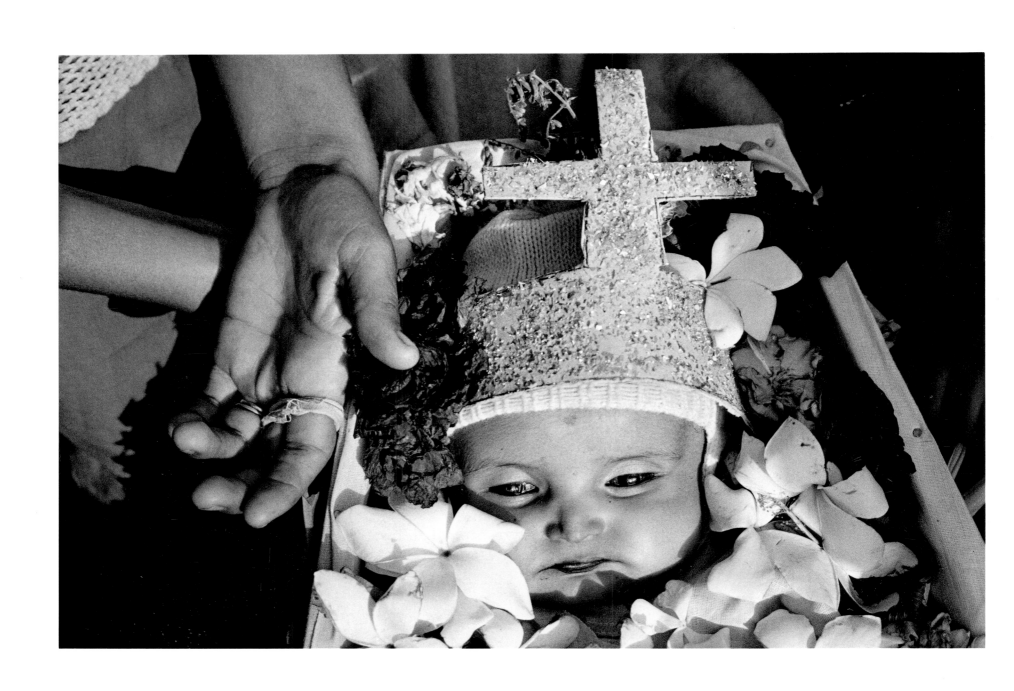

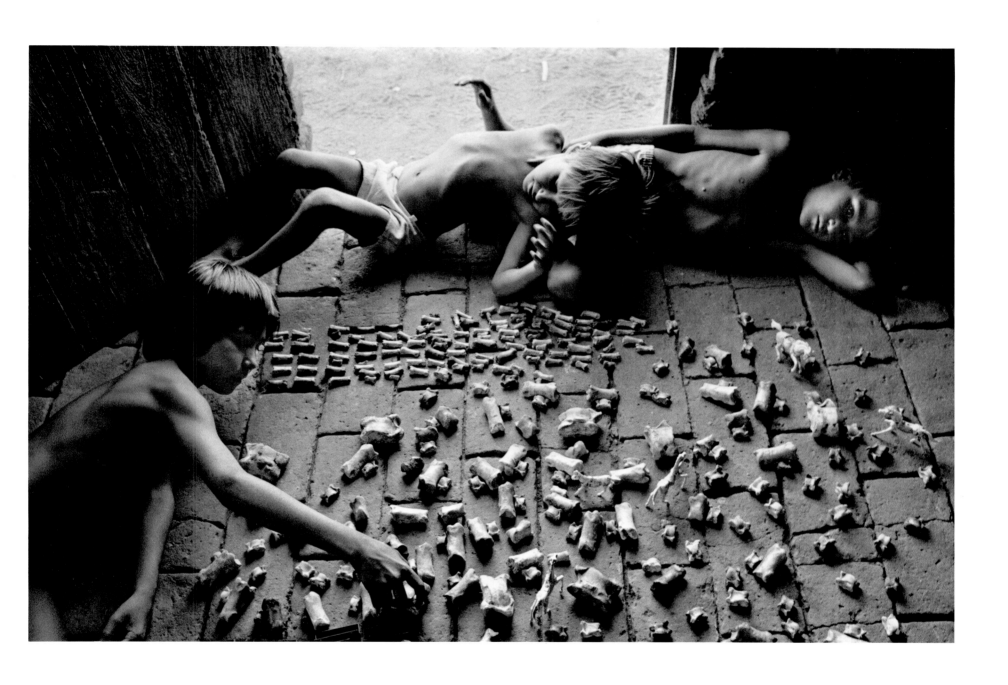

123

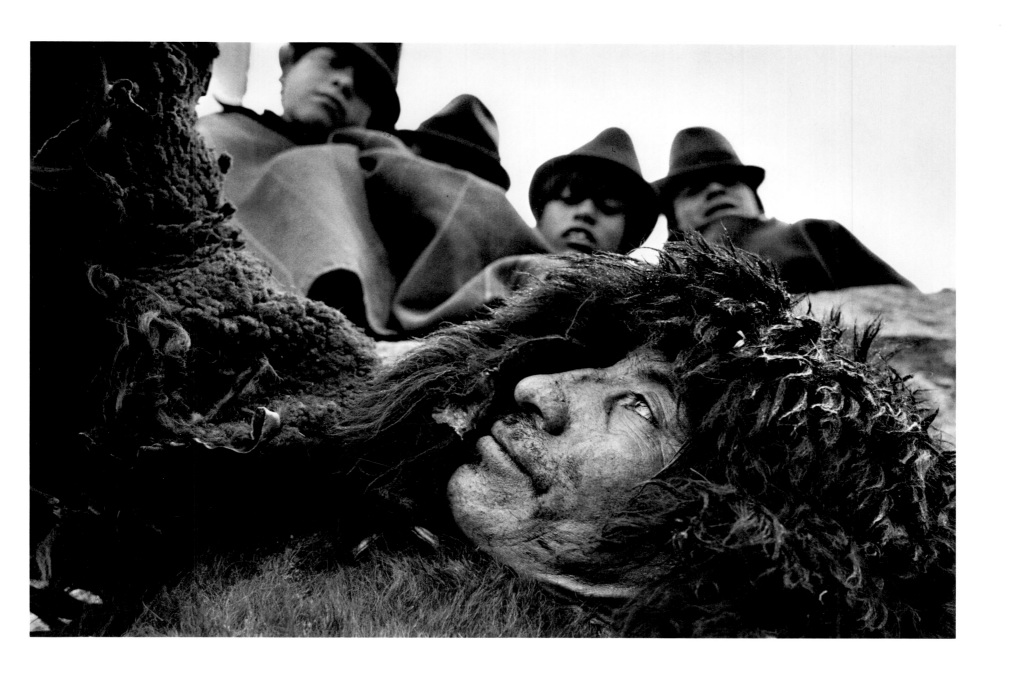

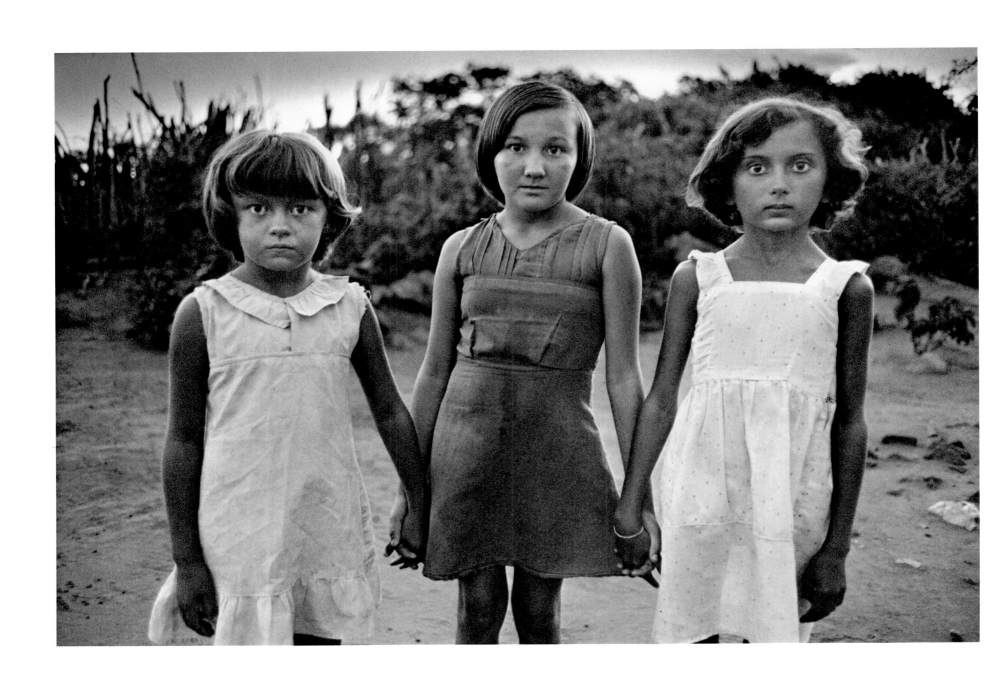

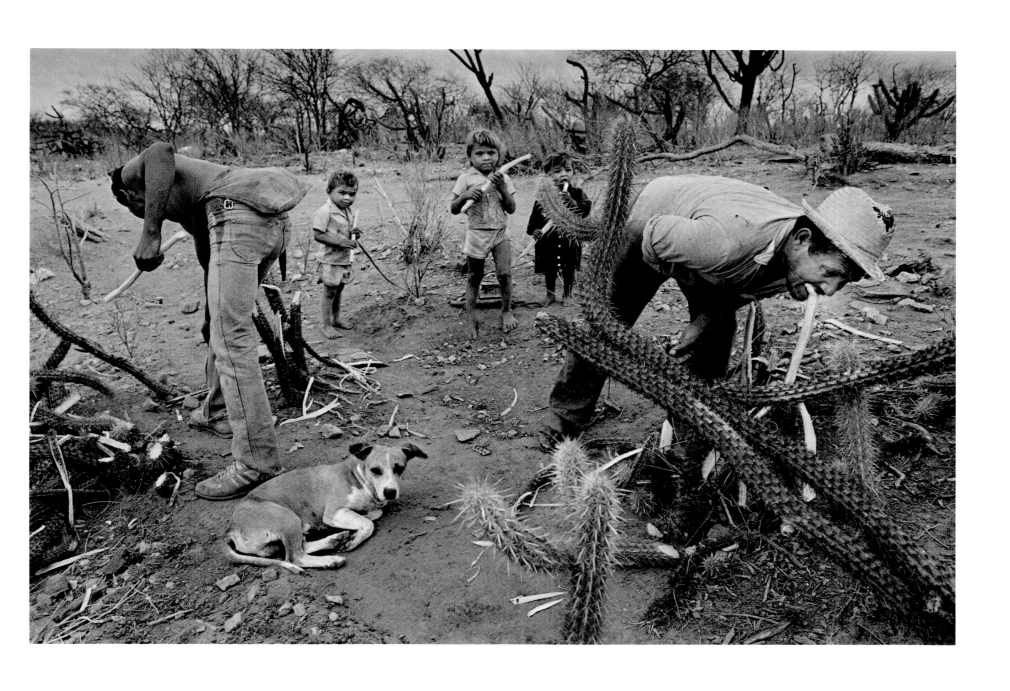

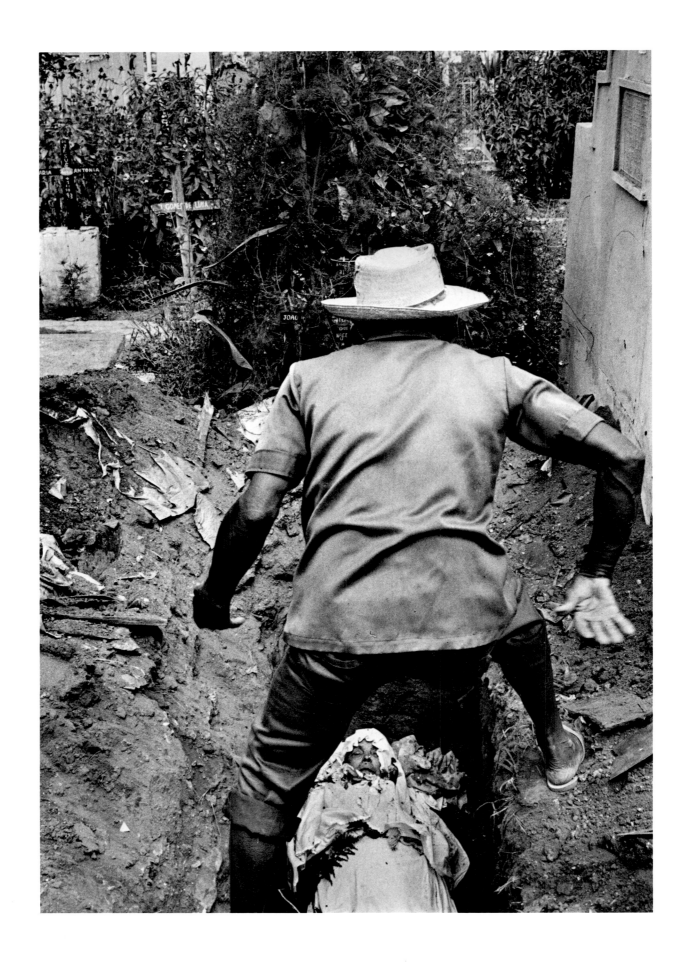

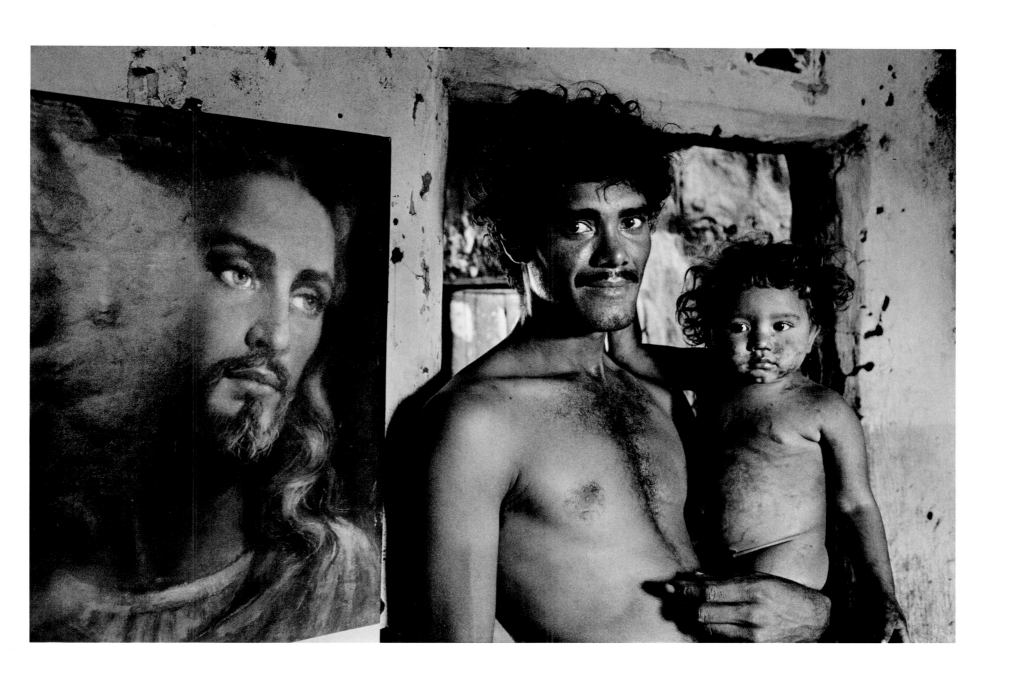

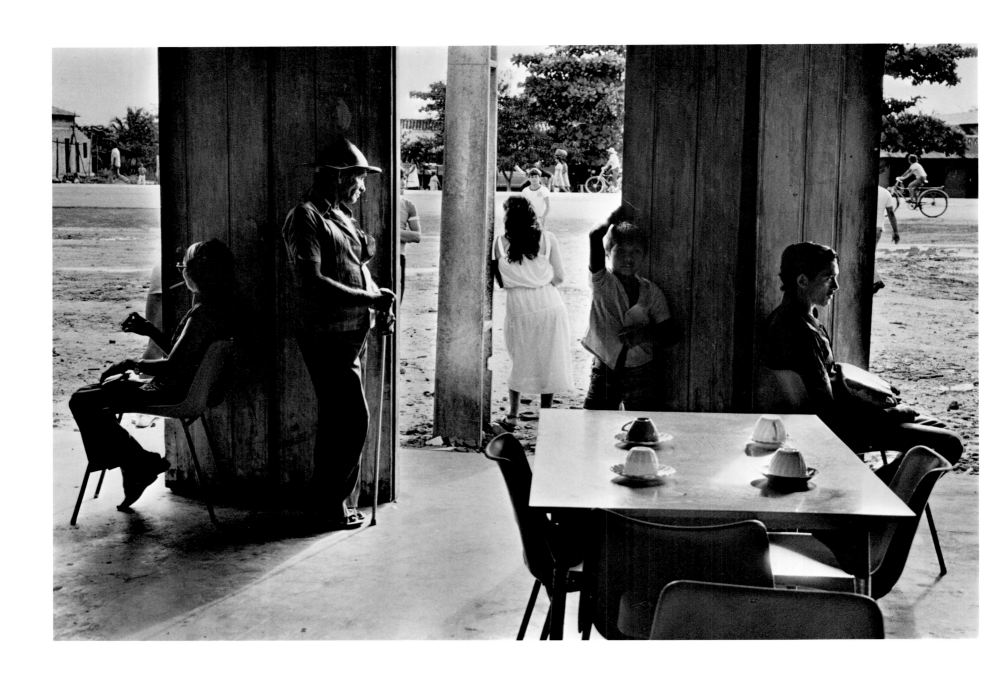

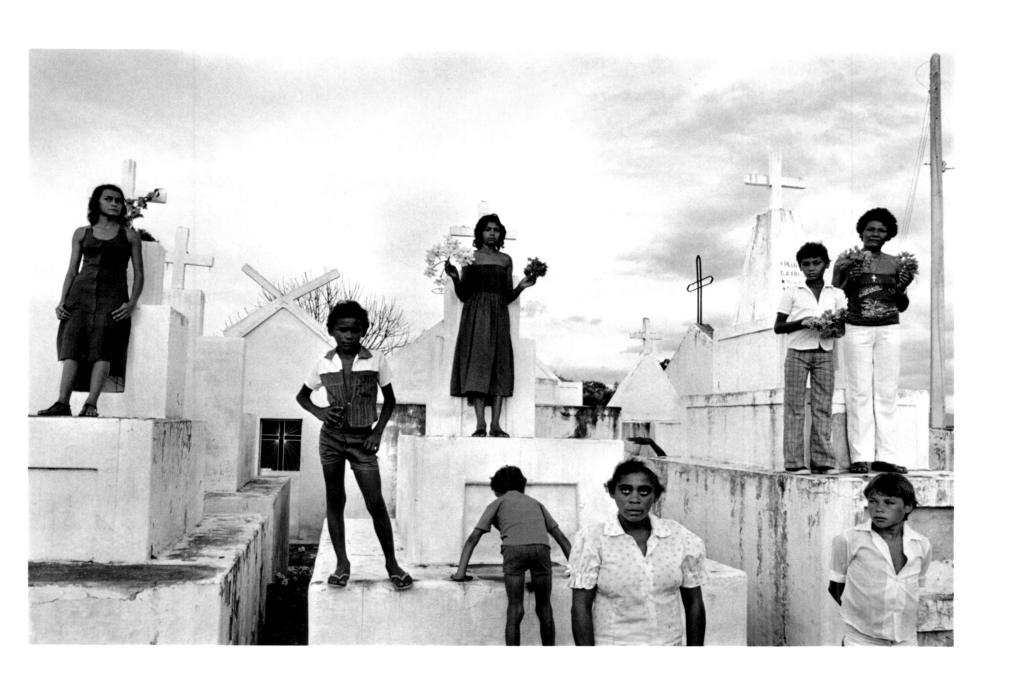

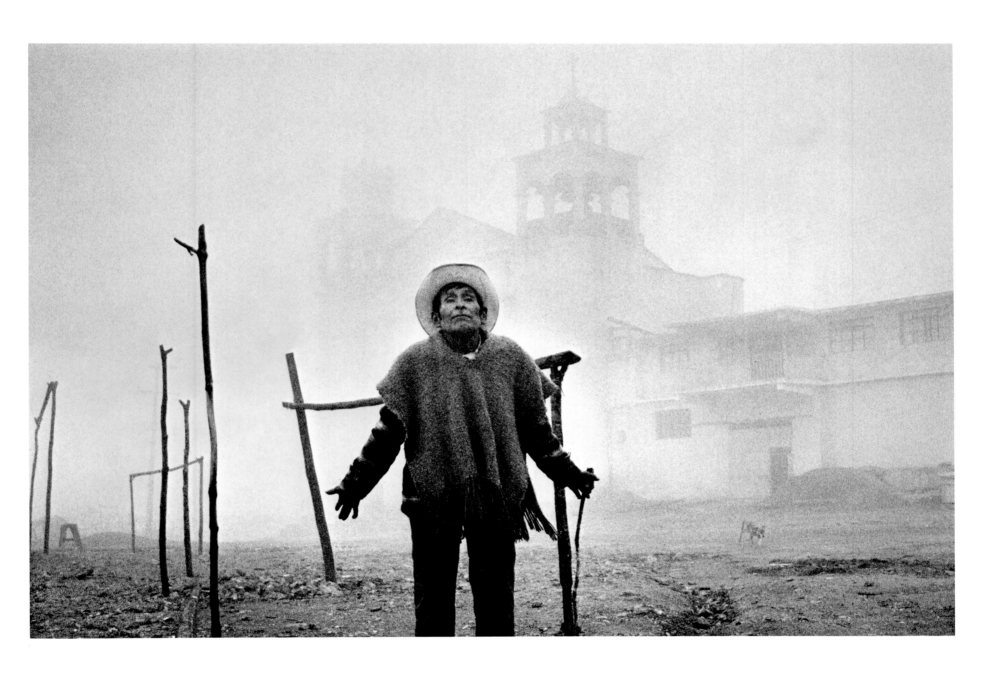

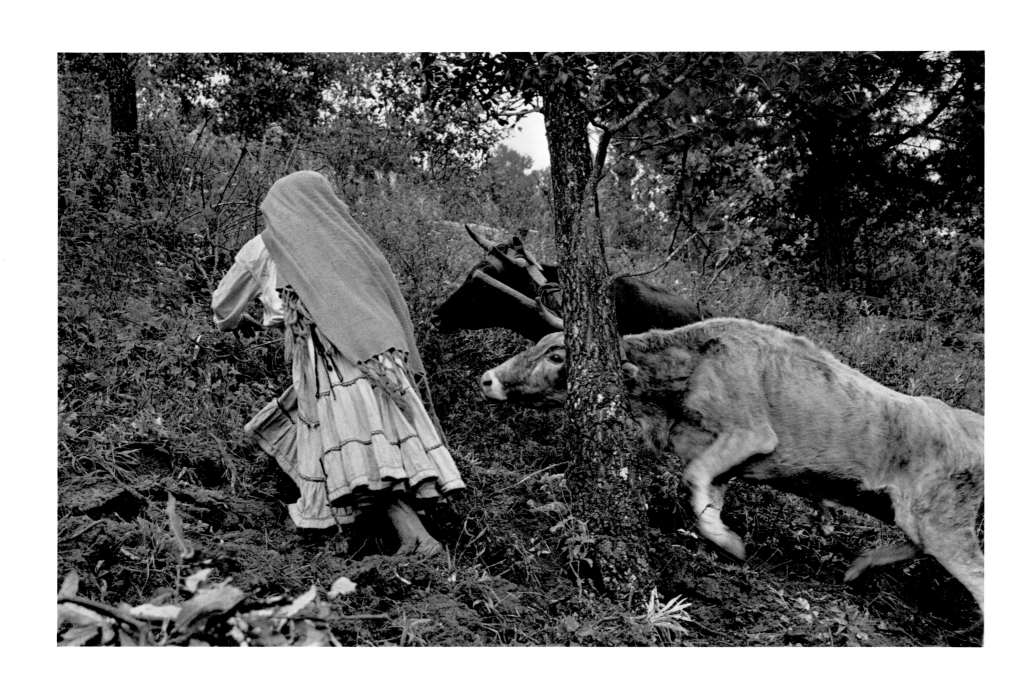

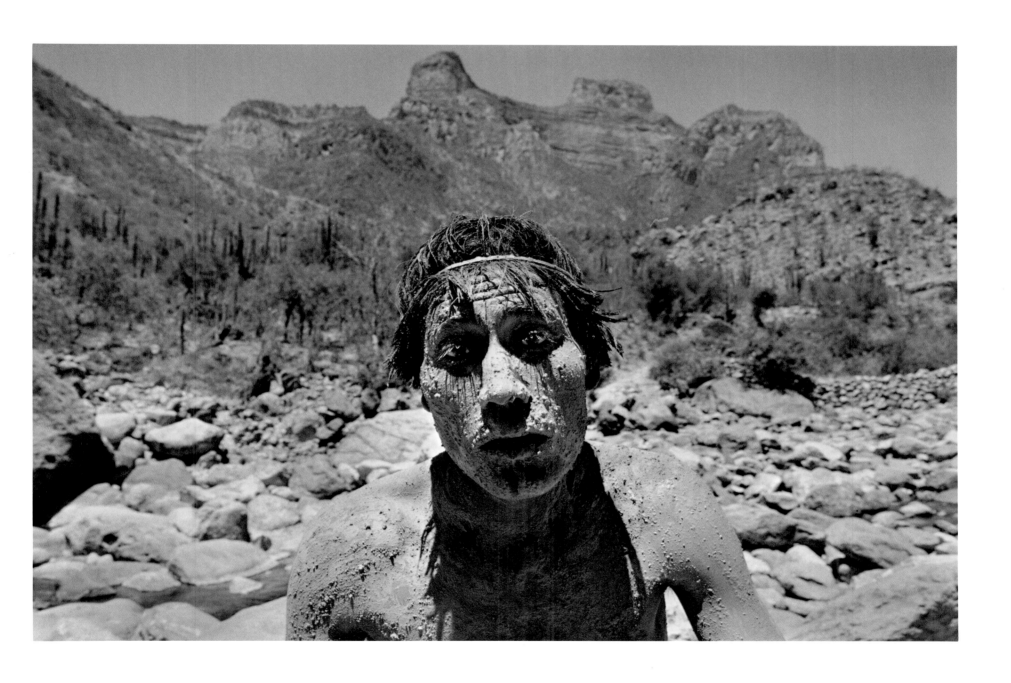

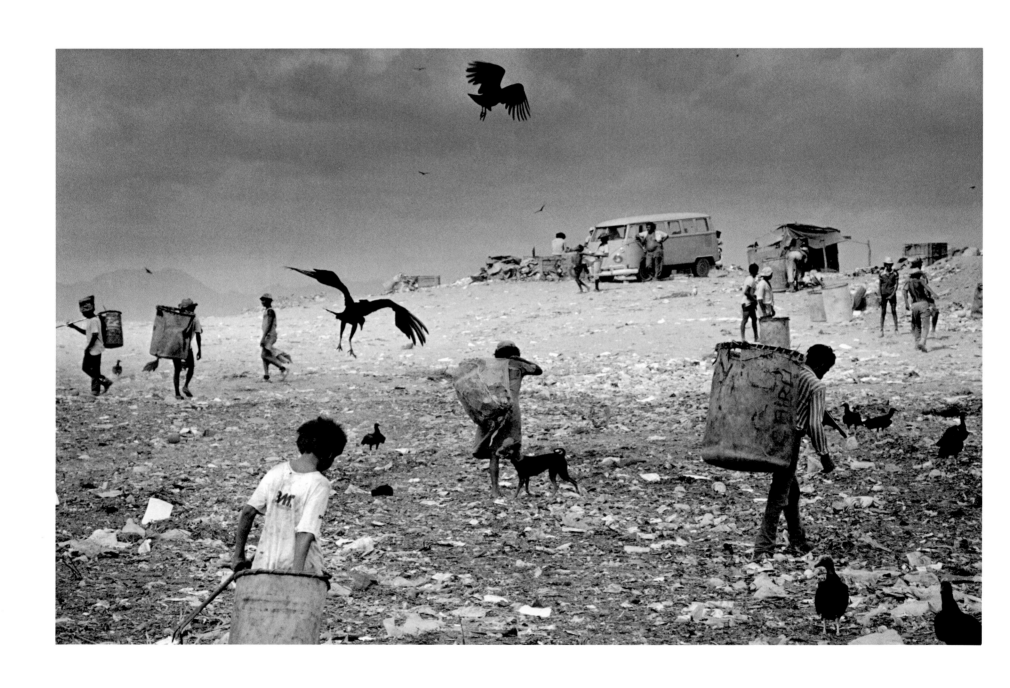

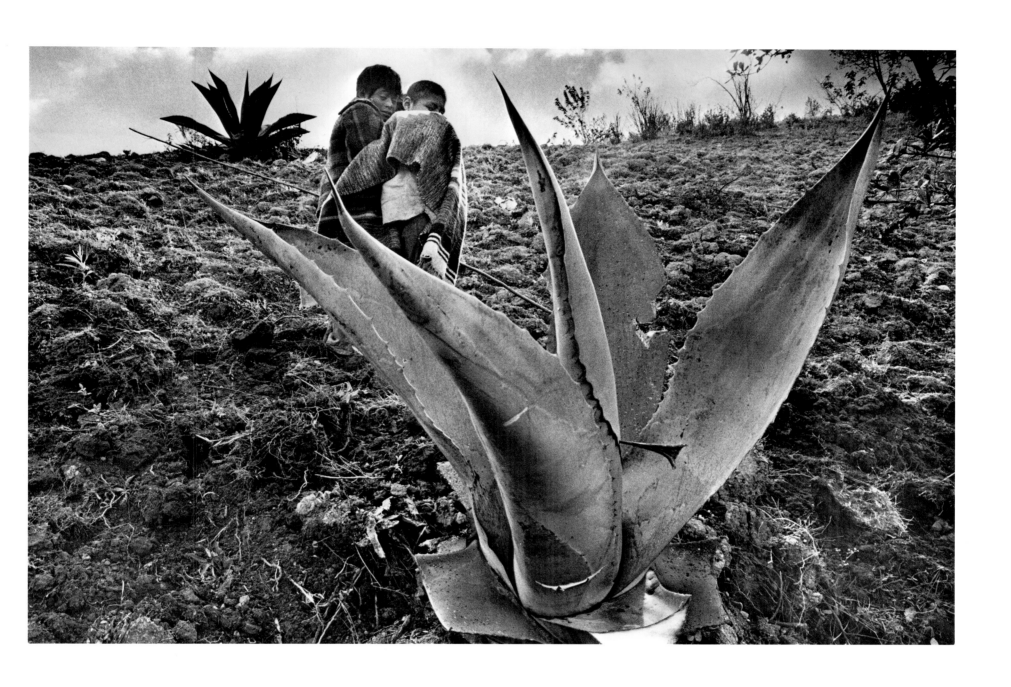

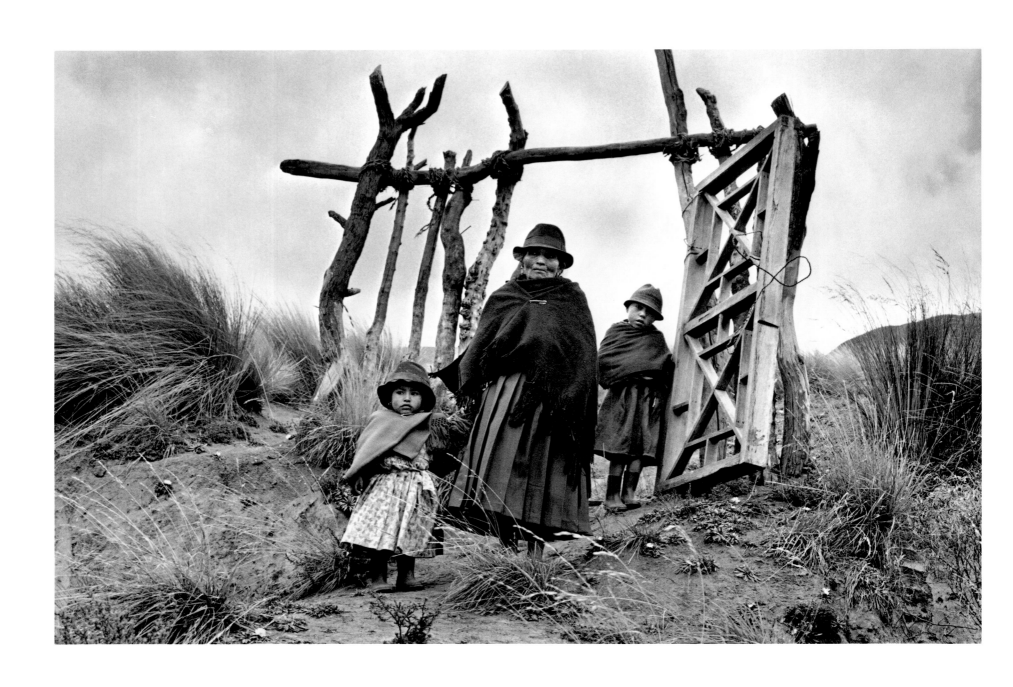

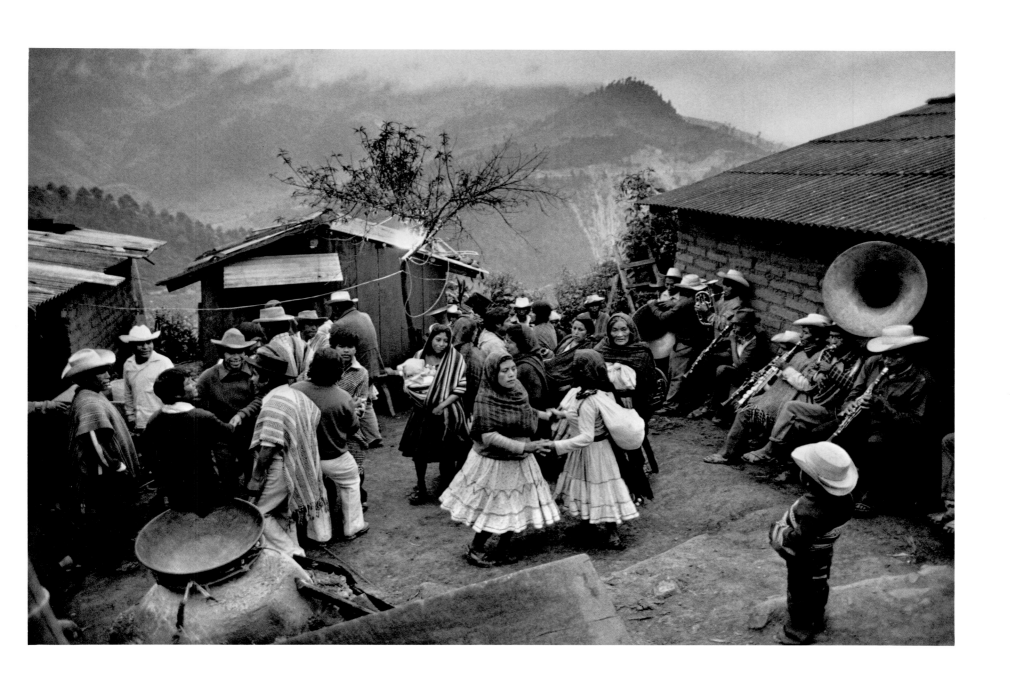

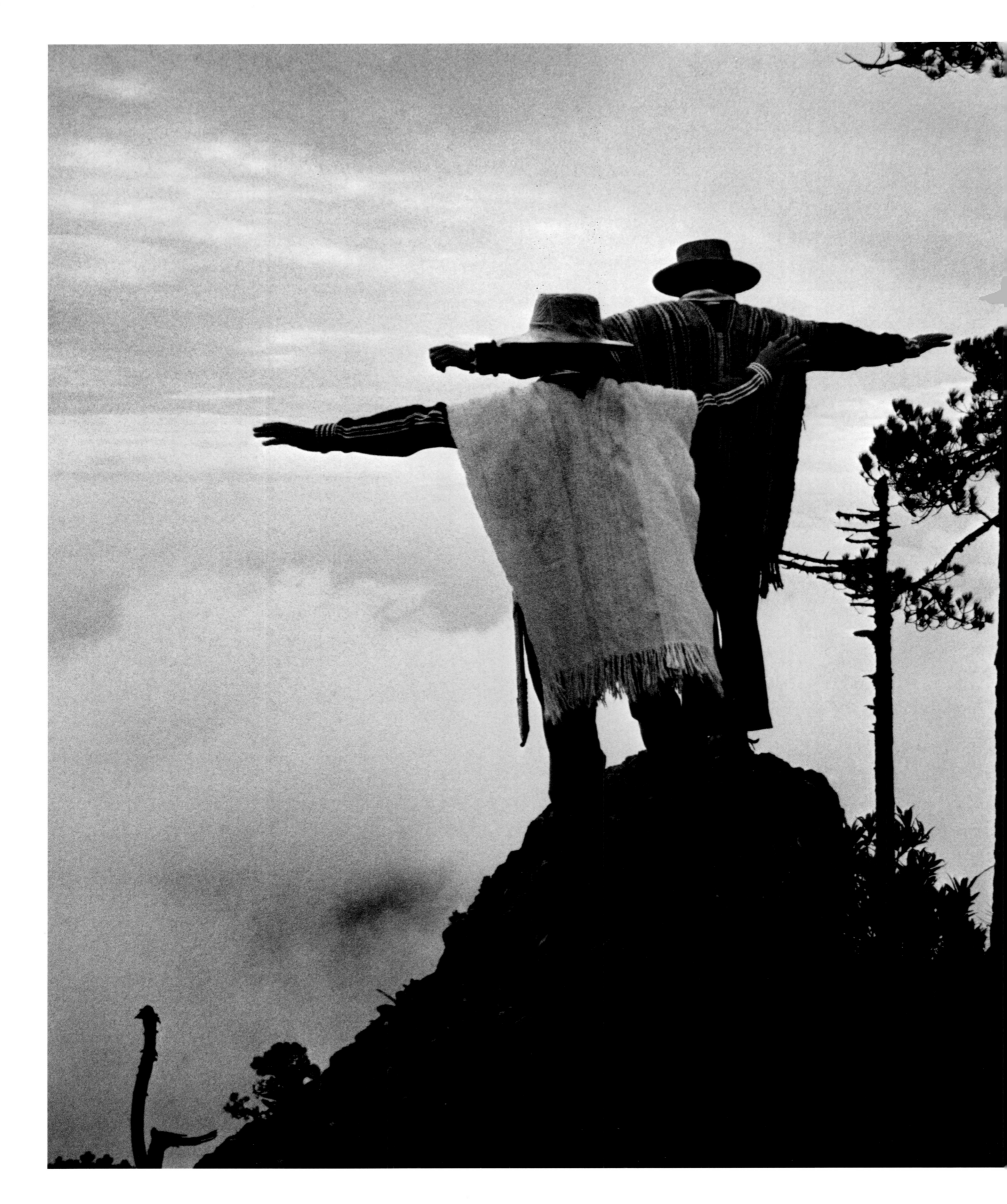

The Lyric Documentarian

Fred Ritchin

He recounts the story in front of the refrigerator in his spacious Paris apartment, with sound effects. *Rrraargh*. The noise starts deep in his throat and gets deeper, rumbling, scary. He compresses his shoulders. *Rrraargh-raa*. His hands come up on either side, describing the enormity of the menace that confronted his tired family on their recent vacation—it was a giant dog, almost a small horse, a monster really.

The Salgados were scared, or at the very least prudently cautious. They had just arrived in Brazilian farm country, at his sister's farm, far away from their own home in the City of Light, the city of restaurants with small well-behaved dogs licking ice cream from little bowls on their owners' laps. Now, behind the screen door, an uncertain welcome was being voiced by a veritable mastodon, one worthy, it seems, of another labor of Hercules.

But, Sebastião relates with evident pride and some wonderment, their youngest son, ten-year-old Rodrigo, was unfazed. Coming from the circumscribed world of the French schoolboy, used to traveling with a briefcase strapped to his back and an identity card prominently displayed in front, always accompanied by an adult, it was he who instinctively made the transition. "Me Digo," he said, pointing at his chest, introducing himself to the dog who was at least his size, opening the door, and patting the beast. The ice was broken. Later the boy and dog would become dining companions if not actual friends—Rodrigo brought his food and they ate together on the floor. But Sebastião was clear: if the dog began to growl, needing his space, his son was hardly naive—he left.

Rodrigo is a vibrant, happy, stubborn second child with a ready smile and rambunctious laugh who wears little red circular glasses atop his husky frame. He loves to listen to music and watch television, and he loves to eat, and he adores his brother Juliano who is six years older, quite gentle and a basketball fanatic. But he cannot speak very much, although he knows words in both Portuguese and French, and sometimes he becomes very frustrated. He was born with Down's syndrome, and it is certainly one of the factors that has determined not only the dynamics of his family but the course of his parents' careers.

Lélia Wanick Salgado, who met her future husband in Brazil when they were both teenagers studying French at the Alliance Française, originally trained as an architect. But with the demands of family life, she has surrendered some of her professional dreams, and other than designing their pleasant, loftlike apartment on a street of African and Arab immigrants, she has abandoned architecture. In recent years, after a stint as a photographic gallery director, Lélia has taken charge of organizing her husband's myriad exhibitions touring Europe and Latin America, designs most of his books, and sells his prints. And it is she who holds the family together while her husband travels, sometimes for months, pursuing that which is part muse and part obsession.

In a way Sebastião's quest is like his own description of his son Rodrigo's successful encounter. He is also constantly opening doors into others' realities, sensing emotional resonances, intuiting when it is okay to stay, to photograph, and when he would be intruding. And despite speaking several languages, much of the way he relates to others is also nonverbal.

I first worked with Sebastião in 1979 when I was picture editor of the *New York Times Magazine*. Needing somebody to photograph Ivo Pitanguy, a plastic surgeon in Brazil known for his work among the poor as well the jet-set rich, I had asked the director of the photographic agency Magnum Photos if one of their photographers happened to

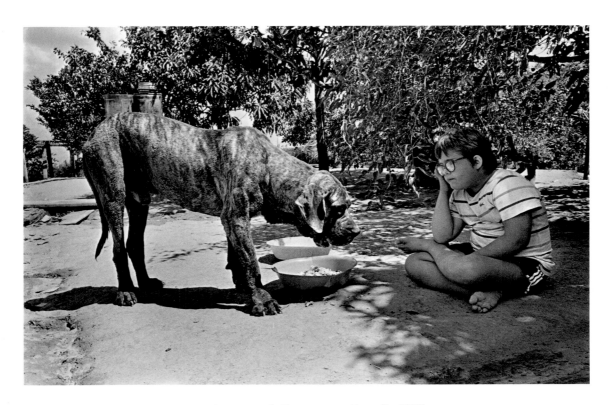

Rodrigo and Campeão, Brazil, 1989.

be in Brazil. Sebastião was there visiting his family, and Magnum sent over a portfolio, which I liked very much. We talked—Sebastião from the quiet of a solitary phone booth in Brazil's impoverished Northeast and I, on a perpetual deadline, at my paper-strewn desk in Manhattan's Times Square, telephones ringing around me. We discussed the assignment—who Pitanguy was and the essential elements of the modestly conceived feature story to be covered in a couple of days and displayed on only a few pages.

The color pictures came back, and I was happily surprised, not only by the vivid color and lively graphics of the images, photographed from a variety of angles with a great many close-ups, but because we had much more documentation than an editor or reader would expect to see—a range of activities that included Pitanguy practicing judo, flying in a small plane, scuba diving, as well as treating a poor, badly scarred burn victim and realigning the not-quite-perfect very rich. It was in fact the most broadly covered feature assignment that I had ever seen as a picture editor.

The handwritten captions from the multilingual photographer were more problematic—one word in Portuguese, the next in French, a word in Spanish—it was a puzzle to figure out. But once the code was cracked, they were informatively detailed if jumpy, and we were very pleased.

Since then I have told a number of people about that assignment, and my narrative was repeated to Sebastião. Recently he revealed to me the reason the story was so well covered: it was the first time he had ever received an assignment directly from an American magazine, and not understanding anything that I had said over the telephone (it seems that at that point he did not speak English), he photographed everything he could think of.

We would work together several times more, the most notable story being a three-day assignment to photograph Ronald Reagan on the occasion of his first hundred days as president. I wanted to work with a photographer who had not been subject to the mythmaking surrounding the 1980 presidential campaign, someone who could see the man and not the orchestrated image and express his or her insight quickly, White House access and magazine budgets being what they were. Sebastião, who hardly knew the United States, was just arriving from Australia, where he had been photographing the middle-of-the-night slaughter of kangaroos by hunters, who immoblize the animals with their headlights in order to shoot them more easily. He also had worked on the first "Day in the Life" photographic book project.

On the second day of the assignment, the world was rocked when Reagan and his press secretary, James Brady, were shot. Sebastião was one of the few photographers there. At the time of the attack almost nobody knew

that the president had been hit—they could see that Brady was lying there gravely wounded, but Reagan's injury was less evident. Even the president's personal photographer, Michael Evans, did not know at first that the man he saw being wheeled into surgery was his boss. Nor was Sebastião aware of exactly what had happened, although it turned out when the film was processed that he had instinctively photographed the wounded president. His images were published throughout the world, bringing him a certain prominence.

But this kind of work is not what Sebastião really cares about—the news event caught on the fly, the quick assignment, the single image—even though as a free-lancer he has always worked with publications and photographic agencies and continues to accept assignments. In 1977, just four years after having commenced his free-lance career as a photojournalist (he switched at the age of twenty-nine from his previous profession of economist), he had already begun the lengthy, self-initiated and generally self-financed voyages into far-flung villages of Latin America to explore and, in a sense, from his Paris perch, claim his roots. He would continue it for seven years, and the project culminated in his first book, *Autres Amériques (Other Americas* in the United States).

Even from among the various assignments we worked on together, the one he would talk most about was, in terms of headline news, the most minor—one about a

class of priests in New York City twenty-five years after their ordination. Sebastião was particularly affected by a parish priest whom he had photographed, Father Bob Fox, who ministered to poor churchgoers in New York's East Harlem. Father Fox, outside the normal duties of a parish priest, had also helped to rebuild gutted tenement buildings—for a while lived in one—and, among other strategies, got to know people by drinking beer with them on their front stoops. He also conducted Mass with congregants playing the guitar. In fact, according to the *New York Times* writer, he conducted "a ministry so unorthodox that by the time one classmate, Msgr. James Feeney, died, Father Fox no longer owned a black suit and had to borrow one of the dead man's for the funeral."

The encounter between photographer and priest was only a small one, but it was the one that stuck with Sebastião. It was as if he was happiest when he could find, amid the overwhelming maze of New York, a human being who was conscious both of daily pleasures and the concomitant pain, not only his own but those of others as well. There is in Sebastião's personality a delight in the emotional intimacy of such contact, in the recognition of a fellow spirit and of a shared vulnerability.

———————————

There have been many Father Foxes in Salgado's work. During 1984-85 he photographed those suffering from famine in the Sahel region of Africa while donating his ser-

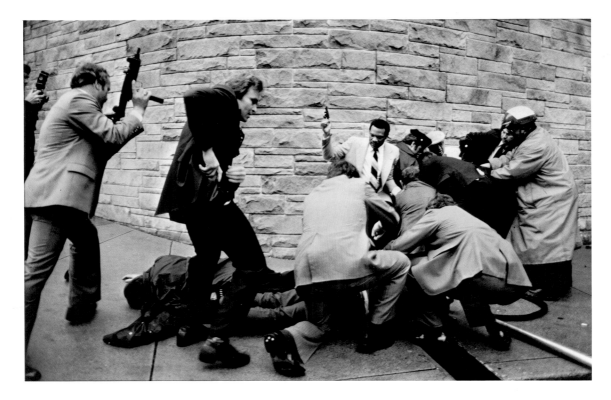

Aftermath of the attack on President Reagan, Washington, D.C., 1981. (Original in color.)

vices to the French relief group, Médecins sans Frontières (Doctors without Borders). Not only did he make extraordinarily dignified, graceful, empathetic images of those living and dying in the cataclysm of disaster in the course of several long visits over fifteen months, but he also recorded the activities of those who labored in the shadow of apocalypse—the young volunteer doctors, nurses, and civil engineers. Similarly, in his Latin American work he developed friendships with priests who would minister to the villagers, sometimes traveling with them, meeting, for example, an elderly priest who required bodyguards because some felt his healing properties would be contained in strands of his hair even after his death.

This affinity is not surprising, considering that Salgado began his professional life with a similar if more practical motivation, as an economist trying to aid development in the Third World. After completing his course work for a doctorate in Paris he worked with the International Coffee Organization, headquartered in London, which tried to help coordinate coffee production and distribution to maximize prices. But it was while on a work assignment in Africa that he decided, on the basis of initial attempts with a camera he borrowed from his wife, that rather than work at the remove of a social scientist he preferred spending more time with the people he was drawn to, photographing them. He found that he could depict them more vividly in photographs than in economic reports. His first report-

age, for the World Council of Churches in 1973, was on starvation in Africa, a tragedy that unfortunately would recur, and he would photograph again.

Being a photographer has allowed him extended contact with people throughout the world, and it is around this contact that he believes his work revolves. "The picture is not made by the photographer," he remarked in a somewhat rare public explanation of his approach, "the picture is more good or less good in function of the relationship that you have with the people you photograph." In the Sahel, for example, he preferred to take a bus rather than rent a car, because when one arrives by car "it's a disaster—you are a guy with a car," a rich guy, and not "with the people." Or, as he put it more broadly, "You need to be accepted by reality." This philosophy also jibes with his sense of personal economy—by traveling third class, rolling his own film, working sixteen-hour days making thousands of small proof prints himself, he was able to accomplish his various extended reportages in the Sahel— in Chad, Ethiopia (including the disputed Tigre province), Mali, and the Sudan—for the very minimal sum of $20,000, with printing being the major expense.

He prefers his way to that of some of the better-funded media personnel. He pointedly remarks, for example, on how during the three or four weeks he spent in one Ethiopian camp over forty television teams reporting on the

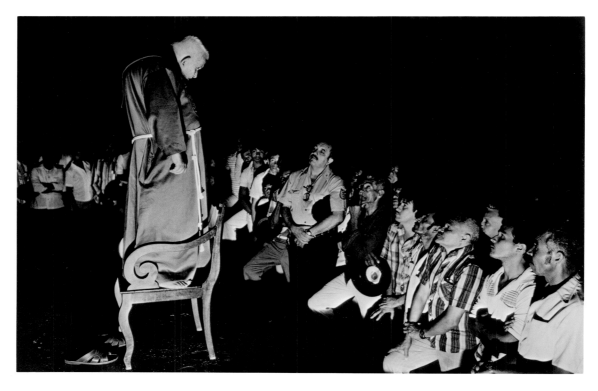

Brother Damião and his faithful, Brazil, 1981.

multitudes of starving and ill came and quickly went—one crew arrived from the United States, chartered a government bus, spent two hours and went back. By contrast, in the other less symbolically important countries in the Sahel he saw only one other journalist. In these cases he finds there is a kind of short-circuited reporting that leaves "no time to identify the reality you are photographing." Instead, one manages only to "bring back what you bring with you."

He compares his own photographic strategy with perhaps the most famous single philosophy of 35 mm photography ever espoused, that of Henri Cartier-Bresson's "decisive moment." In 1952 Cartier-Bresson, a founding member of Salgado's agency, Magnum Photos, expressed his much-quoted credo in the classic volume of his photographs, *The Decisive Moment:* "To me, photography is the simultaneous recognition, in a fraction of a second, of the significance of an event as well as of a precise organization of forms which give that event its proper expression."

Such an approach, Salgado feels, results in a relationship between photographer and subject that is comparable to a tangent perfectly balanced on top of a circle. It is elegant, dramatic, effective, but for himself he feels he must enter the circle, almost, in a sense, "becoming" those he photographs, at the very least working to understand the existence of those he depicts.

Despite the geometric metaphor, Sagado's approach is an intuitive, highly emotional one. While he speaks four languages (Portuguese, Spanish, French and, now, English) and profits from lengthy discussions with the people he meets, it is not an intellectual analysis of the other that he works from. It is from a personal warmth, and an extraordinary reverence for their essential dignity. His approach at least begins, in its respectful empathy, to approximate Martin Buber's sense of the relationship between I and Thou, where the other momentarily becomes one's whole world. His point of view is also motivated by the sentimental, populist embrace of a Marxist-influenced economist. "You photograph with all your ideology" is the way Salgado has put it.

His informed empathy and the outsized beauty of so many of his images serve to transcend the common journalistic shorthand that depicts people reductively, according to the degree of their latest victimization. This shorthand also tends to render its subjects anonymous, particularly in the Third World where it takes masses of ultimately interchangeable "victims" for the Western press to pay attention. In the process, people tend to be denuded of their larger, more complicated humanity, including their culture and the internal resources that allow for self-definition. Such a ploy serves to tug momentarily

at us in the affluent North until we succumb to "compassion fatigue" and go on to the next grouping of two-dimensional figures to be temporarily featured.

By spending more time with people, Salgado feels, he is able to see their suffering and their strength, which approaches at times a spiritual ascendancy. And the sheer grandeur of the imagery, its recognition of nature's vastness, with chiaroscuro lighting and tones that at times seem to swell upward from a profound darkness, making palpable the etched skin of those depicted, aids as well in allowing the people depicted to take a more resonant, enduring, differentiated position in our collective history. The photographer's documentary ambition may have originated in part from an initial nostalgia, but the images themselves maintain a vitalized presence.

Yet photographers are caught in a curious bind. Cartier-Bresson, who at various times derided the documentary impulse in favor of the visual drama, the pursuit of an unfolding choreography, was well aware of the reality/unreality that one is constantly coming up with, the inevitable intermix of fiction and nonfiction. "The pictures . . . that follow," he stated rather ironically in the beginning of his 1968 book, *The World of Henri Cartier-Bresson,* "are not intended to give a general idea of any country, but I am quite unable to assert that the subjects depicted are imaginary and that any resemblance to any individual is coincidental." Salgado's more consistently documentary approach also has its highly interpretive, imaginary aspects, which, despite the apparent matter-of-factness of photography, give the imagery much of its depth. One might say that, while respecting the facts of a situation, Salgado attempts to re-create, through visual metaphor, what he sees as its essential human drama—the invisible made visible.

Salgado's work, while confined to the moment by the mechanics of the camera, is drawn less to celebrating and taming an instant's arbitrariness, its material manifestations, but more to articulating its eternity, its ephemeral profundity, and to locating a mythic, entwining presence. This aspect of his approach is something he has in common with other Latin Americans drawn to what has been called a "magical realism." Similarly, while recognizing the individual's singular importance in his images, he is also quick to draw relationships to the universal. "We are all one people—we are probably all one man," he has asserted. There is, enmeshed in his document of the moment—on Latin American peasants, famine in Africa, or his current project on manual workers around the world— a resonating lyric, a sense of the epic, an iconic landscape. The former economist invokes a poetic sense of struggles so profound that, in large, moody prints, the forces of light

and darkness, of life and death, are summoned in scenes reminiscent at times of the most dramatic Judeo-Christian symbolism.

There are poetic liberties taken. He does not explore, for example, in the Latin American work the vast problems that coexist in an extraordinarily poor people, such as disease, crime, alcoholism. Or, for example, he views the manual laborer as "a kind of hero of production." It is a romantic view that he espouses, one that is loyal to the dignity of the person depicted while circumventing some of the complexities of his or her existence. But when one juxtaposes the images with their various contexts, the lyricism can become particularly searing—the fact, for example, that in the Third World 40,000 children die *daily* of diseases we in the industrialized world have learned to cure long ago, like measles and diarrhea.

There are many other contemporary photographers who have stepped outside of the day-to-day pressures of photojournalism, with its compilation of fragmentary evidence of fast-moving events, to make broader, more authorial statements as to what is happening in the world. A short list from among Salgado's Magnum colleagues alone would include Raymond Depardon, who, besides covering war and celebrities, has published a variety of small books on his experiences in, among other places, Afghanistan and Beirut *(Notes)* and New York *(Correspondance newyorkaise);* Philip Jones Griffiths, whose sardonic book deals with the Vietnam War *(Vietnam Inc.);* Susan Meiselas, who carried out lengthy coverage of the Sandinista Revolution *(Nicaragua);* and Gilles Peress, whose kaleidoscopic rumination on Iran depicts its fundamentalist revolution *(Telex: Iran).*

A key predecessor was W. Eugene Smith, *Life* magazine's master photo-essayist, whose work was published primarily in the 1940s and 1950s. Revered by photographers and readers alike for his intense, empathetic approach to his subjects, Smith came up with powerful depictions of healers—a country doctor, a nurse-midwife, Albert Schweitzer—as well as a romantic look at a Spanish village and the ultimate industrial city, Pittsburgh. He also documented, working with his wife, Aileen, the disastrous effects on the Japanese inhabitants of Minamata of eating mercury-poisoned fish. This last essay, which did a great deal to raise global consciousness of the poisoning of the earth, was published in *Life* (1972). But dissatisfied with the constraints imposed by the magazine format, Smith went on to further articulate his vision in both image and text in a book he co-authored with Aileen *(Minamata,* 1975) that is regarded as a classic in the documentary form.

Salgado, who won the 1982 W. Eugene Smith Grant in Humanistic Photography, his first major award, has long admired Smith, and like him is effective in both magazine and book formats. But whereas Smith could create outsized, transcendent heroes from among the unsung in his narrative essays, Salgado in his work depicts individuals who are resilient but inevitably bound by larger forces—the unequal distribution of wealth, famine, the advance of technology. Smith's vision ("Let Truth Be the Prejudice" was the title of his retrospective exhibition) was a triumphant humanism against the forces of evil. It partly reflects the optimistic perspective of the United States, the superpower Smith lived in, which, at enormous cost, had just helped to vanquish fascism. Salgado's more cautious response, coming from the Third World, is an embrace of the good in people who shall not necessarily inherit.

In part, Salgado's documentaries are motivated by his own spiritual search and reclamation of self. Living in the North, his Brazilian passport revoked by the dictatorship he opposed (he had to file suit to eventually get it back), returning to Latin America for his first major documentary project in 1977 was for him a response to a dilemma of personal identity and one of spiritual unease. Similarly, two earlier and more proximate investigations, into the lives of immigrants in France and into the democratization of nearby Portugal, were subjects of considerable personal import on which he cut his teeth as a photographer.

In Latin America, "Every mountain was an adventure." He walked three days to get to one village, in another was only the second outsider ever there, and in a third was considered a god. He heard the legend about how a giant serpent attacked the village and, driven back, dove into the earth, forming not only a river but, with its return to earth, a volcano as well. In one locale he unintentionally changed the way the people there thought about their nearby river. When he explained that it eventually flowed into the Amazon and then into the Atlantic Ocean, they began to feel sorry for it and the long way it had to go.

This work's title, *Other Americas,* is meant to indicate the double otherness of the Latin American peasant—first, the United States of America having appropriated "America" for itself, and peasants being the other even in their own countries, where they live far outside the circles of power. The book, reflecting its meditative stance, is laid out with almost every photograph across two pages, captioned only with the name of the country and the year it was taken. It is an attempt not to deal with the abject despair of those swarming into cities and the degradation of the proliferating slums, but the strength of those who stayed within the parameters into which they were born, finding a certain stolid acceptance of fate, of death. The people in his pictures inhabit a powerful quietude that greatly differs from the noisy materialism of the North—the photographer turns the tables, able to show those in

Europe and the United States, his primary audience, how the everyday spiritual wealth of the South may outweigh their material riches.

His photographs from the Sahel, published as a book in France as *L'Homme en Détresse (Man in Distress)* and in Spain as *El Fin del Camino (The End of the Road)* (with profits going to Médecins sans Frontières), evince again a respectful familiarity, an articulated dignity. Fathers march for days with dying children draped across their arms, the avalanche of corpses are anointed individually with a traditional oil, children are weighed, suspended as if in the agony of the cross, a woman in Tigre flees, a pot on her head the only protection against patrolling MIGs. There is an exalted beauty to the people—an emaciated boy using a cane stands nude before a withered tree on a carpet of sand, a woman with diseased eyes radiates a visionary sadness. A bruising conflict is created between the formal radiance of the imagery and their agonizing content as a proud, attractive people suffers so.

There are lengthy captions in the books that serve a journalistic function. For Salgado, it was necessary to respond with as much information as possible to a cataclysm that continues even as the world has tired and averted its eyes—5 million people in Ethiopia and Sudan continue to be threatened with famine as politics and civil wars prevent food supplies from getting through. Salgado is hardly sanguine about the world's response, as various countries support one side or another, selling arms, increasing the misery, while much of the humanitarian aid is siphoned off by local officials.

Salgado is also aghast at the shortsightedness and waste of international relief efforts. Of $20 million in aid given by the United States government, for example, he estimates that some $12 million is given to U.S. farmers for grain, $4 million to pay for U.S. aircraft to take it over, using U.S. helicopters and U.S. pilots who drop their supplies without making contact with the people on the ground—the obverse of bomber pilots in Vietnam who never met their victims. They bring food that will be gone as soon as it passes through the digestive tract. He sees much of this aid as being for the United States economy, or the economies of the other non-African countries that similarly have contributed, and much prefers programs that encourage self-sufficiency by the local people who plant their own food, making the $20 million a renewable and not a one-time resource.

Interestingly, in the United States not very much of his work from the Sahel was published at the time it was made. Other than a striking portfolio of two pages in the *New York Times* and four pages in *Newsweek,* the photographs remained largely unknown. While a book was published in France and another eventually in Spain, nothing

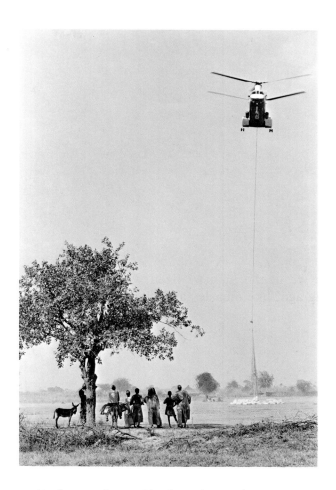

Refugees from Chad in the Sudan, 1985.

was published or shown in galleries here at least in part out of a fear that the public would shy away from such tragic photographs. One literary agent, after looking at a stack of the images with tears in his eyes, remarked that there was no market for it. Paradoxically, it is only with distance from the events of 1984–85 and the photographer's increasing fame that the work becomes more widely available—an unfortunate tendency to elevate the messenger while denying the message.

Salgado's latest project, on the end of large-scale manual labor, what he calls "The Archaeology of Industrialism," is a paean to the end of an era before robots, electronics, and computers take over production. It is about muscle and cooperation and pride in work, and the elemental confrontation between worker and the raw materials of the earth—lumber, sugar cane, limestone, metal, chemicals. It is also, to Salgado visually, about the large, physical human being whose status is being eroded and replaced by the smaller being pressing buttons behind glass partitions.

Salgado speaks of the Soviet car that may go only twenty kilometers before breaking down now being re-

placed by a uniformly made car like cars from other countries—it works better but loses its unique character. He speaks as well of the big-bellied workers for whom the factory has always been the focus of their lives, hanging out after work together in the sauna and drinking tea from a large samovar, who face replacement by robots. The most epic story in this series, in the Serra Pelada mines in his native Brazil, depicts thousands of semi-nude gold miners who swarm up and down great mounds of dirt on dangerous ladders. They scratch for riches with a primordial intensity as if they had emerged from the very earth itself, and on a scale that is more reminiscent of the era of the building of the Egyptian pyramids than of the modern day. Among them are armed guards who know that if they enforce their authority and shoot anyone they will be surrounded and killed for doing so, but they shoot anyway.

With typical discipline and industriousness, Salgado has decided to devote six years to this project, hoping to work in forty or fifty different locations throughout the world. He has contracts from magazines in several countries to publish the work as he does it. Locked into the necessity of nonstop production, Salgado produced early imagery that seemed at first more a record of a moment in history than a depiction of an implicated human spirit. Recently, as the imagery has become more ethereal and sympathetic, Salgado has become happier. His final publication on this subject is again to be a book. Wryly he notes that he is fulfilling the Marxist dream—the workers of the world, at least on paper, will finally be able to unite before, in their present form, they disappear.

In a sense this project, as much as *Other Americas,* is motivated by a loyalty to his roots, when his universe was much more physical and people's natures were less submerged by the technical sophistication of their environment. As a child he was raised first on a large cattle farm where he was born in 1944 and then nearby in Aimorés, a small town of 10,000 (there are still 10,000 people there) in the land-locked state of Minas Gerais, the only boy in a family of eight children. His father had decided to relocate into Brazil's remote interior in 1930, after having his own political problems with the government. The region had its share of violence—the town's mayor was assassinated when Salgado was a child, and a relative of his was killed in an atmosphere that he compares to the Wild West in the United States. On school vacations he would ride on horseback for a week to deliver his father's cattle to

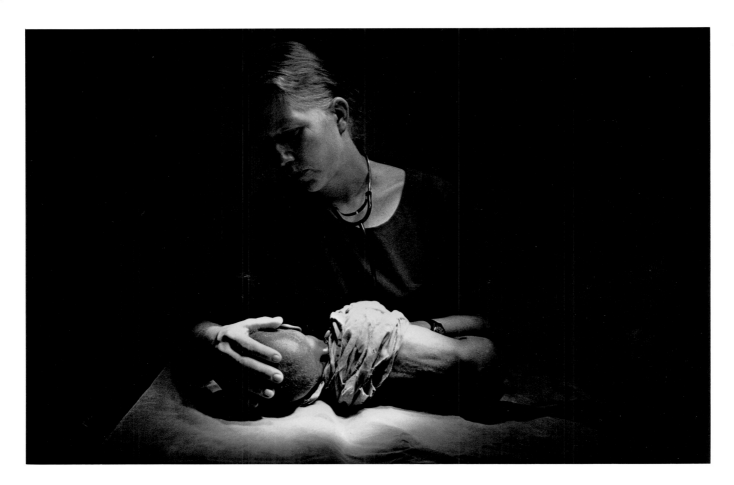

A nurse in Chad, 1985.

the slaughterhouse, going slowly so the cattle would not be too thin when they got there.

At first there was no electricity in the town—he still remembers with affection the taste of his first cold orange. He would leave home before the telephone or television came in, although there was one cinema that played domestic comedies and musicals. His first glimpse of television, at the age of sixteen, came by happenstance when Salgado and a friend went to far-away Rio de Janeiro to take a qualifying exam for a pilot's license—he grew up wanting to be a pilot or a soccer player. They took the first two tests, but were so overwhelmed and homesick that they left before the final, but not before watching television through the window of a neighbor's apartment.

But the event he treasures most from the memories of his youth is the arrival of the traveling circuses, with their hints of the exotic—lions and tigers, clowns and, in particular, the Globe of Death, which was a twenty-five-foot-high sphere within which two motorcyclists chased each other around and around at top speed. Salgado thinks of it still as being the most dangerous and romantic thing he has ever seen.

This loyalty to the feelings of his youth has served him well. He can live in Paris, a major center of photojournalism, and return to people and scenes that are closer to his childhood than the modern city around him. He knows both the North and the South, and his work serves as a bridge between the economically more developed and less developed. It is sentimental, nostalgic, heroic, lyrical, and charged with attempting to redress, somehow, a grotesque imbalance. The images can be and undoubtedly are taken by some as remote tableaux, disconnected from the viewer's own existence. But that is not the way they are intended. They are meant to affirm values linked to what we are leaving behind and to those we have shunted aside. They are not true to every complexity, but attempt to affirm, from the strength of the photographer's ego and virtuosity, a moral sense, verging at times even upon religious epiphany.

The Brazilian youth, from his privileged perspective, has not forgotten those less well off. And he expects others will remember as well. There is nothing wrong with the way you live, he told a crowd of well-dressed New Yorkers at a banquet while accepting one of his numerous awards, as long as all the people of the world have the possibility of living in similar material conditions.

While he is propelled by moral conviction, he is driven to constantly travel vast distances by other feelings as well. For him, as for so many, it is the wonderment of his youth that also survives, motivating him to explore, to experience new permutations of human existence, the Globe of Death still glowing unextinguished in his imagination. Recently, while viewing videotape of himself made for a television documentary, he discovered that he sings while he photographs. It reminded me of a scene from the Brazilian film *The Opera of Malandro*. A young man is playing pool with an older, wiser man and loses, with only a cigarette lighter to pay off his gambling debt. The older man, in trying to determine the lighter's value, clicks it to see what kind of sound it makes. "Does it samba?" he asks. Not what is it made of, nor if it works, but does this lighter have a soul?

Somehow, in a quieter, more austere mood, that is what Salgado's pictures also ask. And they answer, reverentially, Yes. These people are more than the limitations of their poverty, their forgotten labors, their suffering. One only has to look and listen to the music of their existence. And then one might be able to ask the question in reverse—what about us? Do we, in our relative affluence, do we samba, too?

New York City
March 1990

Captions

"Salgado, 17 Times"

2. Children's ward in the Korem refugee camp. Ethiopia, 1984.

6. Wood delivery men for the villages of the Eastern Sierra Madre in the vicinity of Hualtla de Jiménez. Mexico, 1980.

9. Cemetery of the town of Hualtla de Jiménez. Mexico, 1980.

10. Dispute among the workers of the Serra Pelada gold mine and a member of the military police from the state of Pará. Brazil, 1986.

13. Transporting bags of dirt in the Serra Pelada gold mine. Each worker makes up to sixty trips daily from the bottom of the mine to the sediment dump on top. Brazil, 1986.

I. *The End of Manual Labor, 1986–*

17. Partial view of the climbing of ladders and other activities in the gold mine of Serra Pelada. Brazil, 1986.

18. The Serra Pelada gold mine. Brazil, 1986.

19. The men are covered with shiny mud. The soil in this mine is rich in iron. Brazil, 1986.

20. A member of the military police from the state of Pará is disarmed and roughed up by workers on a Sunday afternoon (their day off). Brazil, 1986.

21. Going up the Serra Pelada mine. Brazil, 1986.

22. A moment of rest for this worker. In the back, one can see the activities on several concessions that make up the Serra Pelada mine. Brazil, 1986.

24. Overall view of the Serra Pelada gold mine, where more than 50,000 workers were employed. Brazil, 1986.

27. The cutting of sugarcane for alcohol distilleries. The alcohol is used to power cars. Brazil, 1987.

28. The end of the day for the sugarcane cutters. Cuba, 1988.

29. Worker in a metallurgical plant. He repairs pipes that are used to recover gas. France, 1987.

30. Ship breakers. Bangladesh, 1989.

32. Transport of a heavy piece at the ship breakers' work site. Bangladesh, 1989.

33. Shower room for the pigs before they are electrocuted in a slaughterhouse. United States of America, 1988.

34. The cleaning and preparation of offal in a slaughterhouse. United States of America, 1988.

35. Preparation of high-quality tobacco leaves for making cigars. Cuba, 1988.

36. A coal mine where high-quality coal is extracted for use in industry. India, 1989.

37. Workers on the roof of a coal-burning plant. France, 1988.

38. Sugarcane cutters. Cuba, 1988.

40. The *boias frias* (those who eat cold) in a plantation of sugarcane that is to be used for the production of alcohol. The alcohol, in turn, is used to power cars. Brazil, 1987.

41. A sauna for metallurgical workers in the Ukraine. As the number of men and women is about the same, the sauna is open on alternating days for members of each gender. Soviet Union, 1987.

42. A worker in an iron plant. Soviet Union, 1987.

II. *Diverse Images 1974–87*

45. Children in a school that is entirely supported by the Christian Children's Fund, USA, an organization that aids in the education of more than 8 million children worldwide. Thailand, 1987.

46. In an Addis Ababa hospital during the famine of 1973–74. Ethiopia, 1974.

47. A Laotian refugee camp. Medical help was provided by Médecins sans Frontières of France. Thailand, 1982.

48. A school for young girls in the north of Kenya, which is completely supported by the Christian Children's Fund, USA. Kenya, 1986.

49. During Angola's second war of liberation. Angola, 1975.

50. The war in the Spanish Sahara, at the Darlha front. Spanish Sahara, 1976.

52. A center for the rehabilitation of opium users located in a Laotian refugee camp administered by French members of the Médecins sans Frontières. Thailand, 1982.

53. Religious procession. Portugal, 1975.

54. Religious procession. Portugal, 1975.

55. Religious procession. Portugal, 1975.

56. The House of the People in Altamura, southern Italy. These men, who had previously emigrated to France, Switzerland, or Germany, wait all day to find an odd job. Italy, 1979.

III. *Famine in the Sahel, 1984–85*

59. Protected by their covers against the cold morning wind, refugees wait in the Korem camp. Ethiopia, 1984.

60. During the burial of a little girl in the Korem refugee camp. Ethiopia, 1984.

61. The El Fau cemetery is the end of exile for the refugees from Tigre who have left Ethiopia. Sudan, 1985.

62. The Bati refugee camp. Ethiopia, 1984.

63. In the town of Lere, in the region of the Niger River in the center of Mali. The majority of the towns in this region have become human warehouses where various groups fleeing the drought are piled up. Mali, 1985.

64. In the early morning, after a night of walking, refugees hide themselves under the trees to avoid the surveillance of Ethiopian airplanes. The government would like to avoid having the population of Tigre pass to the Sudan. Ethiopia, 1985.

66. Here one used to be able to find Lake Faguibine, the largest in western Africa; now the desert has installed itself. Only a few humans can be found here, fleshless, looking like the vegetation. Mali, 1985.

67. The last people leave the Teculabab camp, deserted because of a lack of water. They leave in the direction of El Fau, 400 kilometers away, where the water is more abundant. Sudan, 1985.

69. Carrying all their possessions on them, women scout for the airplanes that try to make their escape to Sudan more difficult. Tigre, Ethiopia, 1985.

70. The refugee camp of Wad Sherifay. Sudan, 1985.

71. The refugee camp of Wad Kauly. Sudan, 1985.

72. The refugee camp of Korem. Ethiopia, 1984.

73. The bodies are washed and prepared for burial, according to traditional Coptic rites. Ethiopia, 1984.

75. Refugees arriving from Eritrea to the Wad Sherifay camp. Sudan, 1985.

76. People abandoning their villages in the region of Tombouctou. Mali, 1985.

77. A cemetery for refugees on the outskirts of Gao. Lacking wood for crosses or markers, they indicate the graves with scrap iron from a junkyard. Mali, 1985.

78. Able-bodied men have left for town looking for work and food. They leave behind them their families and the "drought widows." Here people are walking on what used to be Lake Faguibine. Mali, 1985.

81. A body being prepared for burial according to traditional Coptic rites in the Korem camp. Ethiopia, 1984.

82. The dispensary of Alamata, run by the organization World Vision International. Ethiopia, 1984.

83. The children must be weighed and measured in order to adjust their rations. In a nutritional center, Mali, 1985.

84. Nutritional center for children in Douentza. Breast-feeding mothers are also assisted. Mali, 1985.

85. The hospital of Gourma-Rharous. Mali, 1985.

86. The dispensary in the town of Ade. Chad, 1985.

89. With dead eyes worn out by sand storms and chronic infections, this woman from the region of Gondan has arrived at the end of her voyage. Mali, 1985.

90. The refugee camp of Teculabab. Sudan, 1985.

91. The refugee camp of Bati. Ethiopia, 1984.

92. The refugee camp of Bati. The people in the area have scouted out the arrival of food and first aid. They travel in great numbers, at times from very far away, in order to get rations that often end up being quite meager. Ethiopia, 1984.

93. The refugee camp of Korem. Ethiopia, 1984.

94. The periphery of the town of Tokar near the Red Sea. This region used to be prosperous, perhaps the most prosperous in Sudan, because of its production of cotton. The desert has taken over, and the people have left. Sudan, 1985.

IV. *Latin America, 1977–84*

97. San Juan, Chimborazo. Ecuador, 1979.

98. The religious sacrifice of a goat in Tarahumara. Mexico, 1984.

99. During Carnival in Oruro. Bolivia, 1977.

100. A meeting of a religious community in Base, on the road to Attilo, Chimborazo. Ecuador, 1982.

102. A meeting of the Peruvian Peasants Union in the Cuzco area. Peru, 1977.

103. Tarahumara. Mexico, 1984.

104. A holiday celebrating ''El Condor.'' Ecuador, 1982.

105. The village where ''La Culebra'' (the grass snake) was born, Atillo, Chimborazo. Ecuador, 1982.

107. ''Vale do Amanhecer'' (Valley of the Dawn). Brazil, 1980.

108. Easter in Tarahumara. Mexico, 1984.

109. A wedding at the ''Razo de Catarina,'' Sertao de Bahia. Brazil, 1981.

110. First communion in Juazeiro do Norte. Brazil, 1981.

112. Day of the Dead in San Vicente Nautec. Ecuador, 1982.

113. Atillo, Chimborazo. Ecuador, 1982.

115. Workers leaving the pewter mine ''XXth Century,'' Oruro. Bolivia, 1977.

116. A mineral train leaving the pewter mine ''XXth Century,'' Oruro. Bolivia, 1977.

117. A Mixe musician, Oaxaca. Mexico, 1980.

118. The outskirts of Guatemala City. Guatemala, 1978.

120. Market day in Guasteca. Mexico, 1980.

121. San Lucas de los Saraguros. Ecuador, 1982.

122. In the interior of Brazil's Northeast, children are buried with their eyes open so that they can more easily find the way to the heavens. Crateús, Brazil, 1983.

123. Children's games in Brazil's Northeast during the great drought at the beginning of the 1980s. Brazil, 1983.

125. In the very high areas of Ecuador, people sometimes wear sheepskins to protect themselves from the cold and the humidity. Atillo, Ecuador, 1982.

126. Sertao da Paraiba. Brazil, 1981.

127. Cactus can be excellent as a nutritional supplement, as it was in Sertao do Ceara during the great drought at the beginning of the 1980s. Brazil, 1983.

128. In Juazeiro do Norte there is a service that rents coffins to be used for wakes and to carry the dead to the cemetery. At the moment of burial the body is taken out of the coffin so that the coffin can be used several times. Brazil, 1980.

129.

130. Bus stop, Maranhão. Brazil, 1980.

131. During the burial ceremony of a child in Sertao da Paraiba. Brazil, 1980.

133. Mixe Indian, Oaxaca. Mexico, 1980.

134. Mixe Indian, Oaxaca. Mexico, 1980.

135. In Tarahumara. Mexico, 1984.

136. Tens of thousands of refugees from the great drought in Brazil's Northeast concentrate themselves in the vicinity of the cities. Often the only way to survive is to fight with the vultures for the spoiled food in garbage dumps. Fortaleza, Brazil, 1983.

137. Mixe Indians, Oaxaca. Mexico, 1980.

138. A community above Chimborazo. Ecuador, 1982.

139. A ceremony for the end of the harvest among the Mixe Indians in Oaxaca. Mexico, 1980.

140. A thanksgiving prayer to the Mixe god Kioga in gratitude for the good harvest, and asking to survive another year. Oaxaca, Mexico, 1980.

Biography

Main Photographic Essays

1978 "4000 Habitations"—photographic essay on the problems of living conditions in the La Courneuve suburb of Paris. Work ordered by the local council in order to set up a major exhibition exposing this problem.

1979 Photographic research on the varying degrees of success of integration by immigrants into European society, specifically in France, Holland, Germany, Portugal, and Italy.

1977–84 Research on the living conditions of peasants, and the cultural resistance of the Indians and their descendants across Latin America, from Mexico to Brazil.

1984–85 Work done in collaboration with the humanitarian aid group Médecins Sans Frontières (Doctors without Borders) exploring the devastating effects of drought in the Sahel region of Africa.

1986–92 Documentary project on the end of large-scale manual labor in twenty-six countries.

1994–99 "Population Movements Around the World,"—thirty-six photographic investigations on migration trends across the globe.

2001 Photographic essay on the global polio eradication campaign by UNICEF and WHO (World Health Organization).

Honors

1982 W. Eugene Smith Grant in Humanistic Photography, USA; Award for project on Latin American peasants, Ministry of Culture, France

1984 Kodak/City of Paris Award for *Other Americas*, France

1985 World Press Photo Award, Holland; Oskar Barnack Prize, for humanitarian story of the year, West Germany

1986 Ibero-American Photography Award, Spain; Photojournalist of the Year Award, The International Center of Photography, USA; Prix du Livre, for *Sahel, l'Homme en Détresse*, Arles International Festival, France; Grand Prix and Prix du Public for the exhibition "Other Americas" from the "Month of Photography," Paris Audiovisuel, France

1987 Photographer of the Year Award, American Society of Magazine Photographers, USA; Photographer of the Year

Award, Maine Photographic Workshop, USA; Olivier Rebbot Award, Overseas Press Club, USA; Jounalistenpreis Entwicklungspolitik, West Germany; Prix Villa Médicis, Ministry of Foreign Affairs, France

1988 Erich Salomon Award, West Germany; Premio de Fotografía Rey de España, Spain; Photojournalist of the Year Award, International Center of Photography, USA; The Gold Award, Art Directors Club, USA

1989 Erna and Victor Hasselblad Award for Life Achievement, Sweden; The Artist of Merit Josef Sudek Medal, Czechoslovakia

1990 The Maine Photographic Workshop Award for the Best Photography Book, *An Uncertain Grace*, USA; Visa d'Or Award, International Festival of Photojournalism, Perpignan, France

1991 The Commonwealth Award, USA; Le Grand Prix de la Ville de Paris, France; The Gold Award, Art Directors Club, USA

1992 Elected Foreign Honorary Member of the Amercian Academy of Arts and Science, USA; Oskar Barnack Prize, Germany; Art Directors Club Award, Germany

1993 Prize for the Best Photography Book of the Year, *Workers: An Archaeology of the Industrial Age,* Arles International Festival, France: Trophée Match d'Or for Life Achievement, France; The World Hunger Year Harry Chapin Media Award for Photojournalism for *Workers: An Archaeology of the Industrial Age,* USA

1994 Award for the publication *Workers: An Archaeology of the Industrial Age,* International Center of Photography, USA; "Centenary Medal," The Royal Photographic Society of Great Britain, England; "Honorary Fellowship," The Royal Photographic Society of Great Britain, England; "Professional Photographer of the Year," Photographic Manufacturers and Distributors Association, USA; Grand Prix National, Ministry of Culture and Communication, France; Award of Excellence, Society of Newspaper Design, USA; Silver Award, Society of Newspaper Design, USA

1995 Silver Medal, Art Directors Club, USA; Silver Medal, Art Directors Club, Germany

1996 Citation for Excellence, Overseas Press Club of America, USA; Auszeichnung, Art Directors Club, Germany

1997 Prêmio Nacional de Fotografia, Ministry of Culture, Funarte, Brazil; Prêmio A Luta pela Terra, Personalidade da reforma agrária, (movement of landless peasants), Brazil

1998 Silver Medal, Art Directors Club, Germany; Alfred Eisenstaedt "Life Legend" Award, *Life* magazine, USA; Prêmio Jabuti, for *Terra*, Brazil; "Principe de Asturias" Award for Arts, Spain

1999 Alfred Eisenstaedt Award for Magazine Photography, "The Way We Live," USA; Prêmio Unesco, Brazil

2000 Medal of "Presidenza della Repubblica Italiana," International Research Center, Pio Manzù, Italy

2001 "Doctor Honoris Causa," University of Evora, Portugal; Honorary Doctor of Fine Arts, New School University, New York, USA; Honorary Doctor of Fine Arts, The Art Institute of Boston at Lesley University, Boston, USA; Prêmio Muriqui 2000, Conselho Nacional da Reserva da Biosfera da Mata Atlântica, Brazil; UNICEF Special Representative; "Ayuda en Accion" prize, Ayuda en Accion, Spain

Major Traveling Exhibitions

1982–99 "Other Americas," including these and other venues:

Galeria de Fotografia da Funarte, Rio de Janeiro, Brazil, 1982
Museo de Arte Contemporaneo de Madrid, Spain, 1986
Maison de l'Amérique Latine, Paris, France, 1986
Musée de l'Elysée, Lausanne, Switzerland, 1987
Museum Mishkan Le'Omanut, Israel, 1988
Palace of Youth, Shanghai, China, 1989
Musée Municipal, Dudelange, Luxembourg, 1992
Art Gallery, Inter-American Development Bank, Washington, D.C., USA, 1998
Bayrische Staatsoper, Munich, Germany, 1999

1986–97 "Sahel: l' Homme en Détresse," including these and other venues:

Canon Photo Gallery, Amsterdam, The Netherlands, 1986
Musée de l' Elysée, Lausanne, Switzerland, 1987
Museu de Arte de São Paulo, Brazil, 1988
National Gallery of Art, Beijing, China, 1989
Biennale de Cétinié, Montenegro, Yugoslavia, 1997

1989–present "Retrospective," including these and other venues:

Hasselblad Center, Göteborg, Sweden, 1989
Bienal de Cuba, La Havana, Cuba, 1989
Photographer's Gallery, London, England, 1990
National Museum of Modern Art, Tokyo, Japan, 1993
McLellan Galleries, Glasgow, Scotland, 1994
L'Espace Photographique de Paris, France, 1996

1989–96 "An Uncertain Grace," including these and other venues:

San Francisco Museum of Modern Art, USA, 1990
International Center of Photography, New York, USA, 1991
Städtisches Museum, City of Schleswig, Germany, 1996
EFDI, Madrid, Spain, 1999
EFDI, Valencia, Spain, 2000

1992–present "Workers," including these and other venues:

Römisch-Germanisches Museum, Cologne, Germany, 1992
Philadelphia Museum of Art, Pennsylvania, USA, 1993
Palais de Tokyo, Paris, France, 1993
Centro Cultural de Bélem, Lisbon, Portugal, 1993
Biblioteca Nacional, Madrid, Spain, 1993
National Gallery Slovakia, Bratislava, Slovakia, 1993
Royal Festival Hall, London, England, 1993
Palazzo delle Esposicioni, Roma, Italy, 1994
Musée de l'Elysée, Lausanne, Switzerland, 1994
Museu de Arte de São Paulo, MASP, Brazil, 1994
The Bunkamura Museum of Art, Tokyo, Japan, 1994
Arberjdermuseet, Copenhagen, Denmark, 1994
Nederlands Foto Instituut, Rotterdam, Holland, 1994
Palazzo Affari ai Giureconsulti, Milan, Italy, 1994
Kulturhuset, Stockholm, Sweden, 1995
International Center of Photography, New York, USA, 1995
Onomichi Municipal Museum of Art, Hiroshima, Japan, 1995
The Art Gallery of New South Wales, Sydney, Australia, 1995
Palais de Beitaddine, Le Chouf, Lebanon, 1995
Hall Victor Hugo, Limpersberg, Luxemburg, 1996
Museo de Belas Artes, Caracas, Venezuela, 1997
Museu de Arte da Pampulha, Belo Horizonte, Brazil, 1997
Instituto Cultural Brasileiro, Berlin, Germany, 1997
Andorran National Commission for UNESCO, Principality of Andorra, 1998
Museo de Arte Moderno, Mexico City, Mexico, 1998
Contemporary Art Center Zamek Ujazdowski, Warsaw, Poland, 2000
Norsk Industriarbeider Museum, Rjukan, Norway, 2000
Palazzo Cisterna, Biella, Italy, 2001

1994–98 "Serra Pelada," including these and other venues:

Galerie Debret, Paris, France, 1994
Cleveland Center for Contemporary Art, Cleveland, OH, USA, 1996
Groupe d'Animation Photographique, Cholet, France, 1997
Archivo Historico y Museo de Mineria, Pachuca, Mexico, 1998

2000–present "Migrations," including these and other venues:

George Eastman House, Rochester, New York, USA, 2000
Maison Européenne de la Photographie, Paris, France, 2000
Parque das Nações, Pavilhão de Portugal, Lisbon, Portugal, 2000
Planetário-Museu do Universo and Instituto Moreira Salles, Rio de Janeiro, Brazil, 2000
Scuderie Papali al Quirinale, Roma, Italy, 2000

Circulo de Bellas Artes, Madrid, Spain, 2000
United Nations Hall, New York, USA, 2000
Arengario and Istituto Martinitt, Milan, Italy, 2000
Fundación PROA, Buenos Aires, Argentina, 2000
Helsinki City Art Museum, Helsinki, Finland, 2001
Le Botanique, Brussells, Belgium, 2001
Manes Gallery, Prague, Czech Republic, 2001
Deutsches Historisches Museum, Berlin, Germany, 2001
Berkeley Art Museum, California, USA, 2002
The Bunkamura Museum of Art, Tokyo, Japan, 2002

Books

Sahel:L'Homme en Détresse. France: Prisma Presse and Centre National de la Photographie, Médecins Sans Frontières (Doctors without Borders), 1986
Other Americas. USA: Pantheon Books, 1986
Autres Amériques. France: Editions Contrejour, 1986
Otras Americas. Spain: Ediciones ELR, 1986
Outras Américas. Brazil: Companhia das Letras, 1999
Sahel, El Fin del Camino. Spain: Comunidad de Madrid, Medicos Sin Fronteras (Doctors without Borders), 1988
Les Cheminots. France: Comité Central d'Entreprise de la SNCF, 1989
An Uncertain Grace. USA: Aperture, 1990
An Uncertain Grace. Japan: SGM, Sygma Union, 1990
Um Incerto Estado de Graça. Portugal: Editorial Caminho, 1995
The Best Photos / As Melhores Fotos. Brazil: Sebastião Salgado Boccato Editores, 1992
Photopoche, Sebastião Salgado. France: Centre National de la Photographie, 1993
Workers: An Archaeology of the Industrial Age. USA: Aperture, 1993
Workers: An Archaeology of the Industrial Age, England: Phaidon, 1993
La Main de l'Homme. France: Editions de La Martinière, 1993
Trabalho. Portugal: Editorial Caminho, 1993
Trabajadores. Spain: Lunwerg Editores, 1993
Arbeiter. Germany: Zweitausendeins, 1993
Workers: An Archaeology of the Industrial Age. Japan: Iwanami Shoten, 1993
La Mano dell'Uomo. Italy: Contrasto, 1994
Trabalhadores. Brazil: Companhia das Letras, 1996
Terra. France: Editions de La Martinière, 1997
Terra. Portugal: Editorial Caminho, 1997
Terra. Germany: Zweitausendeins, 1997
Terra. Italy: Contrasto, 1997
Terra. England: Phaidon, 1997
Terra. Brazil: Companhia das Letras, 1997
Terra. Spain: Alfaguara, 1997
Um Fotógrafo em Abril. Portugal: Editorial Caminho, 1999
Serra Pelada Photo Poche Societé. France: Editions Nathan, 1999
Exodes. France: Editions de La Martinière, 2000
Exodos. Portugal: Editorial Caminho, 2000
Migranten. Germany: Zweitausendeins, 2000
In Cammino. Italy: Contrasto / Leonardo Arte, 2000
Migrations. USA: Aperture, 2000
Exodos. Brazil: Companhia das Letras, 2000

Exodos. Spain: Fundacion Retevision, 2000
Les Enfants de l'Exode. France: Editions de La Martinière, 2000
Retratos de Crianças do Exodo. Portugal: Editorial Caminho, 2000
Kinder. Germany: Zweitausendeins, 2000
Ritratti. Italy: Contrasto / Leonardo Arte, 2000
The Children. USA: Aperture, 2000
Retratos de Crianças do Exodo. Brazil: Companhia das Letras, 2000
Retratos. Spain: Fundacion Retevision, 2000
Malpensa. Italy: *La città del volo,* SEA Aeroporti di Milano, 2000
Salgado. Italy: Contrasto, 2002.
Une Certaine Grâce. France: Editiones de la Martiniére, 2002

Catalogs

Sebastião Salgado: Fotografias. Brazil: Ministério de Educação e Cultura, Funarte, Rio de Janeiro, 1982
Sebastião Salgado. France: Galerie Municipale du Chateau d' Eau, Toulouse, 1986
Otras Américas. Spain: Universidade de Santiago de Compostela, 1992
Sebastião Salgado: La Revelación Rescatada. Mexico: Museo Casa Diego Rivera, Festival Internacional Cervantino, Guanajuato, 1991
In Human Effort. Japan: The National Museum of Modern Art, Tokyo, 1993
Trabajadores. Spain: CAM, Fundación Cultural, Alicante, 1994
Workers. Japan: Asahi Shimbum, Bunkamura, 1994
La mine d'or de Serra Pelada. France: Galerie Debret, 1994
Arbetare. Sweden: Kulturhuset, 1995
100 photos pour défendre la liberté de la presse. France: Reporters sans frontières, 1996
Portfolio. Germany: Bibliothek der Fotografie, Stern, 1996
La mà de l'home. Principality of Andorra: Andorran National Commission for Unesco, 1998